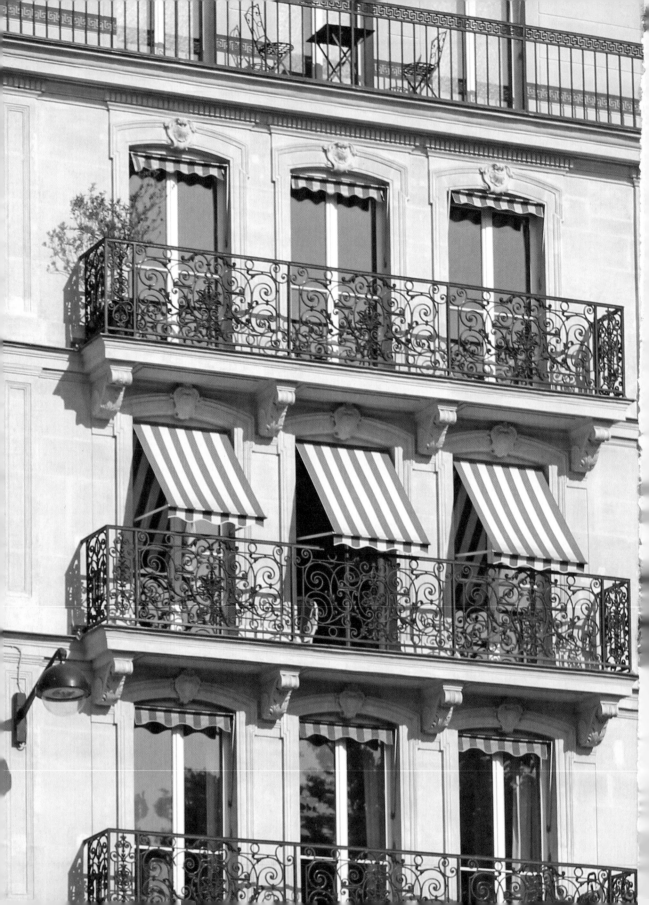

PARIS

AN INSPIRING TOUR *of the* CITY'S CREATIVE HEART

TEXT *and* PHOTOGRAPHS BY

Janelle McCulloch

CHRONICLE BOOKS

SAN FRANCISCO

CONTENTS

Paris handbook 105

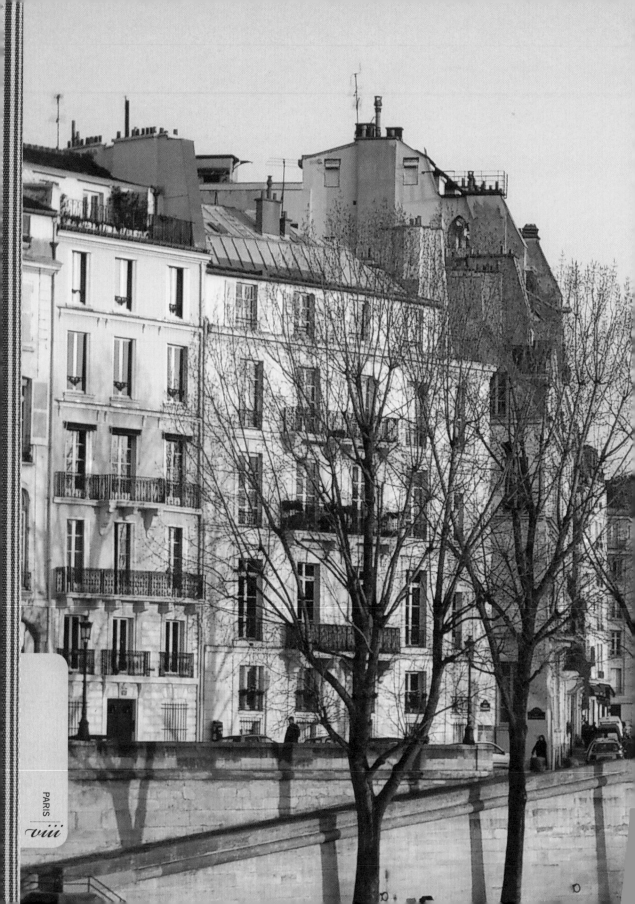

DISCOVERING THE PARISIAN SPIRIT

Paris is far more than a city. It is an irresistible, enthralling source of inspiration and fascination; an urban *wunderkammer* bulging with the unusual, the whimsical, the magical and the memorable.

Because of this, the place has become something of a modern mecca for the world's aesthetes and creative innovators, who make the pilgrimage here each year to witness its splendid displays and quirky collections, discover new ideas and insights and generally indulge in a bit of French *flânerie* (or what's otherwise known as "rambling the *rues* in search of new style").

The joy of Paris, of course, has always been as much about the idling, ogling, musing and contemplating as it has been about the sightseeing, but in the last few years the city seems to have become more stimulating and invigorating thanks to a new generation of creatives – both French-born and Paris-loving expats – who have revitalised the place with their captivating takes on fashion, design and style.

As a journalist, book editor and photographer who specializes in architecture and design, I'm fortunate (and grateful) to have a job that allows me to travel the world at least once a year. And it's the city of love, light and luminous design that draws me back, year after year. It's Paris where I'm most likely to find fabulously imaginative artisans, truly unusual ateliers and eye-poppingly beautiful boutiques. It's Paris where I'm most likely to stumble across fantastic exhibitions, regardless of the month I happen to be visiting. And it's Paris where I'm most likely to get my fix of inspiration and motivation – it's like taking a creative vitamin for the mind.

Despite my love of its alluring streets, charismatic quartiers, quirky characters and sublime urban style, I do have a lingering problem with the city. It has a sneaky tendency to keep the best bits to itself. Like a French woman who plays her hand very close to her Chanel-scented chest, it likes to keep many of its most appealing parts as teasing secrets. Even Parisians notice this. And that's where this book comes in.

After 20 years and countless visits to Paris, I have built up a journalist's "black book" of addresses and contacts, from amazing ateliers and gorgeous little stores to secret design museums, hidden quartiers, cuter-than-cute streets, engaging cafes and book-stores and even affordable design hotels. I am often asked for my opinion on creative or inspirational places to visit in Paris, and I often call on this dog-eared little book for thoughtful recommendations. In turn, I am always seeking out the best tips on inspirational destinations, aware that there is always something new to discover about this constantly evolving capital.

After my last journey to Paris, I came up with the idea of writing a creative guide to Paris for all lovers of art, design and style: a book that offered both inspiration and information, a beautifully illustrated insider's guide with a whole new perspective on Paris. I wanted to write a poetic ode to a city that's been dear to my heart for the better part of two decades, but I also wanted to lift the lid on some of the city's best-kept design and style secrets, from shops, bistros, bookstores, galleries, museums, hotels and ateliers to *rues* that surprise and delight. It's a book that not only shows you where the most creative parts of Paris are but also encourages you to be creative yourself.

And so I'd like to take you on a tour of Paris, highlighting the most creative places and inspiring spaces in this aesthetically rich city. It's a book for design and style enthusiasts, creative entrepreneurs and anyone who loves Paris.

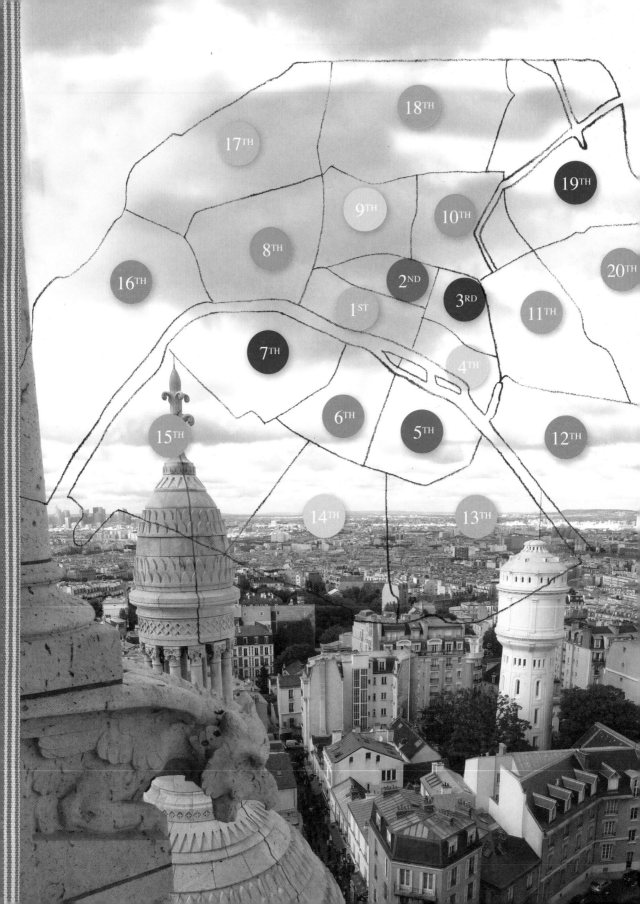

A stroll through Paris

Paris is a beautiful city to visit, but it can also feel a little like a *mille-feuille* at times: gorgeous to gaze upon and near irresistible to most but full of complicated layers that can sometimes seem too much to get through, at least all at once. These "layers" comprise 20 neighborhoods, called arrondissements, which are all different in personality, architecture and atmosphere but are all held together by a unifying, carefully designed grid of interconnecting streets, bridges and buildings.

Tucked within these arrondissements are another 80 smaller and more intimate neighborhoods, called quartiers, which are just as atmospheric and just as interesting to explore. (Each arrondissement has four smaller quartiers to it.) And every one of these arrondissements and quartiers has a name. Few visitors know this; they simply refer to the numbers (3rd, 4th, etc.), which is certainly far easier. But the names are often much more interesting. The 11th arrondissement, for example, is called "de Popincourt" and encompasses the quartiers of Folie-Méricourt, Saint-Ambroise, La Roquette and Sainte-Marguerite. And then there are my favorites: "de l'Entrepôt" (the 10th arrondissement) and "des Gobelins" (the 13th).

It is always a difficult decision choosing which of Paris's arrondissments to explore. Each offers something different to every individual. For this book I selected those areas I felt had the greatest creative appeal. I've always loved the bookshops, boutiques and hidden quartiers of St Germain and the 6th arrondissement, but I also adore the boulevards and grandeur of the 1st. Others will, I know, embrace the charm and secret courtyard of Saint-Paul and the Marais, the classic mise-en-scenes of Montmartre and the revitalized energy of neighboring Pigalle. I've had to leave some areas out but I would like to encourage you to explore these other areas on your own. Seeking out your own private Paris is the best way to discover this beautiful city.

So where to start? Well, the best way to see Paris is to treat it like one of those magnificent *mille-feuilles*: break down the layers, piece by piece, so that you can slowly savor each one.

More and more travelers are choosing to approach Paris in this manner, devoting time not only to each arrondissement but also each quartier or neighborhood within. Well-informed visitors often take an entire afternoon to see a single quartier, reveling in the history, the

atmosphere, the architectural and urban beauty, the various moods during different moments of the day and even the local characters, who can be found in the many markets, cafes, bistros, patisseries, gardens and stores. It's one of the best ways to explore Paris, and it allows you to become intimate with the city very quickly. Indeed, some argue that it's the small neighborhoods, with their personalities, quirks and street pleasures, that really make Paris beautiful – especially when the light filters through the branches of the trees, someone walks by and nods *bonjour* in greeting and the scene starts to magically resemble an old-fashioned postcard.

So how do you enjoy these quiet quartiers and enchanting corners, most of which are set far off the well-trodden boulevards? Well, you can walk the streets like an old-fashioned *flâneur*, which offers all kinds of unexpected visual treats. Or, you can take inspiration from the pages to come. In the following pages I'll show you the Paris that many guidebooks don't tell you about: the secret side streets, the tucked-away gardens, the quiet neighborhood squares and the irresistible cafes, bistros, tea salons, patisseries and stores that make up the fabric of these glorious neighborhood quartiers. I'll try to gently break down the *mille-feuille* that is Paris, so that it is easier to experience and to remember long after you've left, or finished this book.

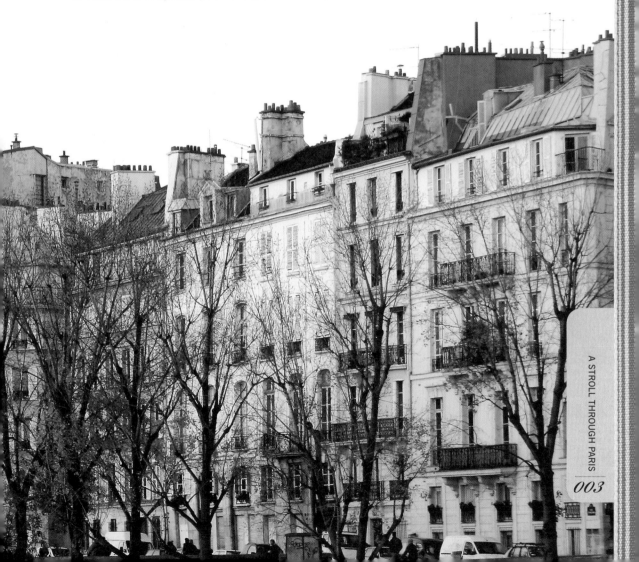

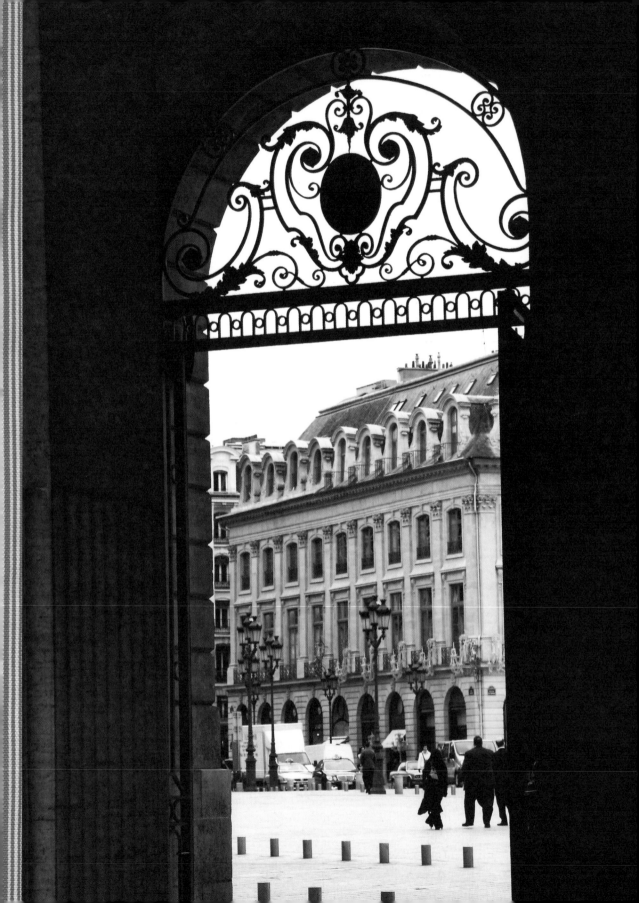

1st

Arrondissement

THE SOPHISTICATE

Haussmann's magnificent architecture, Chanel's black-and-white store on the Rue Cambon, Ladurée's dainty macarons (and nibbling one in the ornate interior of its tea salon), joining the strollers in the Tuileries Garden on a Sunday, walking through the falling leaves in autumn, sipping a steaming mug of hot chocolate at Angelina (Chanel's favorite tea salon), walking beneath the perfectly clipped pleached trees of the Palais Royal, glimpsing the striking glass pyramid of the Louvre via the archways to the east of the forecourt, stumbling across the village-like feel of Place Dauphine, losing yourself in an exhibition at the Museum of Decorative Arts (Musée des Arts Décoratifs) and wandering along the Seine during the pink hour at twilight.

1ST

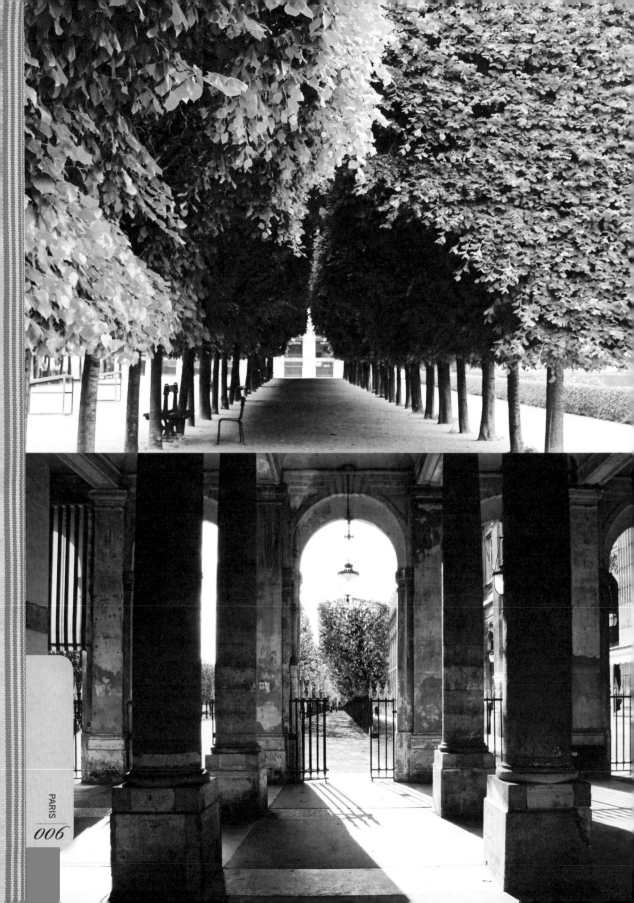

If you want to know where to discover the soul of *le vieux Paris* –
the soft, sentimental Paris of centuries past, rather than the modern,
sometimes sharp-edged Paris of the present and future – then you
need to look for its romantic heart. To do this, start at the enchanting
Square Gabriel Pierné, located where Rue de Seine meets the Seine
on the Left Bank and marked by curious benches shaped like books.
Then head to the river and cross over the tiny, iron, pedestrian-only
bridge known as Pont des Arts, which delicately straddles the Seine
in a captivating, highly photogenic fashion. (While you're doing
so, gaze upriver at one of the most beautiful views in Paris, that
of the islands of Île de la Cité and Île Saint-Louis floating gently
on the Seine.) Then head west toward the Louvre, that magical,
labyrinthine museum bulging with vaulted galleries, curiosities and
iconic art. Keep winding your way west through the sculptural
architecture and courtyards until you reach that idyllic expanse of
green pleached gardens known as the Tuileries. Now, find yourself
a garden seat (don't worry, there will be dozens) and a space among
the plane trees to call your own. Once you've done that, you can
sit back, relax and contemplate the city, because you are now in the
center of the 1st arrondissement and, by turn, the center of Paris.
Before you is the Paris most visitors recognize: the Louvre, the
Tuileries Garden, those grand boulevards and quais and, beyond
them, the Seine shimmering gently in the sun. Historical, magical,
memorable.

One of the world's great spaces, the 1st arrondissement is considered
the very heart of this glorious city. Spread out around the clipped
beauty of the Tuileries and the stern, dignified architecture of the
Louvre, it contains some of the city's most recognizable landmarks,
including the Seine, the Axe Historique (the grand historic axis), the
Place Vendôme and its iconic Hôtel Ritz Paris, the Palais Royal, the
Île de la Cité and even some parts of the Left Bank. (Although much
of the Left Bank is in the 6th arrondissement, the streets close to the
Seine are technically in the 1st.) With its iconic landmarks, postcard-
perfect streets and quintessential Parisian scenes, it's become prime
photographic and sketchbook territory for the creative set. You only
have to wander along its bridges, squares, boulevards and gardens
to feel inspired to pull out a sketchbook and start drawing away
(although I usually just take my camera now: it's quicker, and does
a far better job capturing Paris than I do). However, if you're still
struggling to feel the Parisian spirit then just feast your eyes on
the dramatic gray-and-white striped columns of the Palais Royal's

grand forecourt, the myriad black and gray bridges that stretch elegantly across the Seine, I. M. Pei's pyramid at the Louvre (best seen framed by one of the surrounding archways) or the captivating architecture of the Île de la Cité.

In short, the 1st is an arrondissement of classic Parisian pleasures. Grandeur, glamour, architecture and gardens. You couldn't get much more Parisian if you tried – unless you threw in some Chanel, too. Oh, that's right. Chanel's here as well.

Now, there are those who believe that the 1st arrondissement can sometimes be a little dull. Certainly, it doesn't have the sweet charm and shimmering light of the Île Saint-Louis, the rousing intellectual atmosphere and literary roots of Saint-Germain-des-Prés and the 5th and 6th or the warm villagey feel of the Marais. It's solid,

dignified and distinguished. It doesn't bow to trends or fads, it doesn't try to be the cool kid among the arrondissement coterie, and it would never change itself to impress others. Why would it? It's already magnificent.

In saying all this, it does have its unexpected delights. The 1st may be refined and sophisticated, but it's also occasionally naughty and rebellious (pop into Angelina for a decadent treat and you'll see what I mean!). It's like spending time with a cultivated, well-read grandmother or grandfather with a wicked sense of humor: you think it's going to be a quiet afternoon, but you're never quite sure what might happen.

Marie Antoinette's ghost, Jeanne Lanvin's bathroom and Chanel's favorite tea salon

One of the best places to begin a memorable tour of the 1st is on the island known as **Île de la Cité**, where there are sublime views of Paris on both sides of the island, looking up or downriver through the bridges of the city. The most beautifully designed bridge is the pedestrian-only **Pont des Arts**, off the tip of the Île de la Cité, but really, you could walk across any bridge in this quartier and be rewarded with a glorious vista of the city, any time of the day or night.

There is also one of the prettiest squares in the city here, **Place Dauphine**: a lovely, old, whisper-quiet place on the tip of the Île de la Cité that feels like something from the French countryside.

From here, head to **Notre Dame** for a classic gargoyle's view of Paris (though remember to return just before twilight on a slightly overcast night because the gray clouds and pink sky make for a dramatic 1950s-style photograph). Or, if it's a Sunday, wander through the **Flower and Bird Market** (Marché aux Oiseaux) at Place Louis-Lépine, with its cages full of clucking chickens. (This is one of the surprising and whimsical aspects of this arrondissement that I warned you about.) I love wandering past the cages of roosters, chickens, parakeets, canaries and other twittering species, wondering if they'll end up in some grand Haussmannian apartment on Boulevard Saint-Germain. The flowers can make gorgeous photographs too, although the vendors do like you to buy them after you've shot them.

At this point some people like to visit the diminutive, perfectly designed little chapel **Sainte-Chapelle** to be wowed by its famous stained-glass windows. The chapel was commissioned by King Louis IX to house the Crown of Thorns and a fragment of the True Cross. Try to attend one of the regular, candlelit concerts for a special treat. However, it's also good to pause at the **Conciergerie** and remember Marie Antoinette, imprisoned here and at the Temple prison before her execution. Her cell is still at the Conciergerie (another strange part of this arrondissement), and you can visit it if you wish. I prefer not to, as it's filled with ghoulish mannequins that supposedly replicate the queen and her guards, which I'm quite certain MA would have found tacky and not a suitable tribute to her va-va-voom style. I often wonder if I will see her ghost, which has been spotted hundreds of times both here and at Versailles.

If you feel you need something a little more upbeat after seeing the Conciergerie, then make for the Louvre – not to tackle the labyrinthine gallery but to take inspiration from its smaller and (I think) prettier sister next door on the Rue de Rivoli, the **Museum of Decorative Arts** (Musée des Arts Décoratifs; page 164). Many design aficionados head

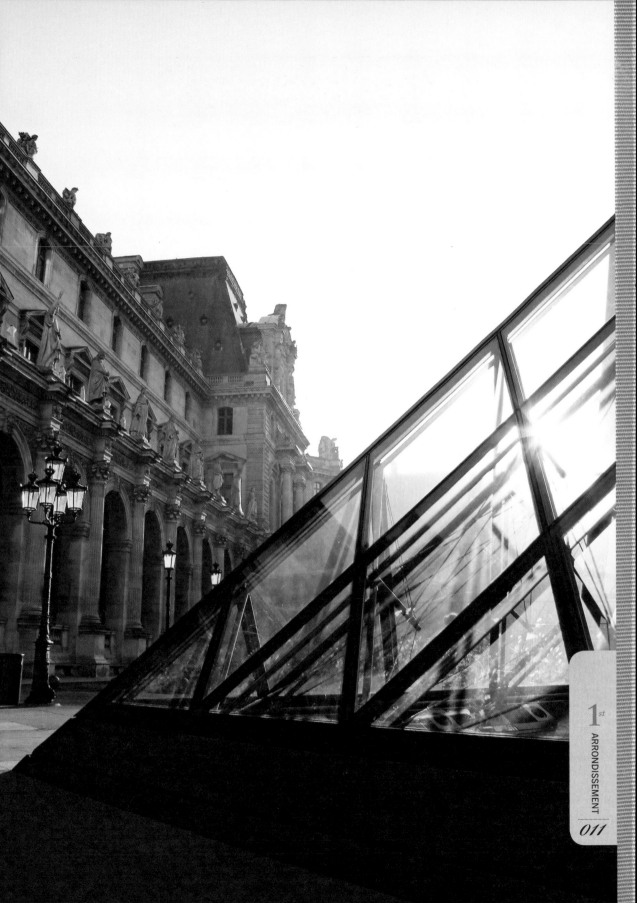

here straight off the plane, and it's easy to see why. It's a treasure trove of fabulousness, from furniture to interior design, objets d'art, wallpaper, tapestries, ceramics and glassware. Don't miss the museum's bookstore, an unforgettable highlight.

After this feast of reading and design riches, head across the road to the Palais Royal, which I think is the most magnificent square in the world. On the way, stop to consider the creative Metro entrance at Place Colette, called **Kiosk of the Night-Walkers** (Kiosque des Noctambules), which is street art in itself.

Hidden behind a nondescript building, the **Palais Royal garden** (Jardin du Palais Royal) is like a Shangri-la in the middle of Paris. These gardens were transformed from a private space to a popular social hub by Louis-Philippe Joseph II, duc d'Orléans (yes, I know – it's a bit of a mouthful), who created the country's first public shopping arcade here from 1781 to 1784. Old Duc seemed to be a bit of a Donald Trump because as soon as they opened, the gardens filled with cafe tables and chairs, circus acts, street performers and crowds all hours of the day and night. Naturally, the poor people of Paris disliked being left out of the fun, and it is said that the first stirrings of the Revolution began near here.

These days, it's far more peaceful to wander around this graceful place, with its parallel rows of clipped lime trees (the French just *love* to pleach a tree), its dignified gravel aisles, its orderly arched arcades and the extraordinary forecourt created by modern conceptual artist Daniel Buren, with its striped gray-and-white columns. There are also a number of gorgeous stores here, including Didier Ludot's vintage boutique (page 181) and the restaurant Le Grand Véfour, where, it is said, Napoleon liked to dine with Josephine on one of their many dates.

After the Palais Royal, you can stop for a shop along the **Rue Saint-Honoré** (Colette and lots of other stores are here), or you can head for another grand green space: the **Tuileries Garden**, to take a seat and catch your breath.

The Tuileries is glorious at all times of year: in autumn and winter, when the "bones" of the trees create a kind of sculptural beauty, and in spring and summer, when they are dressed head to toe in vibrant green. It's a classic Paris park: beautifully symmetrical, shaped by formal, white gravel paths and garden seats and featuring extraordinary vistas. The city's largest and oldest garden is a masterpiece of classical garden design, created in 1664 by André Le Nôtre, who also designed the royal gardens in Versailles. The central axis, which begins at the round reflecting ponds at the Louvre end and continues in an unbroken vista to the western facade at the other, not only creates a spectacular perspective, or line of sight, but also forms a significant part of the grand axis of Paris (the Axe Historique) – a line of monuments, buildings and thoroughfares that extends from the center of Paris out to the west. There's also a terrific bookstore, **Librairie des Jardins** (page 115), for book lovers. If you come to the gardens, be ready to stay a while. Quite simply, the Tuileries is sublime.

After you've enjoyed some fresh air in the gardens, head for the Rue de Rivoli, where there is a fantastic bookstore that will help you brush up your knowledge of the city. It is called **Galignani** (page 114), and it's a thoroughly handsome store full of thoroughly

stylish titles (in both English and French) on art, architecture and interior design.

There are two places where you can finish a tour of the style and design delights of this arrondissement. The first is the octagonal **Place Vendôme**, which inspired Chanel to design the *flaçon* for her first fragrance, N°5. This should always be immediately followed by a visit to the **Chanel** boutique (page 185) itself, a must for any visitor to Paris, even if you lean toward Balmain or Marc Jacobs. The second is the tea salon **Angelina** (page 195), which is where Chanel used to go when she slipped away for a cup of hot chocolate. Tip: get the white hot chocolate rather than the dark, which is served with chocolate whipped cream and is heavy enough to be eaten like pudding with a spoon. Oh Angelina, you are wicked, indeed.

See, I told you the 1st arrondissement isn't as virtuous and dignified as it seems.

A PARIS

2nd and 9th *Arrondissements*
THE RISING STARS

The grand, gilt interior of the Opéra de Paris, the magnificent domed ceiling of Galeries Lafayette department store, the winding streets and covered arcades and passageways, the lovely architecture of the Galerie Colbert and the surprising gentrification of the once seedy but still lively streets near Pigalle.

9TH

2ND

Unlike the Marais, the Left Bank, the Canal Saint-Martin and other perennially popular parts of Paris, the 2nd and 9th have been largely neglected by tourists, apart from a certain type who like to visit the, uh-hem, red-light districts at a certain hour of the night. Along with being the lascivious end of Paris, this is also the somber business sector of the city. It's home to the Paris Bourse (Stock Exchange) and a large number of banking headquarters. It's traditionally been a place where you go to work, or perhaps shop at the department stores, and then leave – unless, of course, you happen to live here.

Not any more. The social landscape of the 2nd and 9th is changing. And boy, is the place rockin' like a Pigalle brothel.

It started with hoteliers, who began running out of room elsewhere and noticed the underused area, with its proximity to the shopping meccas, Printemps and Galeries Lafayette (also known as Les Grands Magasins). They began creating fabulous little boutique hideaways in the streets south of Pigalle. Then, upwardly mobile Parisians began to follow, snapping up apartments in the charismatic, hilly neighborhoods around Trinité after finding that nearby Montmartre (to the north) was priced out of reach. Not long after, the rest of Paris and its tourists followed, flocking here to buy ballet flats at Repetto (the best flats in the city) and to shop until they dropped on their Hermès Kelly bags from Parisian fatigue. Heck, even Zara set up a Home store to sell to all those stylish new buyers. All of a sudden, the 2nd was chic and the 9th started looking so fancy it could have done a cancan at the Moulin Rouge.

So these days, the 2nd, 9th and also the 18th (Montmartre) arrondisements of Paris are all about some serious *passementerie*. Now, *passementerie* is one of the blog world's favorite new terms, along with *brocante*. If you need help (as I did), here's a quick lesson. *Brocantes* are antique or vintage shops and fairs, a *mercerie* is a drapery or haberdashery store and *passementerie* encompasses grosgrain ribbons, buttons, trims and myriad other gorgeous things. An *armoire*, meanwhile, is what you buy for a ridiculous price from the Puces (Saint-Ouen markets) and drag home to store it all in, and a *chaise longue* (*not* a *chaise lorenge,* as my partner calls it) is what you pass out on after you'd had a big day at the Puces. There. Now you're all set.

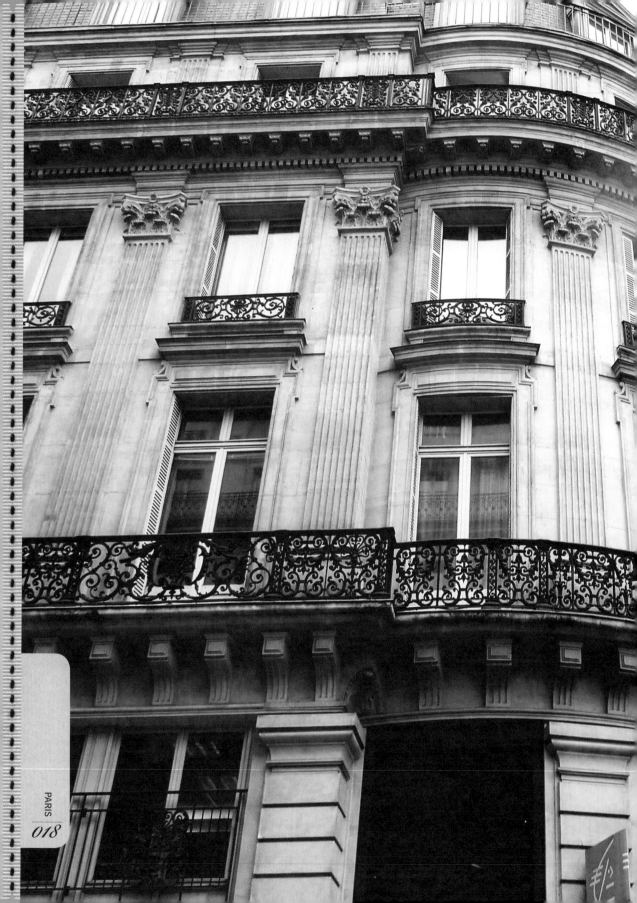

A highlight of the area is Ultramod (page 176), a *mercerie* or haber-dashery store that has been selling buttons, ribbons, hats and silks since 1890 and has retained its traditional look and atmosphere.

Ultramod is the epitome of the shift in winds happening in the slowly changing 2nd and 9th arrondissements. It's an old destination that's being rediscovered and loved by a new generation.

So what else is fab about these somewhat underappreciated arrondissements? Well, let me tell you what I think is worth seeing, starting with the Rue Montorgueil neighborhood.

A WANDER THROUGH THE 2ND AND 9TH

*Cute rues, fabulous food,
gorgeous shops and grand architecture*

Let's begin our tour of the 2nd and 9th arrondissements with a peek around the **Rue Montorgueil**. I stumbled upon the Montorgueil while hiking from Galeries Lafayette to the Place de la République one day to work off a Fauchon lunch. This lively pedestrian street bounces with great bars and bistros, quaint cafes and pretty boutiques, renowned pastry shops like La Maison Stohrer, plus all the fish stores, cheese shops, wine shops and produce stands a foodie could want in one *rue*. It's one of the best places for gourmands to be seen shopping – it's obviously the place to go if you like to make a style statement while shopping for your Parisian-chic leeks.

While you're in the same neighborhood, there are several other rather special streets worth exploring – although these are not so much *rues* as *rue-ettes*. More accurately, they're tiny, covered passageways full of design detail and great shopping opportunities that should not be missed. Significant to architecture lovers, these enchanting **19th-century arcades** allow you to step back in time, to an age when shopping was an aesthetic pleasure. They first popped up at the beginning of the 19th century as a solution to Paris's dank, muddy, odorous streets, which were then largely devoid of footpaths. Businessmen and retailers, sensing that shoppers needed a better way to browse, designed these beautiful passages, which immediately became a hit with the stylish Parisian crowd. By the middle of the 19th century there were about two dozen of these covered spaces, each of them different in architecture, style and sometimes even retail focus. However, as the Paris authorities paved the main streets and added footpaths and gas street lighting, most of them disappeared.

Thankfully, not all went the way of horse and carriage and there are still a number left, including the Galerie Vivienne, the Galerie Colbert, the Passage du Grand Cerf, the Passage Lemoine, the Passage Jouffroy, the Passage des Princes, the Passage du Bourg-L'abbé and the Passage du Ponceau.

The character of each varies, but out of all of them I think the most worthwhile are **Galerie Vivienne** (page 137), for its quiet charm, and **Passage du Grand Cerf** (page 137), located next to the rather insalubrious but gentrifying Rue Saint-Denis area, for its architecture and the up-and-coming design talent it hosts. Both are within walking distance of Rue Montorgueil.

When you've finished wandering the covered arcades, head west a little way until you reach Rue Montmartre. Near here, at 27 Rue du Mail, is one of the best decorating stores in Paris, the showroom of **Pierre Frey** (page 156). However, it's not the famous

showroom that many fabric fans come for but the archives of the company's **headquarters**, located nearby. These archives contain some of the most amazing fabric collections in the city, including fabrics that the company has collected from all periods and styles to create a kind of historic reference for the future. There's historical bedding, beautiful toiles and gorgeous brocades, along with exquisite old architectural models of rooms that were used to show the wealthy aristocrats how the fabrics would look in their mansions. There's also embroidered clothing, old leather-bound books full of antique fabrics and even wallpaper books full of fascinating designs from centuries past. If you can gain access to these archives, count yourself lucky: I've heard some architects and interiors designers say this is the best tour in Paris.

Now, let's move to the other end of the neighborhood and the grand, opulent, ever-so-slightly-over-the-top **Palais Garnier**, also known as the **Opéra de Paris,** which shouts excess from every corner of its lavish staircase and stage. A grand Beaux-Arts bit of architecture designed by Monsieur Charles Garnier in the neobaroque style, its most astounding features include the grand staircase and the central chandelier, which weighs over six tons. In 1896, one of the counterweights for this grand chandelier fell, killing someone – and that was just the counterweight! There are also lots of other eccentric bits, including an underground lake, cellars and other architectural elements, all of which were the inspirations for the classic Gothic novel *The Phantom of the Opera.* And yes, there is really a subterranean lake under the structure. It is the grand staircase, however, that has to be seen to be believed. I think I want one in my house. It's all just too, too fabulous for words.

Nearby, within credit card–throwing distance, are the two *grands magasins*, **Galeries Lafayette and Printemps**, which call out like a siren to shoppers the world over and are worth seeing, if only for the amazing interiors and rooftop views. Printemps is perhaps the best because it has a 360-degree view of the Paris skyline from the roof and a glorious stained-glass cupola worthy of any Gothic cathedral. However, I prefer to drop by the **Zara Home** store nearby, as its homewares are not only distinctly different from the usual French fare but also wonderfully inexpensive. If only I could fit their rugs in my carry-on case.

And then there's my favorite part of this area, which can be reached by a walk through some of the area's prettiest (and hilliest) residential streets and then a wander down a cobbled lane. It's here, facing a divine little garden at 16 Rue Chaptal, that you'll find one of the most magical museums in the city: the **Romantic Museum** (Musée de la Vie Romantique; page 169), a place that captures the artistic, literary and musical life of the Romantic period, and will make you feel as though you're a world away from the bustling city boulevards.

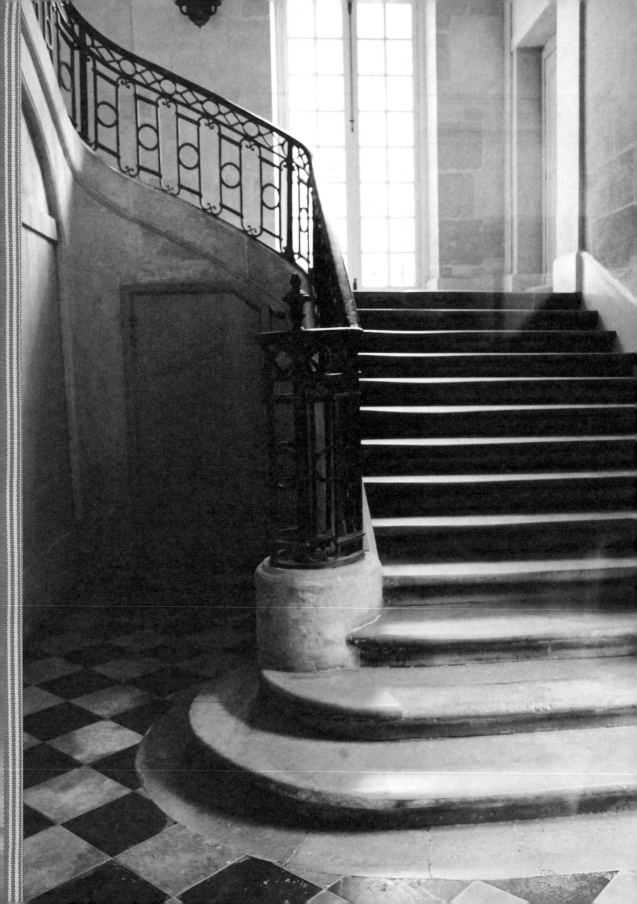

3rd

Arrondissement
THE HIPSTER

The exquisite beauty of the Carnavalet Museum, showing the history of Paris through a series of interiors, maps, miniature models and replica rooms; the labyrinthine, medieval streets with their art galleries and avant-garde artisans; the flavors and smells of the Marché des Enfants Rouges, Paris's oldest covered market; the hidden gardens and secret courtyards, the roof lines and the chimneys; the unexpected surprises as you turn a corner and see a park, a beautiful old building or simply a cute cafe with a spare table free.

3RD

Oh, how I love the 3rd! I love every bit of its intricate network of narrow streets, its medieval and Renaissance-era architecture and its intimate feel. I love the exquisite beauty of the Carnavalet Museum and its secret parterred, monastery-style garden. I love the area's craftsmen, artisans and enterprising designers with their minuscule, *boîte* (box)-style boutiques. I love how cafes and boutiques here are open on Sundays, which isn't necessarily the case elsewhere in this city. And I love mooching around and discovering new cafes, galleries and shopping hideaways every time I wander through – which is, after all, what being in Paris is all about. I could pack up and live here if I had a spare million euros sitting in my bedroom drawer.

I tell you, the 3rd is simply sublime. It's the fun part of Paris. Where other parts of the city, including the 1st and 6th arrons, are grander and more dignified, their architecture dressed in elegant grays and whites, the Upper Marais is wildly colorful and full of character. It is the Paris we'd all like to see, the Paris we'd all like to be part of.

A bit of history about this ancient area before we go on: it was the Knights Templar who originally settled this neighborhood during the Middle Ages. They drained the Marais (the swamplands) and then built their own little walled village here. Later, during the 17th century, King Henri IV came along, noticed the potential and set up shop, which of course attracted a legion of sycophantic aristocrats who wanted to be close to royalty. It was these aristocrats who built the grand mansions on the former swampland, many of which are still standing today. Two of the most accessible are the Hôtel Salé, now the Musée Picasso, and the Hôtel Carnavalet, now the Musée Carnavalet.

Much of the engaging personality of the 3rd comes from its tiny, winding, character-filled streets, which are among the few in inner Paris that have been preserved in this way. (Most of Paris was overhauled in the mid-19th century under the direction of Napoleon III and his architect Baron Georges-Eugène Haussmann, but thankfully they left this area intact. Good on you Georges, I say.) These maze-like passageways, many of which date from the 15th and 16th centuries, are perfect for the kind of intensive exploration that people come to Paris for. They also serve as the perfect backdrop for the intriguing shops, hotels, galleries and cafes scattered through this absorbing little arrondissement.

For many years the Upper Marais was largely overlooked by tourists, who preferred to spend time in the 4th, which is further south near the Seine. This may have been a good thing, because it preserved the "feel" of this enchanting area (these days the 4th's problems come as a direct result of its staggering popularity). Thus, the Upper Marais is still relatively authentic in many ways.

Most importantly, the side streets are still blissfully quiet from pedestrian traffic but still peppered with interesting indie boutiques and ateliers, fabulous avant-garde artisans, deconstructed art galleries and surprisingly creative hotels. Sure, the moneyed bobos (bohemian bourgeois) are moving in as fast as you can say "Have you seen the Upper Marais?" but it will be a while before the place changes. The 4th it's not. And thank King Henri for that!

A WANDER THROUGH THE 3RD

Sexy cafes and bistros, stylish stores and gorgeous hotels
..................

So where to start on an exploration of the old Haut? Well, **Cafe Charlot** (page 202) of course, which is considered the unofficial epicenter of this hipster village – famed for its delicious food and delicious-looking customers.

Now, what's next on the agenda? Shopping, of course. If you're into fashion you'll love this neighborhood, which has recently seen funky newcomers like the American Jack Henry, Scandinavian Barbara Kurdziel, Korean designer Moon Young Hee and New Zealand expat Catherine McMahon set up shop with amazing new boutiques. But if it's design you want, there's plenty of that here, too.

To start you on a design tour of the 3rd, I'll take you to one of my absolute favorite stores in Paris: a tiny shop that's as thin as a photograph but as interesting as an Annie Leibovitz portrait. Located just across the road from Cafe Charlot, it's called **Images & Portraits** (page 149) and is owned by a former Paris- and New York–based photojournalist. It's also a collector's dream – full of vintage cameras and boxes and boxes of old black-and-white photographs for sale, many revealing the glamour of earlier eras. It is a real Parisian treasure and a perfect example of the discoveries waiting to be found in the Upper Marais.

The **Museum of European Photography** (Maison Européenne de la Photographie; page 165), a museum devoted entirely to contemporary photography in the Lower Marais, or the 4th, is also worth a visit for fans of this genre.

Once you're finished flicking through memories, if you need a little pick-me-up or some brunch, pop into one of the many fabulous food shops, cafes and restaurants on Rue de Bretagne or, even better, explore the **Marché des Enfants Rouge** (page 211) off the Rue de Bretagne, which is Paris's oldest covered market. There's a diverse, multicultural mix of cuisines to choose from, from Moroccan to African, South American to Portuguese – the heavenly aromas are reason enough to detour here.

While we're discussing great food and secret places to find it, take time to hunt down an enthralling eatery called **Anahi** (page 199), a formerly dilapidated charcuterie that's been transformed into an unusual Argentinian restaurant and has hosted big names in the fashion world.

Speaking of fashion designers, one of Paris's most famous fashion names, Christian Lacroix, has made his architectural mark on the 3rd with an extraordinary hotel called the **Hôtel du Petit Moulin** (29 Rue de Poitou). It's contained within the shell of an old bakery, and the facade is exactly as it was when it was a bakery, complete with

"Boulangerie" signage over the door. It's about as photogenic as they come. It's where fashion meets art meets wondrous dreams. And as a consequence, it's booked up for much of the year.

Oh, and if you can't get a room there and you want a hideaway that's just as fabulous, try the **Marais House** (Rue de Turenne), an amazing four-level bed and breakfast with a fantastically flamboyant interior. With huge fireplaces, wall-to-wall opulence and the overall feel of an aristocratic *palais*, it's a rather special place to stay – and not that expensive for the riches offered within. Book well in advance. It's very popular.

A few doors up from the Hôtel du Petit Moulin is **The Collection** (page 157), a curious little *boîte*-style store peddling some of the best homewares in the area, from whimsical wallpaper to curious vases, all of which are exclusive, unique or handcrafted. If this whets your appetite for amazing design, skip over to **Merci** (page 153). It's been touted as the "new Colette" (another hipper-than-hip homewares store), but I think it's far more than Colette ever was. I say, *"Merci, Merci"* with gratitude every time I go there.

Further south, there are some of the best museums in Paris, including the **Museum of Hunting and Nature** (Musée de la Chasse et de la Nature; page 168), which is full of taxidermied beauty and cabinets of curiosities, and the **Museum Cognacq-Jay** (8 Rue Elzévir), which features a gorgeous collection of fine art and decorative items with an emphasis on 18th-century France.

And then there's the enchanting **Carnavalet Museum** (Musée Carnavalet; page 161). I come to this place every time I'm in Paris (it helps that the entry is free), because there's always something different to see. And the museum's garden is a sheer delight.

Now, it's time to finish the tour of the 3rd by leading you south, to Marais's other half, the 4th. And this is where things really get interesting.

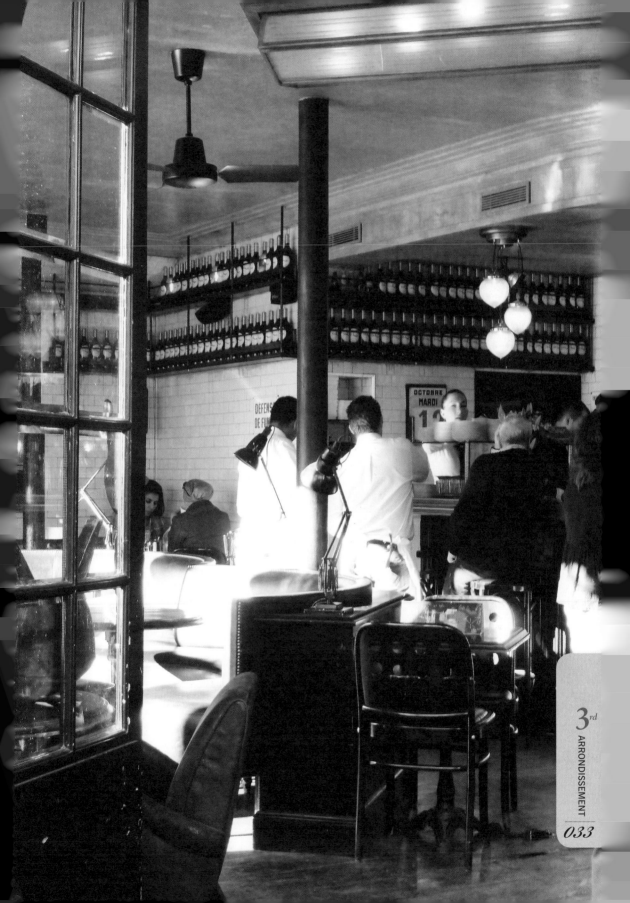

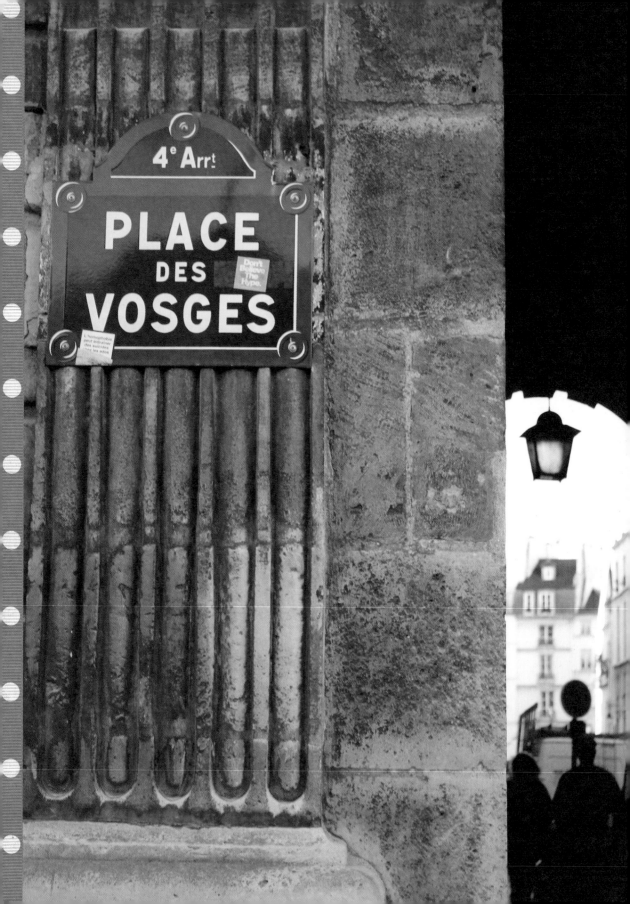

4th

Arrondissement

THE FALLEN STAR

The charming village feel; the nightlife; the fashion; the style; the museums; the gorgeous vintage stores; the art and design galleries; the meandering streets and enticing doorways concealing secret, picture-perfect Parisian mansions and ancient courtyards; the fabulous bars and hideaways, and the controversy. Oh, the controversy!

4TH

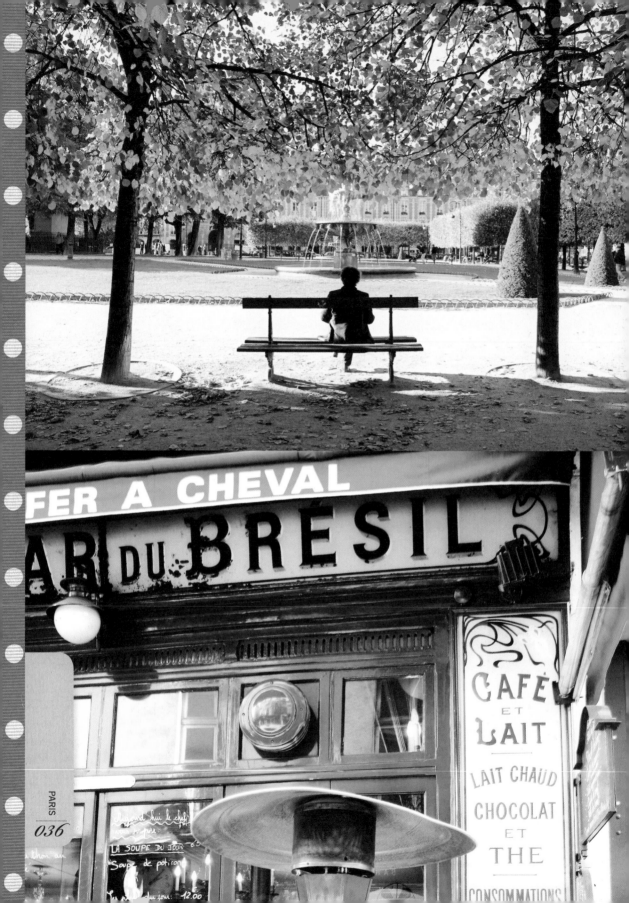

The Lower Marais has suffered a bit of late. In fact, it's suffered a lot. You could almost say it's become a victim of its own publicity.

For a while the Lower Marais was the most happening part of Paris. This was because it had what creative people call "soul." It was home to the city's orthodox Jewish residents, and it was then adopted by the gay crowd, who added their own flamboyant style. Because of this quirky juxtaposition of demographics, it was interesting. It was also hip. Edgy. Cool.

Then, as word of the Marais's magic spread and people flocked here, it lost some of its street cred beneath the onslaught of tourists. Eventually it became so popular that the mid-range fashion chains muscled in. And then everything began to change. Real estate prices skyrocketed, the cute old Jewish bakeries were pushed out by mall-style stores, the edgy boutiques were replaced by, well, not-so-edgy ones and everyone else started looking a little confused – as if to say, "What happened when we looked away?"

It was around this time that the international media got wind of it. Newspapers such as the *Guardian* in London wrote scathing pieces about the mall-ization of the Marais, stylish magazines were reluctant to devote column space to the place (they shifted focus to its northern neighbor, the 3rd) and even the most dedicated of Rue des Rosiers followers began bemoaning the state of play.

By 2009 the 4th had officially fallen off the Cool Radar. It still possessed a certain *je ne sais quoi*, but the magic had slipped away. The Lower Marais, it seemed, had passed its use-by date.

Now, I've tried to find fragments of the old 4th around the Marais neighborhood; I really have. I've searched high and low for some of the authenticity that made this place famous. But it seems to have become lost beneath the overgentrification. It's still a haven for the gay community (one gay friend told me the place was still throbbing, and I don't think he was referring to the bar music), but it's almost as if the sheen has come off. Last time I was there I wandered down the Rue des Rosiers, hoping to find some semblance of the Marais we all once knew and adored. But all I could see was a Lee jeans store. The final straw came when a Quad bike rumbled by. Yes, that's right: a Quad bike. The kind you see on farms. In Texas. And I don't think a kindly old Jewish man was riding it.

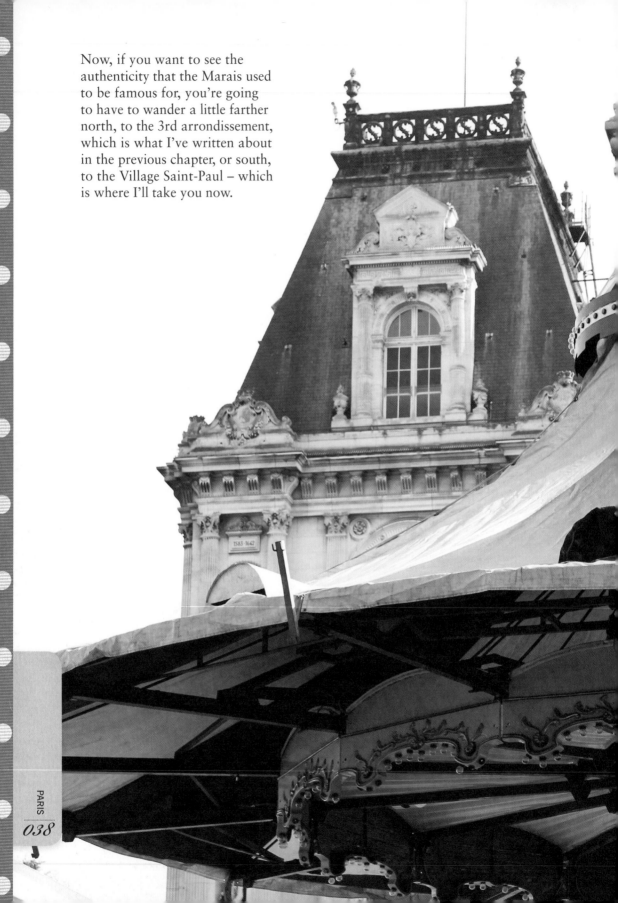

Now, if you want to see the authenticity that the Marais used to be famous for, you're going to have to wander a little farther north, to the 3rd arrondissement, which is what I've written about in the previous chapter, or south, to the Village Saint-Paul – which is where I'll take you now.

A WANDER THROUGH THE 4TH

Secret villages, hidden antiques and homeware delights

The best part of the Lower Marais, or the 4th, is the **Village Saint-Paul.** Situated on the southern border of the 4th, near the Seine, Saint-Paul is one of the best-kept secrets in Paris. A world away from the bustling streets near Rue Saint-Antoine and Rue des Rosiers, it's a village within a village: a network of courtyards, cobbled alleys and medieval walls that combine to create a country-style hamlet, right in the center of the city. Filling these courtyards and streets are more than 200 antique dealers selling furniture and other decorative items, many tucked away in charming hole-in-the-wall hideaways. It's fitting that this area has been colonized by vintage and antique dealers because Rue du Faubourg Saint-Antoine was once the center of a village of furniture-making artisans. Many of the stone streets are pedestrian only, and thus blissfully free from the groan of traffic. The place really comes alive on weekends, but it's sleepy until late morning or even lunchtime, so don't come here too early expecting to be served.

To get your bearings, start at Rue Saint-Paul, a charming street filled with antique and homewares stores, and then wander down until you see a side street that takes your fancy. Sometimes it's bustling; sometimes it's quiet; but even when it's quiet there's a lovely low-key village charm to the scene. And take your camera: you'll find some great photographic opportunities here.

After you've explored the Village Saint-Paul, walk across the Pont-Marie to the quaint **Île Saint-Louis**, the smaller version of the Île de la Cité. Another gorgeous, village-style quartier, this photogenic island is so cute you can't help but think that some Hollywood director put it together on a back lot of DreamWorks Studios and then shipped it, wooden doors and all, to the middle of Paris. The surprising thing is that, despite the curb appeal and postcard-perfect bakeries, *fromageries* and cafes, it's never overrun with tourists. It's almost as if it's a secret island, lost to both Paris and the modern world.

Now, there are many, my friends among them, who believe that the Île Saint-Louis is haunted. It certainly seems to have more than its fair share of spirits and strange experiences, but that's perhaps because it's more ancient than the rest of the city. Unusual things do seem to happen here, but don't let that stop you from wandering the tiny streets – the biggest shock you're likely to get is the price of dinner at one of the restaurants.

There is so much to see on the Île Saint-Louis, but it's the kind of place that's best discovered the old-fashioned way: by wandering its streets and lingering in its corners. (Oh – and the island is especially romantic at night, so if you're angling for some Parisian love, take your partner here.)

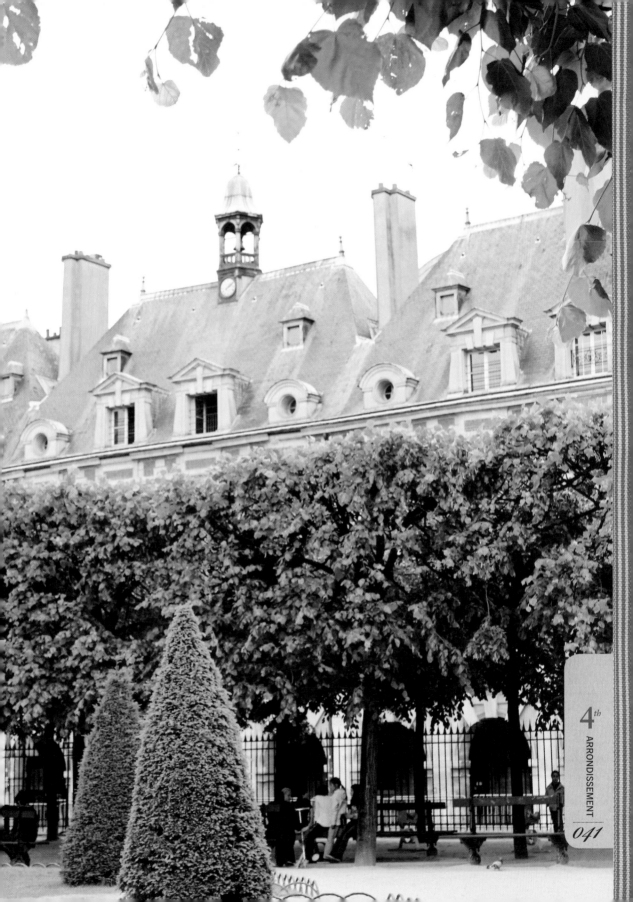

One of the most fascinating things about the island is that locals rarely leave it, even to go shopping or visit family and friends. For many of these locals, visiting the Right or Left Bank is akin to visiting another country. If you're there early in the morning you'll see the islanders on their daily strolls, pedigrees on each end of a leash, circling slowly to see who's coming and going from the mossy old mansions.

A highlight is **Helena Rubinstein's house** (24 Quai de Béthune). Rubinstein was a Polish/Australian cosmetics queen known for apocryphal quips and fancy creams. When she'd made her millions, she bought a centuries-old mansion on this island and knocked it down to build herself a new house with a rather gaudy and very un-Parisian design, amid much controversy. Richard Avedon took his famous photographs of American model Dorian Leigh here in 1949.

Other famous names who have made their home here include writer and philosopher Voltaire, poet Charles Baudelaire (who penned the now-famous line *"Luxe, calme et volupt?"*) and Hemingway. Sculptor Camille Claudel lived at 19 Quai de Bourbon (several months after the movie *Camille Claudel* came out in 1988, the footpaths were impassable). Nancy Cunard of the shipping fortune occupied 2 Rue le Regrattier. And the Rothschilds once resided at the private *hôtel particulier* Hôtel Lambert on Quai Anjou on the eastern tip, before selling it to Qatari Prince Abdullah for the princely sum of 80 million euros (as you would, if you could).

If you're in the mood for a sweet treat, the world-renowned **Berthillon** ice cream is here (you'll see the queues). Try the rhubarb, pear or grapefruit in a cone. Nothing beats licking the top of a Berthillon as you're sitting on the stone steps overlooking the river on a warm summer's day.

Once you've finished rambling the *rues* here, ramble back to the Right Bank along the Pont Louis-Philippe (stop for the requisite gaze of Paris up or down the river). Keep wandering north up the **Pont Louis-Philippe** toward the Rue de Rivoli. On either side of you are some of the city's best paper and stationery stores, tempting you inside with beautiful window displays that elevate paper into an artform.

Once you've finished sighing over paper displays, turn left and head west, until you reach the **Hôtel de Ville**. Now stop.

Most people walk straight past the Hôtel de Ville's enormous square, which is wedged between the river and Rue de Rivoli. In a way it's understandable: the place can seem dull. But let me tell you why it's worth lingering here. Made famous as the backdrop for photographer Robert Doisneau's memorable image of two lovers kissing in 1950, this grand structure is Paris's city hall. It was built in 1357 by Etienne Marcel, rebuilt in the 16th century by King François and then reconstructed between 1872 and 1882. All this effort has been worth it as the place is gorgeous. The old Ville is va-va-voom not only in summer, when carousels and faux beaches spring up, but also in winter, when ice rinks and festive lights are erected and it's all very *jolie*. Even if you're in a hurry, it's worth a peek as you rush past.

Another interesting thing about it is its gruesome history. The forecourt in front of the Hôtel de Ville, Place de Grève, was once known as "death square" because of the sheer number of executions that took place here.

When you're ready to move on, head across the road to **BHV** (pronounced "bay-ahsh-vay"; page 141). I don't want to spend too much time on department stores in this book, but BHV is different, or rather, its basement is. Downstairs, there's a fascinating labyrinthine jumble of hardware and homewares. It's Homewares Heaven.

Now, once you've finished stuffing your bags with BHV homewares, head out the doors of the store. (That's it: be strong, keep walking.) You're probably in need of a wee rest, but you'll have to wait a bit, because there are a few more things to see before you can go home and have a cup of tea.

A few streets north of BHV is another design powerhouse, the **Pompidou Center** (Centre National d'Art et de Culture Georges Pompidou; page 169). This distinctive inside-out building, created in the high-tech architectural style (some hate it, some love it), houses a vast public library, exhibition spaces, a bookstore (Librairie Flammarion; page 115), a restaurant and the **National Museum of Modern Art** (Musée National d'Art Moderne; page 169), which is the largest modern art museum in Europe.

When you've had enough of the Pomp, return to the Rue de Rivoli and keep walking east, then turn left when you reach **Rue Vieille du Temple**. This street and the intersecting Rue des Francs-Bourgeois are lovely for more shopping and photo ops, and many of the shops here are open on Sunday when other shops in Paris aren't. If you desperately need to stop for caffeine, the cutest cafe in Paris is here, **Le Petit Fer à Cheval** (page 206). Everything about this tiny *boîte* is sublime, from the unique swirl of the mosaic floor tiles to the fabulousness of the vintage chandelier.

After you've had your fill of caffeine, keep walking down Bourgeois until you reach the final destination on this tour: the beautiful, peaceful **Places des Vosges**. It's the world's first purposely designed urban square, and is about 460 feet on each side. Marked by precise symmetry and French charm, it's a lovely place to pause for some air and a seat among the pleached trees, especially on weekends when the locals head here for some relaxation. Finally, make for the southwest corner of the square's arcades, and a secret door that leads to the garden of the **Hôtel de Sully**, an enchanting place located on the site of a former orangery (get your map out if you can't find it). Tranquil and memorable, it's one of Paris's little secrets.

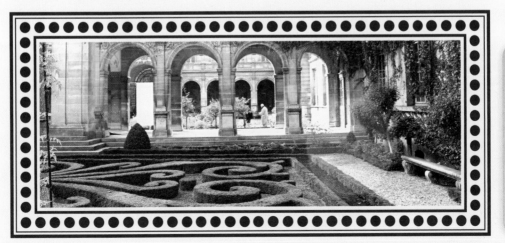

5th

Arrondissement
THE BOHEMIAN

The Jardin des Plantes and its glorious menagerie, the exotic gardens and tearoom of the Paris Mosque, the grace and sheer grandeur of the Panthéon and the trails between Boulevard Saint-Germain and the Seine – tiny side streets filled with atmosphere, architecture and an enchanting silvery light.

5TH

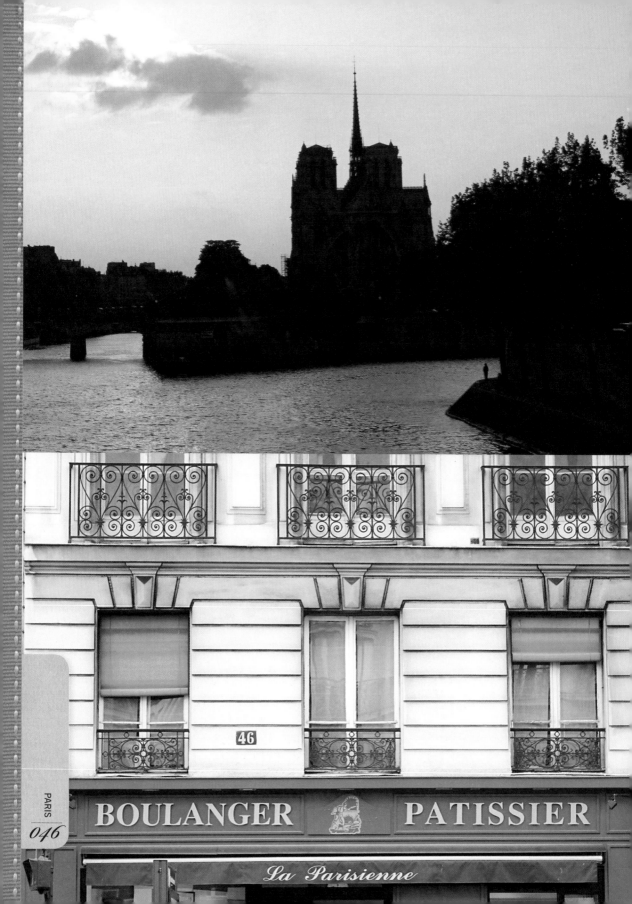

I've always loved Hemingway. There's just something about him: his masculinity, his cheeky grin, his adventurous spirit, his remarkable way with words, his wives (all so gorgeous), his discipline and even his to-die-for colonial home in Florida's Key West. I often pay my respects to him at his various residences, including his apartment on Rue Férou near Saint-Sulpice. But the area he truly felt at home was the Quartier Latin (or Latin Quarter).

Situated south of the river Seine, where it borders the chic 6th, this arrondissement is known as the Quartier Latin because it was and still is dominated by universities and schools. (The "Latin" stands for the Latin scholars who once studied here.) The 5th is also one of the oldest districts of the city, dating back to ancient times. For these reasons it has a kind of scholarly feel to it, much like Oxford in England. Many of the streets are library-quiet (even though the area around the Sorbonne is distinctly raucous), and while the general air is one of shabby gentility or fading grandeur, overall it's a surprisingly intriguing place to explore.

The beating heart of this legendary arrondissement is undoubtedly Place Saint-Michel, with its baroque, pink marble fountain of Saint Michel killing a demon of some sort. The Paris Commune of 1871 began here, as did the student uprising of 1968. You could say it's the Washington Square Park of Paris. Sadly, the swarms of artists, writers, poets, musicians and art students are now few and far between, but there are still hundreds of crooked streets leading off the Boulevard Saint-Michel, running like capillaries through the quartier, and it's an interesting place to wander for an hour or more.

In fact, there's quite a lot to explore in this distinctive, labyrinthine quartier, which formed the setting for Puccini's opera, *La Bohème*. I'm now going to take you on a tour of my favorites. I think you'll like them.

Books, bohemians, secret bathing and other curious things

···············

The best, certainly the most fitting, place to begin a tour of the Quartier Latin is **Shakespeare and Company** (page 116), the legendary bookstore near the Quai de Montebello. It's the quintessential Parisian bookstore. Piles of books, old sofas and leather armchairs, posters, creaky floors, crooked stairs, even the occasional cat. All you need is a cup of tea and you'd be in reading heaven.

Next up, fight your way out of the store (take a deep breath if you must) and visit the *bouquinistes* (secondhand book sellers) on the Seine, selling books, vintage posters and old cards, before heading south to where Saint-Michel intersects the Boulevard Saint-Germain. Here, on the Quartier Latin side, you'll find the **Cluny Museum** (Musée de Cluny; page 164), an amazing place set on the remnants of ancient Roman baths (an astounding feat of architecture that you can see as part of the museum's exhibits). The place is one of the city's greatest treasures.

From here, continue veering south (follow the students) until you see signs for the **Panthéon**. Don't worry; you'll find it. It's bigger than anything else around. Essentially a massive mausoleum, this architectural marvel is gorgeous and a must-see for design lovers (its dome is fantastic for photographs). Among those buried in its crypt are Voltaire, Victor Hugo, Émile Zola, Marie Curie, René Descartes and Louis Braille. And the physicist Foucault proved the rotation of Earth by hanging his 220-foot pendulum from the dome in 1851. Someone told me the Panthéon was built by Louis XV after he recovered from gout and wanted to do something nice for Saint Geneviève, Paris's patron saint. I think that's rather lovely.

From here I like to weave my way down to the Paris Mosque through the curious Place de la Contrescarpe: a lovely, slightly worn-looking square that often featured in Hemingway's stories. Keep walking through because we need to reach the highlight of this tour. You may need your map to find this next bit but persevere: it's worth it.

The **Grande Mosquée de Paris**, or "Great Mosque of Paris," is one of the city's sweetest little places. "Sweet" may not seem a fitting word for a place that has "grand" in its title, but there's no other description for it. The secret Moorish garden is sweet, the lovely tea salon and courtyard are sweet and the hammam bathing area is … well, perhaps not sweet but certainly extremely interesting.

With architecture that closely resembles its counterparts in Marrakech, this place gives visitors the chance to explore the mysteries of North Africa without leaving Paris. Decorated with gorgeous blue mosaics, enormous old wooden doors and wrought iron shipped from Morocco, it was built in 1922 to honor the North African countries that helped France during World War I. If you're interested in a tour of the building,

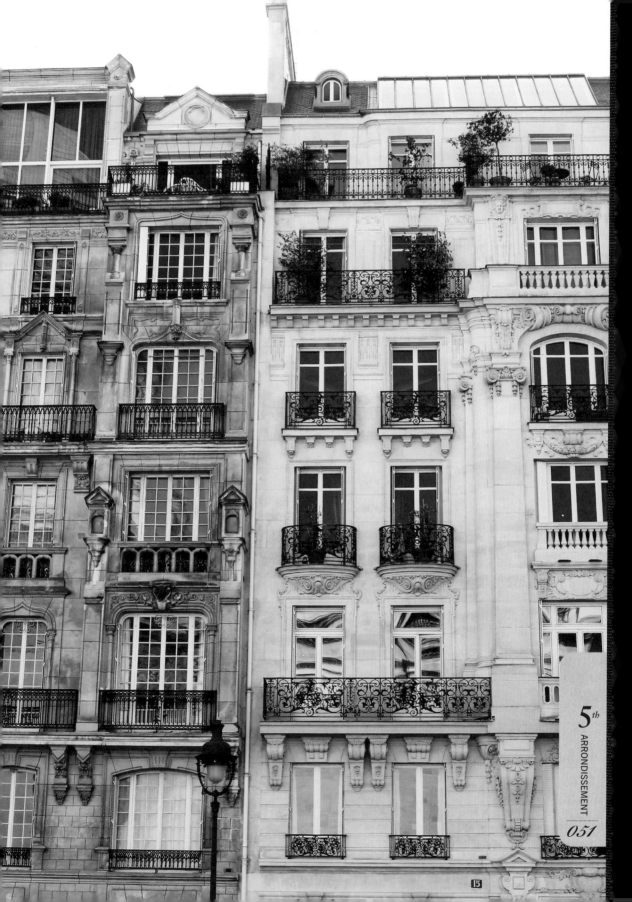

its central courtyard and its Moorish garden, there are tours, but personally I like to slip around the back and experience the flip side: the **tea salon** (La Grand Mosquée de Paris; page 195) and hammam, which are reached by a near-secret door. You can enjoy a meal in the tea salon or indulge in a real treat and spend an afternoon in the heavy vapors of the steam baths, letting your exhaustion melt away. Don't forget your swimsuit and check the times before you go, as some days – usually Tuesdays and Sundays – are reserved for men only.

To finish off a tour of the 5th, I'm going to lead you across the road to the **Jardin des Plantes**. This beautiful green space doesn't get the attention that the glamorous Luxembourg Gardens do. I'm not sure if that's because it's not as grand, or simply because it's tucked away here in the far corners of the 5th. Luckily for us, it means there's more room to wander around.

Planted in 1635 as a medicinal herb garden, the Jardin des Plantes is the main botanical garden in France and includes the botanical school, which trains botanists and constructs demonstration gardens, and the **National Museum of Natural History**, which comprises the Grand Gallery of Evolution, the Mineralogy Museum, the Paleontology Museum and the Entomology Museum. There is also a **small zoo**, founded in 1795 using animals from the royal menagerie at Versailles (reason enough to visit it!). It's lovely on a sunny day, particularly for children. One of the most beautiful buildings in Paris is here too, the large **Art Deco Wintergarden**, along with a Rose Garden that contains hundreds of species of roses – wonderful in summer.

There is another place here that is truly extraordinary, and that's the Cabinet of Curiosities known as the **Cabinet Bonnier de la Mosson**, which is tucked into the back of the otherwise-dull Museum of Natural History.

The Cabinet of Curiosities first became popular in Renaissance Europe, when enthusiastic collectors, including all those explorers and botanists who traveled the world and brought back exotic species of animal and plant life, used them to show off their unusual stuff (for want of a better word). A few centuries on, they're starting to pop up again, as people realize how intriguing they can be.

The fabulous Cabinet Bonnier de la Mosson is particularly exquisite. Housed in a luxurious piece of furniture of pale Dutch wood that looks like an ornate wedding cake, this 1735 collection of taxidermied birds, butterflies and other bits stands as a decorative ode to the intersection between aesthetics and science. It was amassed and exhibited thanks to a family fortune and is considered by many the most imaginative French cabinet of the early 18th century.

Enchanting, indeed.

5th
th
ARRONDISSEMENT

6th

Arrondissement
THE ARISTOCRAT

The sheer beauty of Rue de Furstemberg (a classic Parisian scene), the tiny boîtes and bars around Rue Guisarde filled with jazz and backstreet glamour, the graceful gravel paths and tree-lined avenues of the Luxembourg Gardens, the design and home stores around Rue Jacob, the bookstores off Saint-Germain, the secret intersecting courtyards off Cour de Commerce Saint-Andre and the enticing shoe stores around Rue du Cherche-Midi.

6TH

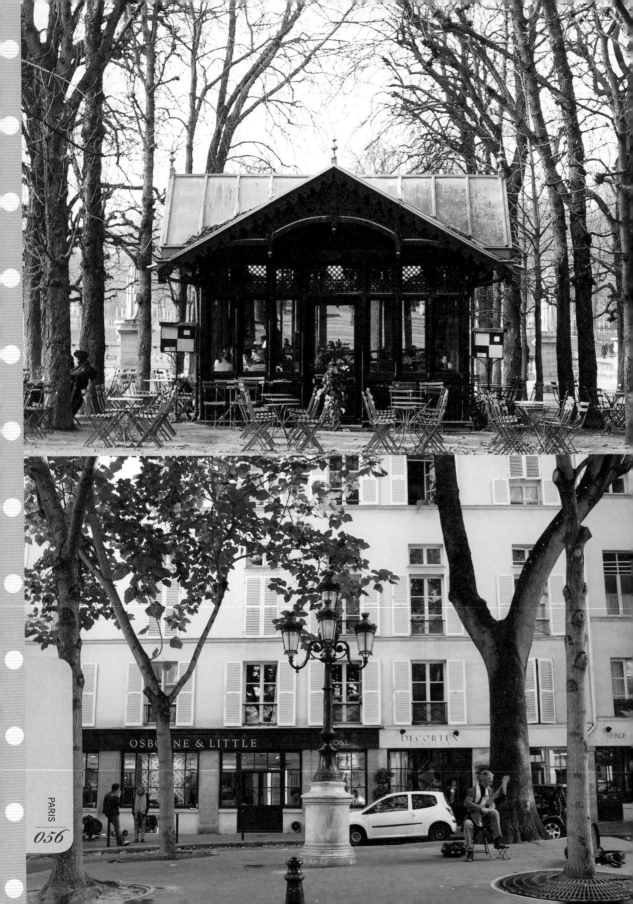

Paris is a place where the locals know the meaning of the word "glamour." It's a place where chandeliers are as common as croissants, fancy hotels with fancy names speckle the cityscape and even the entrances to the Metro are fashioned with the same care as a couture gown. Glamour here is customary – expected, mainstream. Remember, this is not a city that embraces casual.

If you want to see how the Parisians do glamour, there are several places you can go. One is Avenue Montaigne in the 8th arrondissement, where stores such as the beautifully renovated Balmain boutique epitomize the word. Another is the 6th arrondissement, where it's so much a part of the fabric of daily life that locals barely blink when Ralph Lauren opens a store on the Boulevard Saint-Germain. The difference between the two places is that the 8th can sometimes seem intimidating, while the 6th welcomes all types of visitors, even those dressed in jeans. I know, because I'm always walking through here with The Wrong Outfit on and nobody raises an eyebrow.

The 6th has always been rather special and not because of its style. It's a spectacularly beautiful place with a perfect mix of wide boulevards and beguiling side streets, classic Parisian bistros and fantastic French stores, elegant Haussmannian architecture and verdant green gardens. It's renowned for its profusion of decorating and design stores, bookstores (many of Paris's publishing houses are located here), florists and fashion boutiques and, of course, those iconic sidewalk cafes, the Lipp, Deux Magots and Cafe de Flore among them.

You may already be familiar with the area through the novels of Hemingway, F. Scott Fitzgerald and co., the songs of Serge Gainsbourg and Juliette Gréco, the movies, the magazine shoots and all those tales of bohemians and existentialists (some real; some urban legend). Like its intellectual neighbor the 5th, the 6th has always had a keen mind and a brazen spirit, not to mention a quick wit. Not surprisingly, it is the heartland of Paris publishing, and the spiritual home for more than a few of the world's best writers. It's also full of antiquarian book and print dealers. If you love bookstores, you'll be in your element here.

However, in the last decade or so the 6th has morphed from a literary playground into a design and fashion hotspot. Inspired by the area's cool, bookish nature, many of the world's leading luxury brands, including Louis Vuitton and Ralph Lauren, have moved

into the 6th, opening up stylish boutiques to appeal to the wealthy and well-read. There had been a smattering of decorating and fashion stores here before, but by 2010 the area was virtually another Fifth Avenue. Some people loathe it; others have happily embraced the change, Hermès handbags at the ready. Whatever you feel about the 6th's transformation, one thing is certain: the luxury stores are here to stay.

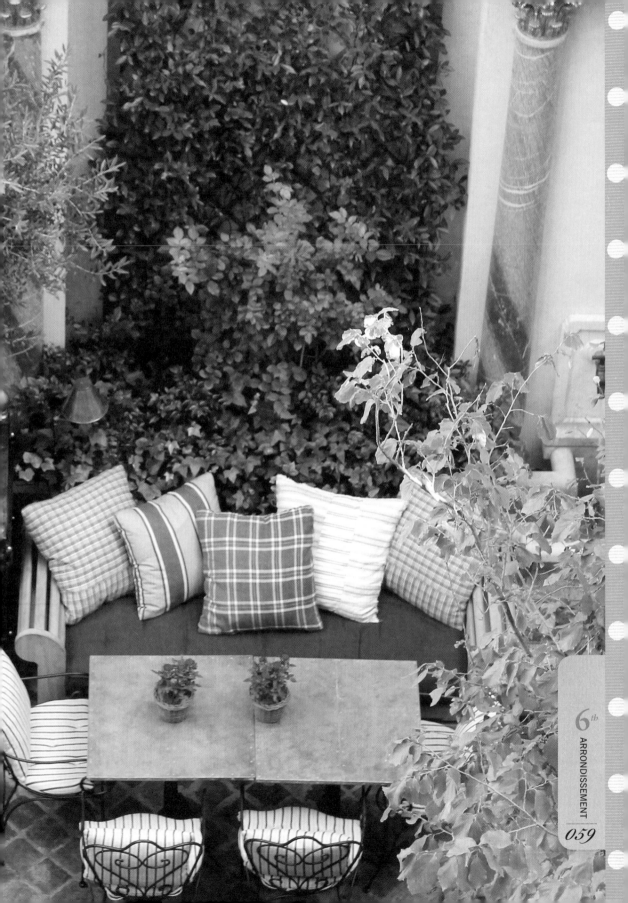

Fashionable fabrics, stylish design books and glamorous garden paths

My favourite place to begin a tour of the 6th is always **Place de Furstemberg**, in the cuter-than-cute Rue de Furstemberg. If you haven't been here before, just look for an intimate little French square anchored by a tiered 19th-century streetlamp and four flowering paulownia trees, which American author Henry Miller described in *Tropic of Cancer*. It's an exquisite place that looks like it's been lifted from an impressionist canvas, and is just as photogenic in autumn and winter as it is in summer and spring. The divine **Delacroix Museum** is here too, with its cheerful first-floor apartment and darling garden studio where romantic artist Eugène Delacroix created his masterpieces.

Rue de Furstemberg is the starting point for a fabulous (self-led) tour of fabric stores that I like to do, gazing at the various windows and their textile displays. Among the most beautiful in this design-focused quartier are **Manuel Canovas** (6 Rue Abbaye), where bolts of fabrics are printed not only with spectacular, oversized blossoms but also in bold shades (raspberry, pomegranate, grape), and **Pierre Frey** (page 156), where the spirited silks are fashioned into oh-so-glamorous galleries that are difficult to resist. Also here on the Place de Furstemberg is **Flamant** (page 148), the Belgian homewares store that has seemingly taken over the design world with its sleek, predominantly gray-and-beige interiors. Half an hour in this neighborhood and you'll start itching to redecorate.

When you've finally finished exploring here, head west on Rue Jacob (where there are yet more design places and a great gardening bookstore) and make for the Boulevard Saint-Germain. Now, you can either pop into the ornate tea salon **Ladurée** (page 198) for a coffee and a dainty macaron or two (best if you're hyperventilating over the money you've spent at Flamant). Or you can keep walking until you reach the oldest church in Paris, the glorious Benedictine Abbey of Saint-Germain-des-Prés, and the iconic cafe directly opposite, **Deux Magots**. This legendary drinking spot and the two cafes near it, **Brasserie Lipp** and **Cafe de Flore**, form the unofficial centre of literary Paris.

For decades this atmospheric part of the city was the smoke- and gossip-filled haunt of writers, artists and philosophers – and a fair few of their hangers-on too. It was the home away from home for the writers of the "Lost Generation" of the 1920s and 1930s, and the area is still the favorite quartier for a great many authors – of both the bestselling and the struggling kind, although only the former can really afford it. The quartier is also a hub for the city's publishing sector. It's because of these literary ties that many bookstores have opened in the 6th, ranging from the intellectual's favorite, **La Hune** (page 115), to the sexy **Assouline** (page 114) and the expat community's go-to for English titles, the **Village Voice** (page 118). **Taschen** is here, as is Karl Lagerfeld's tiny bookstore, **7L** (page 113), in space adjoining his photo studio on the Rue de Lille.

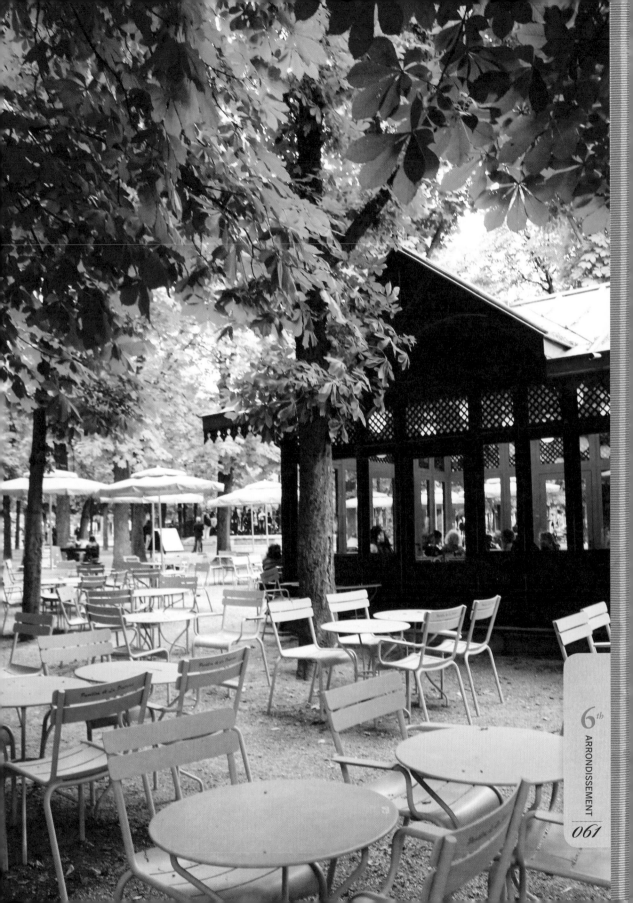

Once you've had enough of bookstore browsing, head east on Boulevard Saint-Germain and then turn north up **Rue de Buci**. There are lots of great fashion boutiques and design stores here and on **Rue de Seine**, but I want to lead you further on, to a series of secret courtyards that are possibly the most picturesque in Paris. Once you're on Rue Saint-Andre des Arts, take a sharp turn right (south) down a covered arcade called **Cour de Commerce Saint-André**. This passageway is enchanting in itself, but it leads to an even prettier place: a series of private squares called **Cour de Rohan** (look for the black iron gate on your left, although it's sometimes only open on Wednesdays). This delightful collection of cobbled side streets was the setting for the film *Gigi*, and if you look very closely you'll also see the remains of a wall built in 1200 by King Louis-Philippe to safeguard the city. Lots of artists try and paint it, while photographers click madly away. If you can't gain access, don't worry: there's plenty to see in Cour de Commerce Saint-André, including the world's first coffeehouse and the oldest restaurant in Paris, **Le Procope**, where Napoleon's hat is still on display. (Voltaire was known to drink 40 cups of coffee here every day.)

Next, walk out onto Boulevard Saint-Germain and head south to one of my all-time favorite places, the **Luxembourg Gardens**. If you want to know where Parisians go when they feel stressed, head to these gardens, quaintly nicknamed "Luco" by the locals. The equivalent of Central Park in New York, this enormous, beautifully designed green space is perfect for chilling out (although the Parisians would never put it in such a gauche fashion.) American film director Sofia Coppola said she liked to come here when the filming of *Marie Antoinette* (2006) became too much. The gardens evolved as a result of Henri IV's assassination in the 17th century. His wife, Marie de Medici, couldn't face living in the Louvre without her hubby, so she commissioned the Palais du Luxembourg and its surrounding gardens to remind her of her childhood home, Florence's Palazzo Pitti. The space is divided into two sections, called *à la française* and *à l'anglaise*, the former exemplifying the French garden design trends and the latter following the English model. The overall design is largely formal, with endless paths of white gravel peppered by statues of saints and French royalty, but the landscape doesn't feel daunting. Indeed, it's been carefully configured so it even appeals to children – who are the park's most ardent fans. (In the center is a grand octagonal pond where mini-Parisians like to play with their model boats.) The park has been open to the public since the 17th century, and the public has consistently embraced it. Even if you don't have a romantic or horticultural cell in your body, you'll still love the Lux.

After exploring these gardens, walk out of one of the northern entrances on Rue de Vaugirard and head for the **Cathedral of Saint-Sulpice**. Set on a charming square in the heart of Saint-Germain, this church achieved a kind of cult status after it was featured in *The Da Vinci Code*. Since the book came out they've done a bit of a tidy-up and an ecclesiastical nip 'n' tuck. Hopefully, by the time you visit, the covers will have come off. One thing I'd like to point out is the spectacular penthouse that overlooks the church and square – you'll recognize it by the extraordinarily large conservatory adorning the top.

There's one last place I want to take you before we wrap up this ramble around the *rues*. And it's a goodie.

It's called **Deyrolle** (page 125) and it's one of the oddest places in Paris – an extraordinary store that's part taxidermy shop, part museum and part Alice-in-Wonderland fantasy. Owned by Prince Louis-Albert de Broglie, this grand space – think high-ceilinged rooms with chandeliers and stately windows – is filled to the corners with animals. Taxidermied ones. You need to see it to believe it.

Of course, there are many more design and decorating stores, fashion boutiques and other intriguing destinations in this arrondissement, particularly on Rue du Bac, Rue Saint-Sulpice and Rue du Cherche-Midi. But, for now, I want you to head back to Boulevard Saint-Germain and turn west, toward the 7th arrondissement. Now, look down. Are you suitably attired? Good. Because we're about to hit Paris's poshest district.

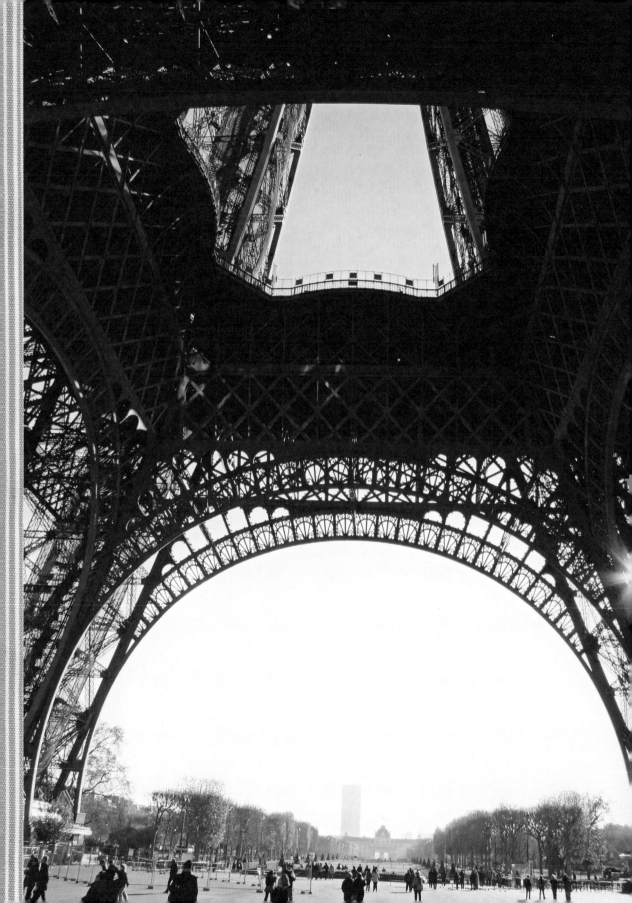

7th

Arrondissement
THE GRAND DAME

The view from the iconic Eiffel Tower (although looking up at the tower from the base is almost better than looking down at the view from the top), the tranquility of the Rodin Museum and its glorious gardens, the grand interior of the Orsay Museum (and the magical view of Paris glimpsed through its clock), the retail riches of Le Bon Marché and the sights, smells and flavors of the Rue Cler street market.

7TH

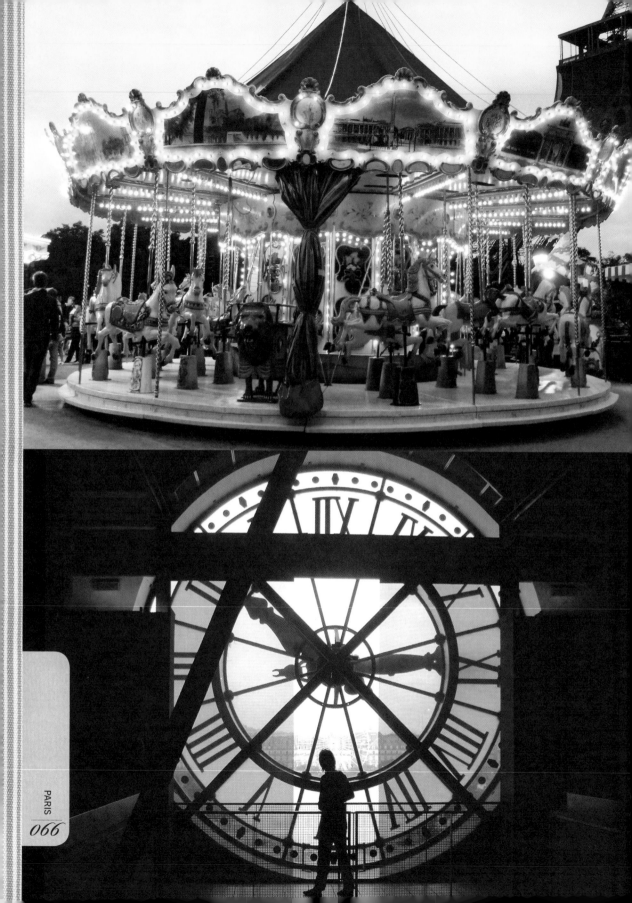

The fiercely prestigious 7th arrondissement is "Old Money": aristocrats, diplomats, the Very Rich and those with no money but fine family trees to fall back on. (Locals like to say that the 16th is where the nouveau riche live and the 7th is where the "proper rich" live.) Everything about the 7th, from the sumptuous apartments to the magnificent courtyard doors and the grand department stores, whispers of quiet luxury, refined style and what real estate agents call "exclusivity." Even the street markets (such as Rue Cler) are swish. Because of these things and the fact that the Eiffel Tower is right on your doorstep (and therefore potentially within sight of your wrought-iron balcony), the 7th is perhaps the most expensive area to live in Paris. It is *trés, trés* swanky.

Most people associate the 7th with its sights: the Eiffel Tower, the Rodin Museum, the Museum Orsay (Musée d'Orsay) among them. And these are indeed worth visiting. But there are lots of other reasons to visit the 7th. It is one of the best neighborhoods in terms of art, antiques, furniture, and homewares and decorating stores – although they do tend to be on the pricey side. And its food and street markets are first-class (its *boulangeries* are prettier than a Ladurée box). Then there are the other attractions, such as the fashion.

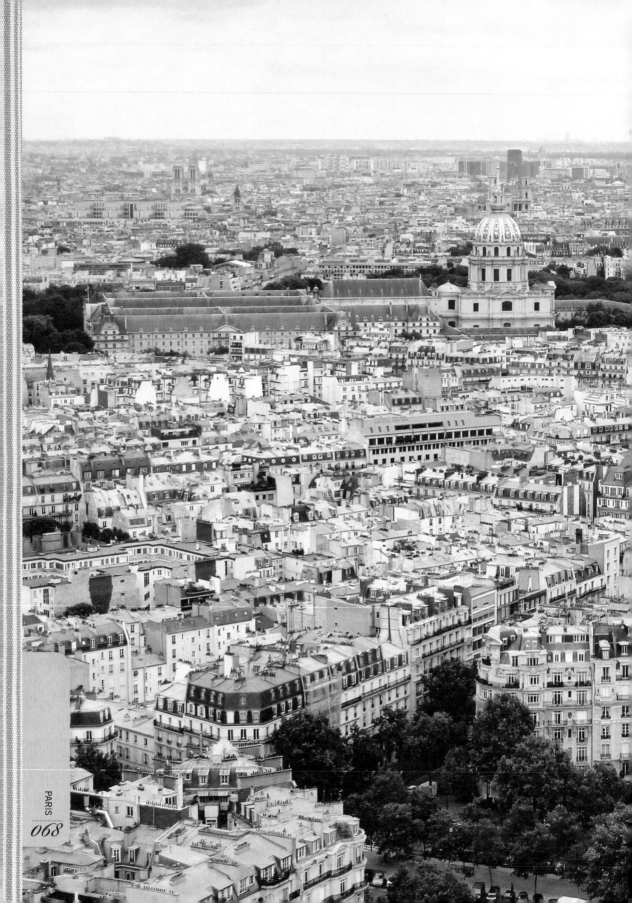

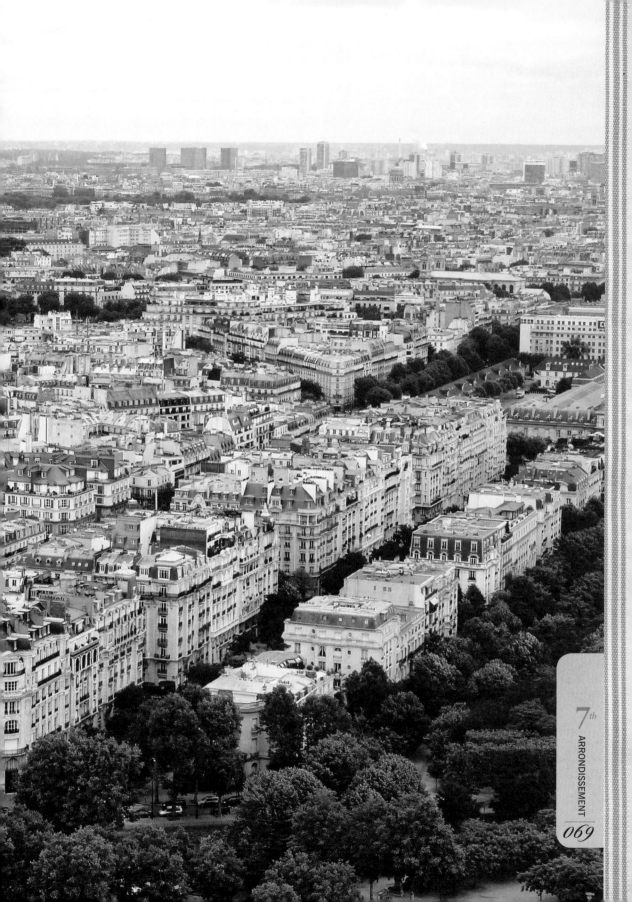

Posh food, perfectly presented museums and oh-my views
..................

The trick with touring the 7th is to go during the week. On weekends, a good many of the galleries and design stores are closed (particularly the galleries), probably because their owners have escaped to their country châteaux for some rest and a few crates of Château Margaux. Part of the magic of the 7th is stumbling across gorgeous stores and great galleries, and it's not as much fun when the sign on the door says CLOSED.

To begin a tour of this opulent quartier, start where most serious 7th shoppers start: **Le Bon Marché** (page 152). I have tried to shy away from department stores in this book, but this one is different: it's quite possibly one of the loveliest of its kind in the world. Le Bon Marché has worked hard to position itself in the luxury market, selling upmarket fashion and homewares, and has done it by using its ornate architecture and interior design to attract and impress customers and give them an extraordinary shopping experience. Don't miss the spectacular ceiling, the revamped homewares floor and the famous Grande Épicerie food hall – endlessly fascinating to browse through, no matter which aisle you're in.

Not surprisingly, the quartier around Bon Marché has become a bustling area of stylish stores, featuring clothing, furniture, art, antiques and even a bookbinder or two. The florists put on particularly spectacular displays, which turn the footpaths into miniature gardens. It's intoxicating in spring and summer, when the scents of lavender, roses and other bouquets pervade the Parisian air.

If you need a break from punishing your credit card at all the lush stores, or just want some time out from the crowds, make for the **Rodin Museum** (Musée Rodin; page 169). Rodin, of course, is famous for his sculptures – *The Thinker* and *The Kiss* among them. But this swish museum, housed in a pretty 18th-century château called Hôtel Biron, is just as appealing as the art inside. Don't miss the gardens and the pretty tearooms – great for a light lunch and a rest beneath the trees.

Continue along to 57 Rue de Varenne past the beautiful **Hôtel Matignon**. Diplomat and politician Talleyrand once lived here and since 1958 it's been the official residence of the French prime minister.

From here, make your way to the Seine, because we're about to see something else that's pretty special: the **Orsay Museum** (Musée d'Orsay; page 168). Worth a visit for the architecture alone, this famous museum has been carved out of a former railway station, the Gare d'Orsay, which, with its fancy Beaux-Arts edifice, was probably too gorgeous to be a humble railway station for too long. Because of its railway-station origins, the building sits on a major vantage point on the Seine, where its glorious railway clocks gaze out over Paris.

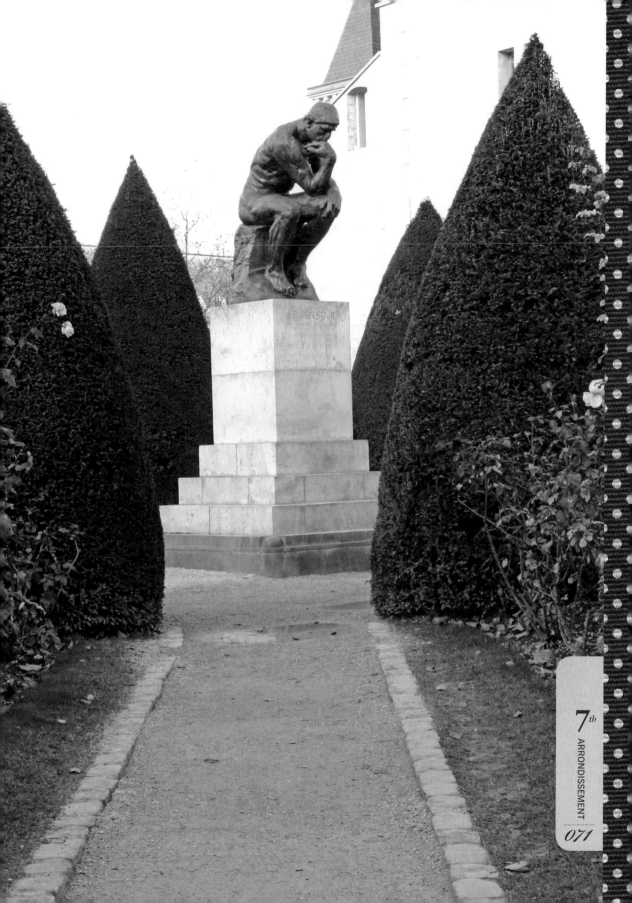

Next, walk along the embankment of the Seine a little way until you reach the **Pont Alexandre III**, a bridge that makes others look positively dull in comparison. Well endowed with gold lampposts, cherubic sculptures, wicked nymphs and four magnificent rearing horses on both ends of the bridge, it's so sexy that it's had a bit part in numerous movies over the years. The best time to see it is just before sunset, when its glorious streetlamps light up. Bring a partner for maximum memories.

Before you head for the Eiffel Tower, which is the last stop on this tour, take a detour to **Rue Cler** for a stroll through some truly delicious stores. The spirit of this lovely pedestrian street never changes, whether it's summer or winter, and there's always something yummy to buy, from *salmon en croûte* to quails stuffed with foie gras. **Cafe du Marché** (corner Rue du Champ du Mars and Rue Cler) is one of the neighborhood's hot spots and a good place to sit and watch the comings and goings of the 7th's denizens.

Lastly, finish your tour of the 7th with a hike up the **Eiffel Tower**. Gorgeous at twilight, when the famous frame forms a silhouette against the night sky, the Eiffel Tower is one of those places you have to go at least once in your life. The best way to enjoy it is to pack a picnic of gourmet nibbles from the Rue Cler and head here at the end of a sunny afternoon. Find a soft patch of green grass to call your own, open a bottle of wine, tear bread, slather cheese or pâté on top and wait for the sun to set and the lights to come on. There isn't a more magical experience in Paris.

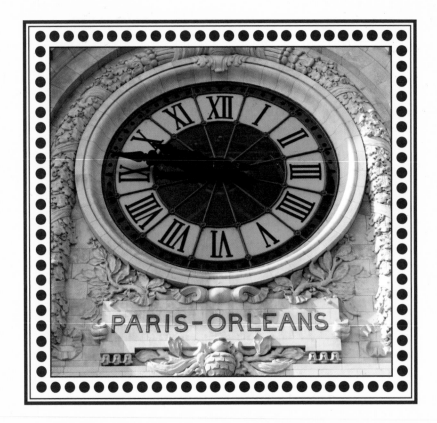

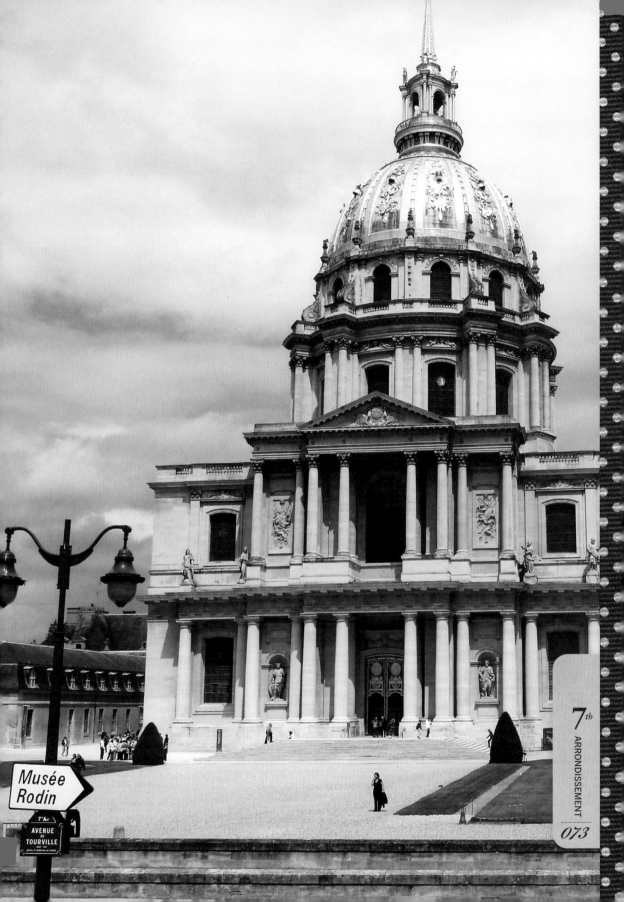

8th

Arrondissement
THE FASHIONISTA

The stylish designer boutiques of Avenue Montaigne; the haute couture style and refined glamour; the exquisite restaurants and grand, historic hotels; the endless energy of the Champs-Élysées; the ornate glamour of Ladurée; the quiet beauty of Parc Monceau and the sheer elegance of it all.

8TH

Parisians do nothing by halves when it comes to scarves. Have you noticed? Almost every Parisian woman worth her Hermès handbag has a serious collection of scarves. I've seen some wardrobes that are made up solely of scarves; that's how earnest Parisians are about them. And their technique is so impressive, too. These people could tie scarves for the Olympics. However, sometimes their scarf fetish goes too far. American dancer Isadora Duncan, who had moved to Paris in her youth, was killed by a flowing silk number that got caught in the wheel spokes of the car she was riding in. Can you believe it? What a dramatic way to go.

If you want to know just how delirious these people are about scarves, you can go to any bookstore in Paris, where there will undoubtedly be several titles on the subject. You can also visit one of the regular exhibitions that are held throughout the year, or pop into one of the dozens of vintage stores, where they're always on prominent show. Alternatively, you can go to the 8th arrondissement and wait. On any given day you'll see stylish Parisians strolling up and down the Avenue Montaigne accessorizing with a swathe of color. I'm telling you, Paris is preoccupied with scarf-y displays.

Of course, scarves are not the only things that Parisians love to throw around themselves. They adore all kinds of fashion, from shoes to jewelery. They're also rather clever at tying a trenchcoat. (Tip: Always tie the belt. Never buckle it. And do it up on the left side of your waist.)

Now, all this is very well if you're French, but if you're a foreigner, it can be rather intimidating. No matter what you wear you can often feel that you don't measure up, no matter how adept you are at tying your vintage Hermès.

If this happens to you, don't worry; there is a solution. And it's called the 8th arrondissement. Known for being one of the city's most tasteful neighborhoods, the 8th is like a real-life catwalk, only the models here are very well-dressed locals stepping out for a spot of Champagne rather than long-limbed professionals flown in from New York. Along with the 6th, it is one of the best places to pick up a few free sartorial tips, simply by watching the madames at play.

Now, I should warn you about a few things before you head this way. Shopping here is far more than a whim. It's a serious art form. And when you see the stores, you'll know why. (The newly renovated Balmain was so beautiful, *World of Interiors* magazine put it on the cover.) But don't let that put you off. Paris is for everyone, after all, not just those who can afford a couture wardrobe.

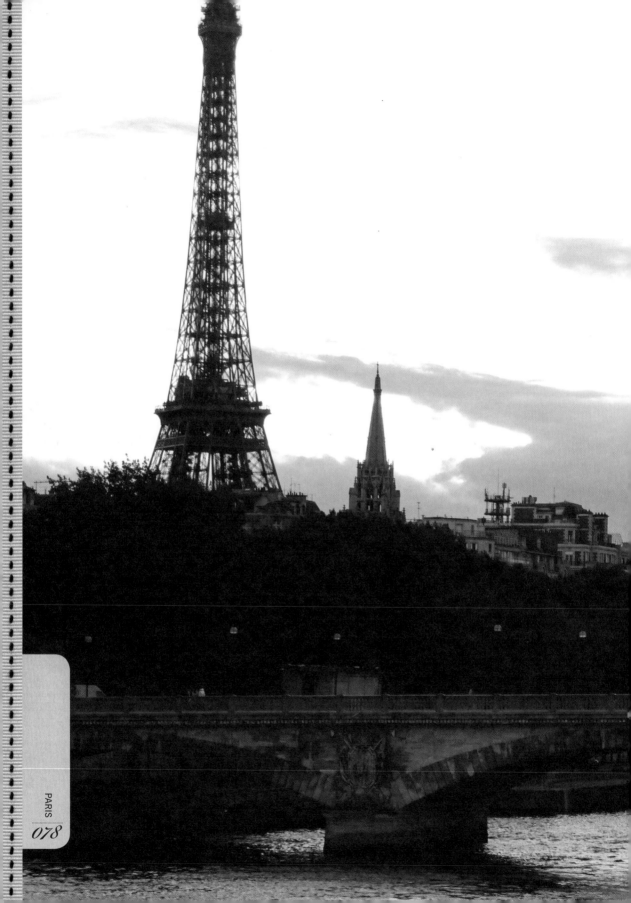

8th
ARRONDISSEMENT

079

Chanel, Balmain and the beautiful set

There are lots of "fashion neighborhoods" around this *trés chic* city, but few can rival the elegance of **Avenue Montaigne**. Lined from end to end with legendary labels, it's a gallery of serious sophistication. It's also the best place to begin a tour of the 8th, although there is a danger you'll never leave the place!

Here's a brief bit of history about the street before we begin browsing. The Avenue Montaigne was first named "Allée des Veuves" (Widow's Lane) because ladies in mourning found comfort in its leafy shadows. It was renamed in 1723 to the far more stylish but perhaps less memorable moniker Avenue Montaigne. The street's architecture, style and mood shifted over the years but, like a model who hits her stride later in life, it finally reached prominence in the 1980s when the fashion greats migrated here from the Rue du Faubourg Saint-Honoré. The LVHM group had an initiative to dress up the *rue*: they invested heavily in the area's real estate in order to form a gracious promenade for their leading stores, such as Louis Vuitton (at number 56), Dior (30), Loewe (46), Céline (38) and Christian Lacroix (26). Since then, they've been joined by Jil Sander, Prada, Ferragamo and Ungaro. Even Joseph and Calvin Klein have come in to the mix. Note: if you want to see the beautiful people and the bags they've bought, book a table for lunch at L'Avenue.

Once you've seen the hushed luxury of Chanel, Balmain and co., wander down to the **Hôtel Plaza Athénée** (25 Avenue Montaigne). The favorite *pied-à-terre* of many European movie stars, millionaires, royalty and heads of state, this lavish palace hotel achieved a new kind of fame when Carrie Bradshaw checked in here in the final episodes of *Sex and the City.* If you want a truly memorable night, check into one of the top suites: the views are the kind you remember for a lifetime.

Now, keep wandering west, turning on President Wilson, and walk until you reach the **Museum of Fashion and Costume** (Musée de la Mode et du Costume; page 165), an inspirational museum with fascinating exhibits on the history of fashion. Note that the entrance is at 10 Avenue Pierre 1er de Serbie.

Now, make your way north to the **Champs-Élysées**, taking a peek at the scarily busy **Arc de Triomphe** on the way, if you haven't already seen it. Beyond this intersection, the world-famous Avenue des Champs-Élysées stretches out to offer a visual link through the city. It was created in 1667 by Louis XIV's gardener, André Le Nôtre, in order to improve the view from the Tuileries Garden, although the avenue is rather different from what it looked like back then. It can also be exhausting with its throngs of tourists. If you need a break, wind your way down the Champs to **Ladurée** (page 198). The macarons are must-haves, but it's the interior that's really delicious.

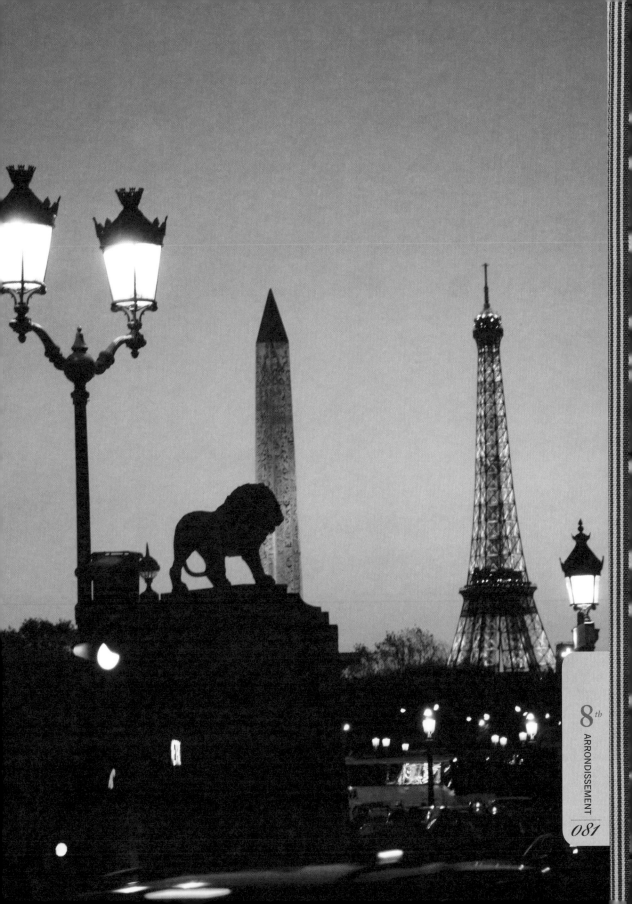

At the east end of the Champs-Élysées is **Place de la Concorde**, the largest square in Paris. It was here (when it was then called Place de la Révolution) that King Louis XVI, Marie Antoinette and many others were guillotined during the Revolution. You can either take a look around here (although there's not much to see other than a lot of cars), or head north to the lovely **Jacquemart-André Museum** (Musée Jacquemart-André; page 164), which displays art in a unique mid-19th-century mansion.

Another museum worth seeing in the 8th is the **Musée Nissim de Camondo** (63 Rue de Monceau), which was inspired by the Petit Trianon at Versailles. (Reason enough to visit, I say.) Keen to create his own showpiece, Moïse de Camondo built this residence to display the collection of classical French furnishings he had collected over the course of 20 years.

While you're in the area, don't miss the beautiful **Parc Monceau**, which is famous for its rose gardens and architectural follies, including an Egyptian pyramid, a Chinese fort, a Dutch windmill and Corinthian pillars. It's quiet and gentle, and offers a lovely break from the lavish opulence and sometimes in-your-face luxury of the 8th.

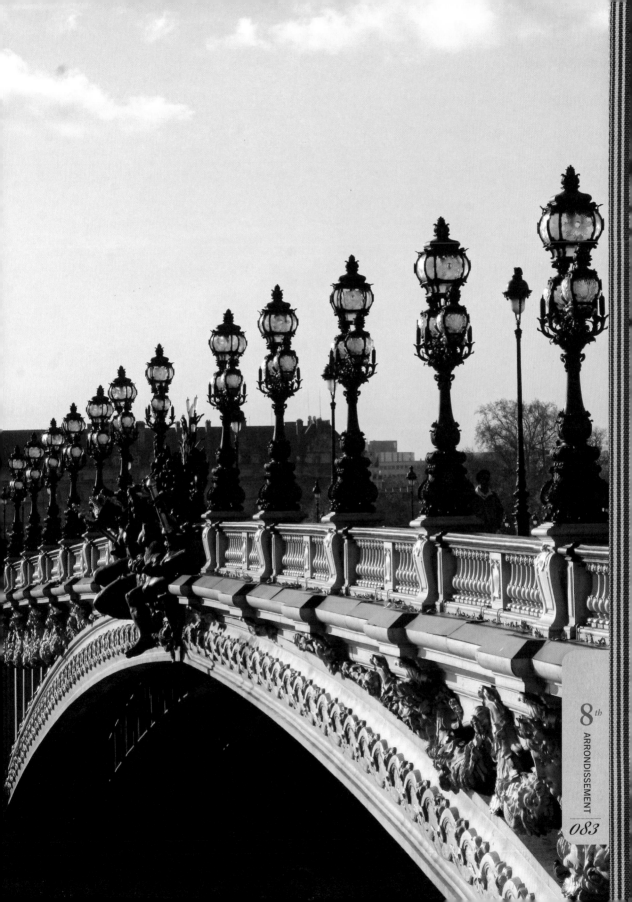

10th and 11th
Arrondissements
THE YOUNG BLOODS

The lively bars and cafes; the remnants of authentic old Paris and age-old craftsmen and ateliers mixed with brash new bars; the tranquil Canal Saint-Martin slicing through the shady streets and the energy, audacity and innovative attitude.

10TH

11TH

When the lower part of the Marais became popular with the international masses and the area lost much of its magic from the onslaught of tour groups and camera-toting tourists, the cool crowd decided to move farther north and east. They'd already started colonizing the Upper Marais (the 3rd), but it wasn't far enough away. So they wandered down the Rue Saint-Antoine and then peered with interest across the Place de la Bastille. When they reached the other side, they stopped, looked up from their iPods and design guides and noticed all the tiny passages and alleys trailing off Saint-Antoine and the Avenue Ledru Rollin.

The curious cool crowd started exploring. They noticed that the area sandwiched between the Bastille, the Place de la Nation to the east and Rue Oberkampf to the north had become a hothouse of creative talent – although it has to be said that communities of skilled craftsmen and artisans, especially those in the carpeting and furniture business, had lived and worked along the Rue du Faubourg Saint-Antoine since the mid-15th century. They noticed that many of the arcades, passageways, side streets and hidden squares with names like Cour de l'Étoile-d'Or, Cour des Trois-Frères, Cour de la Maison-Brûlée, Passage de la Bonne-Graine, Cour de Saint-Esprit, Passage de la Boule-Blanche and Cour du Bel-Air seemed idyllic and untouched by modern life, and that some of them even gave the impression of being a century back in time. And they noticed that there was a distinct beauty in the curving timber staircases, the cobblestoned alleyways and the patina of the aged facades, with their faded typography. It wasn't long before they began to be seduced by the gritty beauty, atmospheric alleyways and creative artists of this working-class quartier. And they started moving in. The aesthetic was far from the winding medieval streets and architectural charms of the Marais, but it was also refreshingly untouched. It was, they said, *trés* authentic.

Fast-forward several years and the formerly rough Bastille has been given a bit of a scrub and an injection of new blood, not to mention a whole lot of entrepreneurial cash. These days it's one of the city's hippest districts. Characterized by a seemingly endless mix of galleries, design stores and fashion boutiques, plus a lot of wild bars and even livelier cafes, this once quiet, blue-collar neighborhood is now very happening and particularly popular with younger Parisians. (If you're over 30, you may feel ancient here.) Unfortunately, it's suffered from the same affliction that partly damaged the Marais. Many of the old studios and cute *boulangeries*

have been bought up by high-street brands, with the result that Rue du Faubourg Saint-Antoine now looks like London's Oxford Street. But there are some parts of the Bastille that are certainly worth seeing.

The best time to see the Bastille is perhaps at night, because that's when you get the real atmosphere of the place. The northeastern area around the vibrant Rue de Lappe and extremely long Rue de la Roquette is the busiest thanks to its many cafes, bars and nightclubs, but a lot of them are tucked away, so just follow the congo lines of Parisians and in-the-know travelers to discover some great little places. During the day, follow the same philosophy and target the tiny alleys that fork off the main thoroughfares. Look for signs that indicate ateliers, artisans or galleries. There are lots of hidden places such as the charming, much admired Viaduc des Arts arcade, an urban renewal project that has turned an old elevated rail line into a design-focused arcade full of studios and arts and crafts places. However, the area is changing day by day, so read the online media and tourist magazines in Paris for updates, exhibitions and places to add to your arrondissement to-do list.

The Canal Saint-Martin, once the down-and-out cousin on the northeastern border, is also undergoing the same transformation that has seen its Bastille neighbor become a big-name quartier, although it hasn't quite reached the same level of popularity yet. (For example, there's no Habitat homewares in the Canal Saint-Martin as there is in Bastille, and Antoine et Lili doesn't really qualify as a chain store – yet.) The scene is similar on Rue Oberkampf, Saint-Maur and Jean-Pierre-Timbaud, where artists and small designers have also set up shop, attracted by the low rents and authentic Old Paris's atmosphere. Following in their footsteps are many of the city's bobos (bourgeois bohemians) and bright young professionals, who are also fixated by the still-affordable property prices and the opportunity to be part of a cool new quartier.

Although they are neighbors, the two arrondissements – the 10th and the 11th – are like chalk and cheese, or brie and edam. The 11th, the Bastille area, is a network of wide boulevards and tiny passageways that can be difficult to navigate and explore on your own unless you know your way or have a map of all the good places to go. The 10th, however, which encompasses the Canal Saint-Martin, is a relatively easy area to explore because the best bits are right on or near the canal itself. In saying this, the Bastille is fairly safe after the streets were cleaned up (just follow the crowds and you'll be fine). The Canal can still feel rough in parts after a certain hour – although it's pretty, popular and extremely safe during the day.

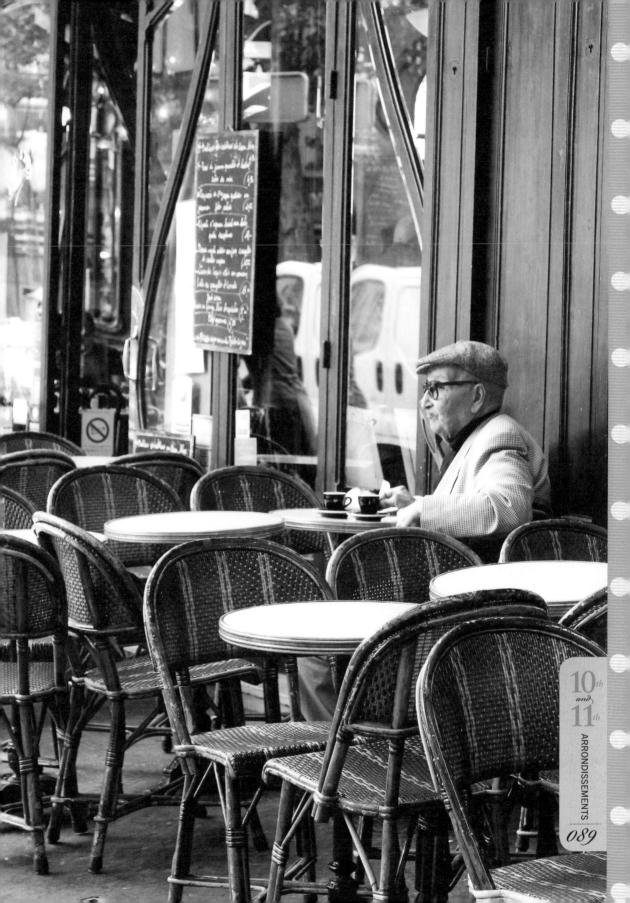

Boho atmosphere, hideaway-style bars, canal views and late-night people watching

The best place to begin a wander of the 10th and 11th arrondissements depends on the time of day. If you're planning to explore the area after dusk – and this is really when the hip bars and restaurants come alive – then you're best to begin anywhere near the corner of **Rue du Faubourg Saint-Antoine** and **Avenue Ledru Rollin**. The main thoroughfare of Rue du Faubourg Saint-Antoine is very commercialized now and heavily populated by the young, but the energy and atmosphere of the place will still put you in the mood for a night of partying.

One of the best places to begin festivities and embrace the new mood of the Bastille is **Barrio Latino** at 46–48 Rue du Faubourg. It is a fabulously opulent Latin bar and nightclub occupying four decadent floors of a building designed by Gustave Eiffel (of Eiffel Tower fame). The wrought-iron interior, velvet sofas and general air of luxury is indicative of how the old Paris is successfully meeting the new.

After you've had a drink here, turn north down Avenue Ledru Rollin toward **Rue de Charonne** and the many hideaway-style bars and atmospheric restaurants that are dotted around here. One of the best for a late dinner or snack is **Le Bistrot du Peintre** (page 203). Voted one of the most beautiful of the authentic old bars in Paris, it's easy to see why people love it.

From here, keep wandering north toward **Place de la Républic** where there is nightlife all sides, or grab a taxi to the 11th arrondissement and **Rue Oberkampf**, where **Cafe Charbon** (page 199) charms Parisians and tourists alike with its high ceilings, period features, enormous mirrors and boho atmosphere. It's a fabulous place to catch up with friends, or make new (Parisian) ones with which to practice your language (verbal or nonverbal) long into the night!

If you are going on a daytime adventure, the **Canal Saint-Martin** area is a great place to visit. While its dim streets can become a little alarming at night if you're unfamiliar with the area, during the day the waterway looks absolutely glorious, even on an overcast day. This area is one where meandering really does reap rewards. Take a tourist boat along the canal for a different view of Paris, linger on one of the lovely old iron bridges, grab a baguette from a cafe and have a picnic lunch on the side of the waterway or pull up a chair at one of the many eateries. Atmospheric cafes and restaurants flank the canal. One of the best is **Hôtel du Nord** at 102 Quai de Jemmapes, a classic 1930s-style Paris bar and restaurant with a zinc bar, velvet curtains and extensive

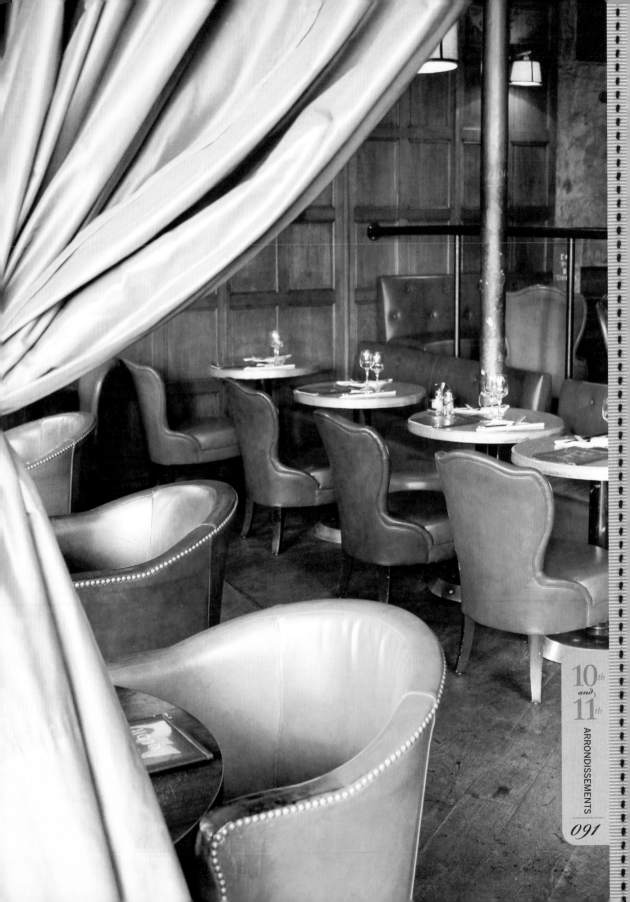

upstairs library. **Chez Prune** at 71 Quai de Valmy is an eclectic but fashionable joint where Parisians like to be seen and is therefore usually buzzing with crowded tables (although the views of the canal are just as good as the clientele). On Sundays, two streets running parallel to the canal, **Quai de Valmy** and **Quai de Jemmapes**, are reserved for pedestrians and cyclists – great for renting a bike and seeing the city from a fresh angle.

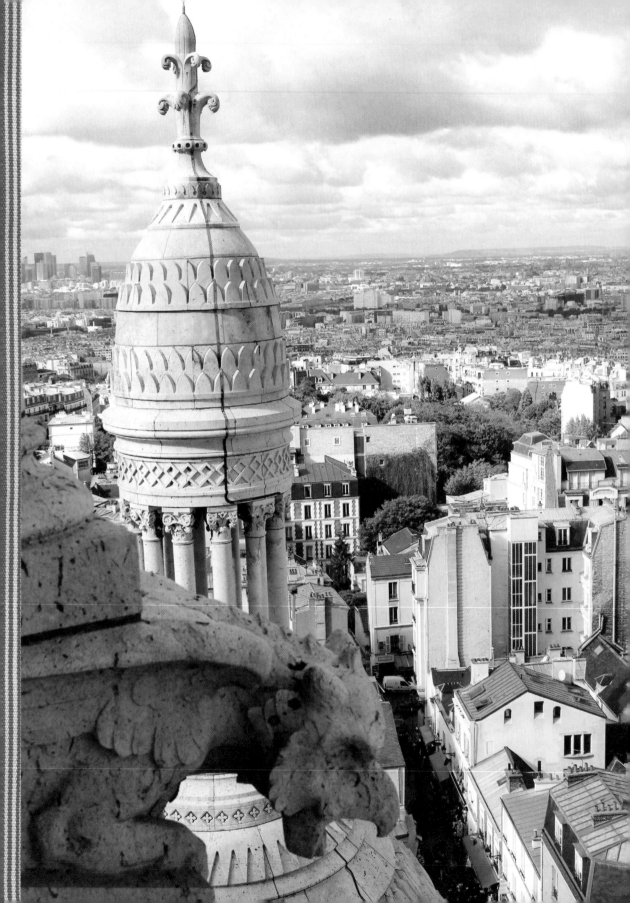

18th

Arrondissement

THE ENCHANTER

The eye-popping view from the top of the Sacré-Cœur; the tiny, winding streets and staircases; the dozens of artists painting scenes that have barely changed over the last 100 years; the bustling food markets and buzzing streets; the quirky stores and restaurants; the adorable little vineyard; the fabulous fabric shops and the fantastic, filmic atmosphere.

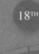

18TH

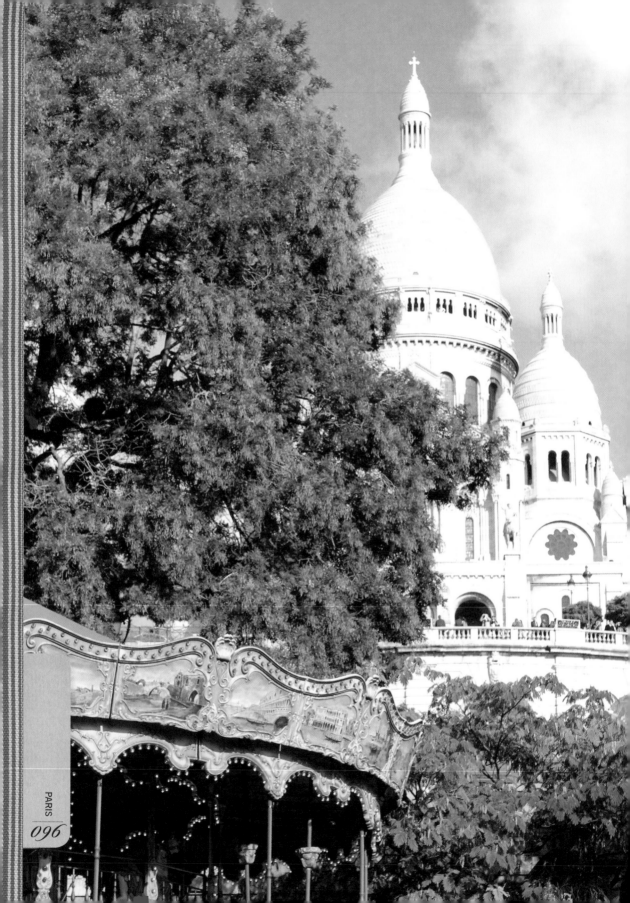

There are some Parisian places that everyone knows and recognizes. The Louvre is one. The Arc de Triomphe, of course, is another. And most people would be able to identify the Eiffel Tower with one eye closed. But there is one place that really makes foreigners' hearts go "awwwhhh" – thanks to the movies *Amélie* and *Moulin Rouge!* and a slew of artists who have painted the place a thousand different ways, from the bottom of its charming staircases to the tip of its spectacular butte.

Its name? The village of Montmartre.

Immortalized in film and on canvases by the likes of Picasso, Pissarro, Matisse, Renoir, Van Gogh and Baz Luhrmann, Montmartre is surely one of the most iconic parts of this symbol-rich city. Blessed with some of the most heart-stoppingly beautiful panoramas and street scenes in Paris, this hilly, character-filled village is chock-full of history and personality. In fact, it almost has as much personality as Amélie herself. While some tourists loathe its clichéd street scenes (the Place du Tertre is certainly tacky), the area is still going strong thanks to an overall grace and loveliness that never seems to fade, no matter how many backpackers traipse up and down its staircases.

A bit of history before we go on. Montmartre, which means "mountain of the martyr," was given its name because of the martyrdom of Saint Denis, the bishop of Paris and now the patron saint of France, who was unfortunately decapitated on the hill by the nasty Romans. (Legend has it that Saint Denis simply picked up his head, washed it off and carried it 5 miles to the north to what is now the town of Saint-Denis before he finally dropped down dead.)

The area has long been a source of fascination for the rest of Paris, and not just because it's set apart from the city, both spiritually (with its history of saints and monasteries) and geographically (it's 425 feet above sea level, hence the spectacular views). It's also aesthetically different from the rest of the city. In some parts it still looks like the country village it once was, complete with quiet winding streets and country-style boutiques.

The quartier originally became popular because it was outside the city limits and therefore free of Paris taxes. The local nuns also made great wine. Put the two together and you can see how it quickly took off as a top spot for a drink or three and a good time. Artists in particular loved it because they could work in their studios all day and then come out at night for an absinthe and some social life.

By the end of the century, Montmartre and its Left Bank counterpart had become two of the main centers of art and creative life in Paris.

It continued as a hot spot of entertainment well into the beginning of the 20th century, although it had its seedy side, too. By the end of the 20th century, however, it was so popular it was becoming a cartoon version of its former self.

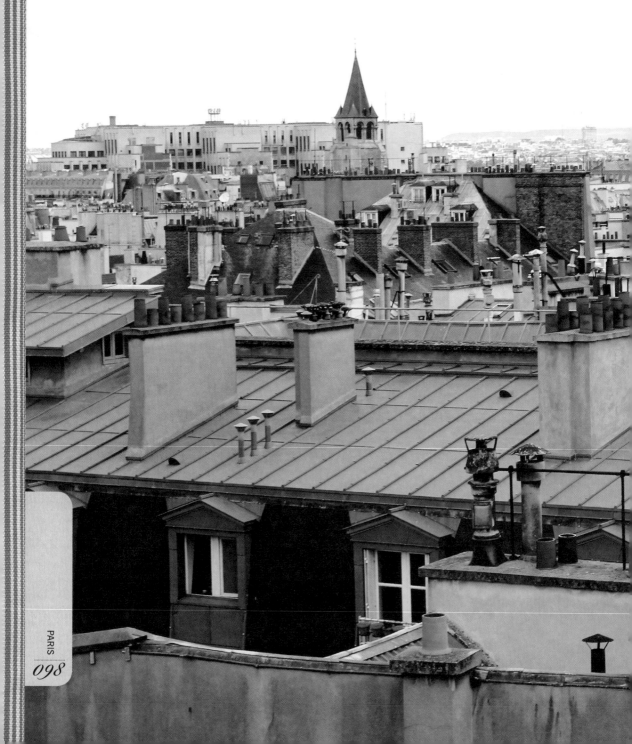

Enter *Amélie*. This enchanting film, plus Baz Luhrmann's *Moulin Rouge!*, helped shine the light on Montmartre again and presented it in a fresh new way. At the same time a new generation of fans moved into the area, taking over its pretty but run-down apartments and buying up its cute little top-floor garrets with their irresistible rooftop views. All of a sudden the charm returned and Montmartre was fashionable again.

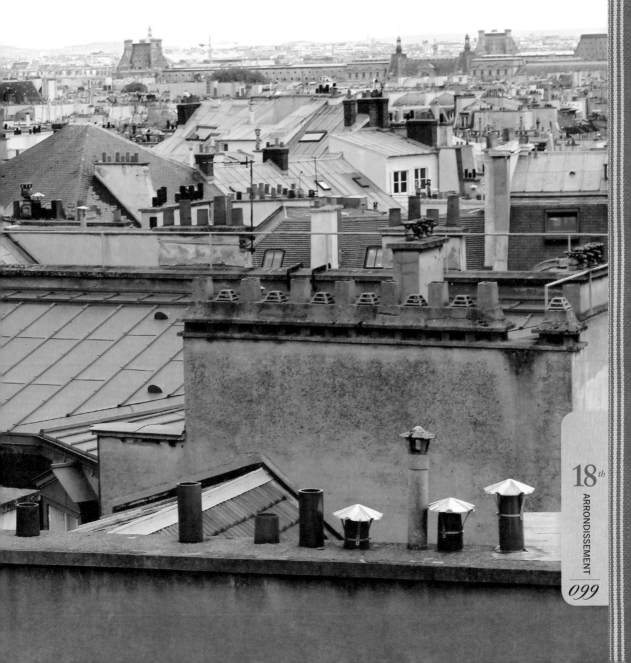

Postcard scenes, quirky characters and classic painterly and cinematic moments

....................

If you're a photographer, an artist, an architect, a designer or simply someone who loves to be inspired, you'll be in heaven here: the creativity is so abundant in Montmartre it almost seems as though it's soaked into the mood of the place.

There are many things to see on this fabulous historical old hill, among them the white-domed basilica of the **Sacré-Cœur** (the views from its towers alone are worth the exhausting climb). But perhaps the best place to begin is down at the **Moulin Rouge** (French for "red windmill"), the place that gave film director Baz Luhrmann so much inspiration for his movie. You'll be able to spot it easily – just look for the iconic windmill and the tourists milling around outside taking photos. This is the area that inspired painters such as Toulouse-Lautrec to depict Montmartre as a district of cabarets, circus freaks and colorful bawdy prostitutes. Inside, the shows are far slicker than 100 years ago, but it's still worth a visit, if only to see the spectacular cancan dancing.

From here, begin winding your way up the hill along the ancient road **Rue Lepic** until you reach **Rue des Abbesses**. Many famous people have resided or worked on this street, including Van Gogh, who lived at number 54 with his brother, and Louis Renault, who built his first car in 1898 and won a bet with his friends that his invention was capable of driving up the slope of Rue Lepic. If you're lucky, the street stalls will be out, the sellers will be chatting and the locals will be brandishing their straw bags full of plump eggplants. Wander down Abbesses and turn left up Rue Ravignan, which leads to the pretty, tree-studded Place Émile-Goudeau. Here, across from the **Timhotel**, is the **Bateau-Lavoir**, or Boat Washhouse, area, known as the cradle of cubism. Past residents include Picasso, Modigliani, Rousseau and Braque.

Keep winding your way north, up to Rue Norvins, until you reach the spot where Rues Norvins, Saint-Rustique and Des Saules collide a few steps from Rue Poulbot. This is a classic Montmartre scene – so pretty it was captured in a famous Utrillo painting. Then, go down Rue Poulbot and you'll reach **Espace Dalí Montmartre** (Dali Museum), which features 300 original Dalí works. A little way on, at **Place du Calvaire**, you'll find one of the best views of Paris. After a few more steps, you'll reach the lovely old square of **Place du Tertre**, where artists aplenty capture tourists posing for the requisite portrait.

The **Musée de Montmartre** (Montmartre Museum) is a 17th-century house that was once occupied by Van Gogh and Renoir, and it presents a collection of mementos of the neighborhood. Nearby there's an exquisite little winery that still produces a good crop – a grape-harvesting festival is held here every October. Finish your tour with a stop at the cemetery **Cimetière de Montmartre** (Montmartre Cemetry), the final resting place of Nijinsky, Stendhal, Degas and Truffaut, among many others.

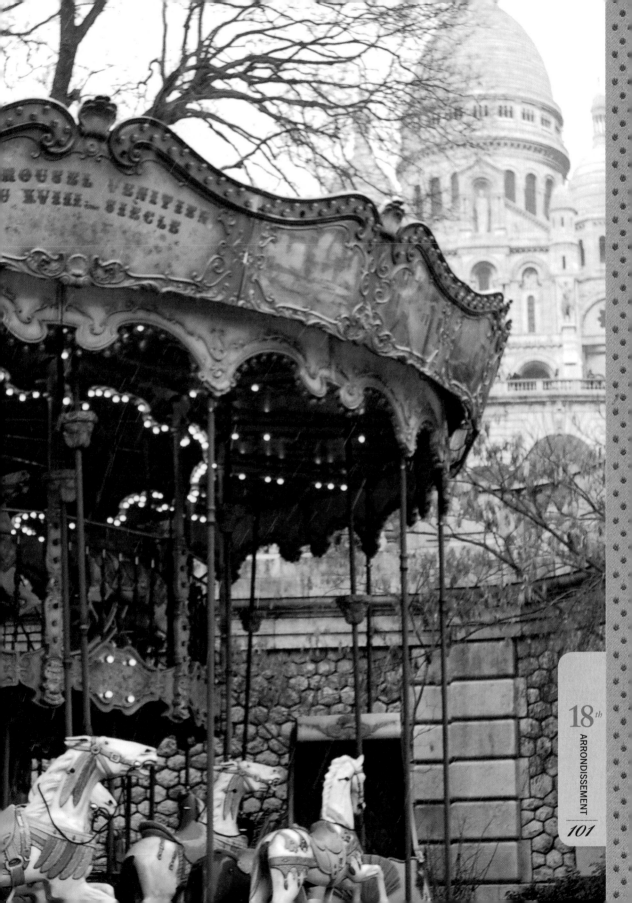

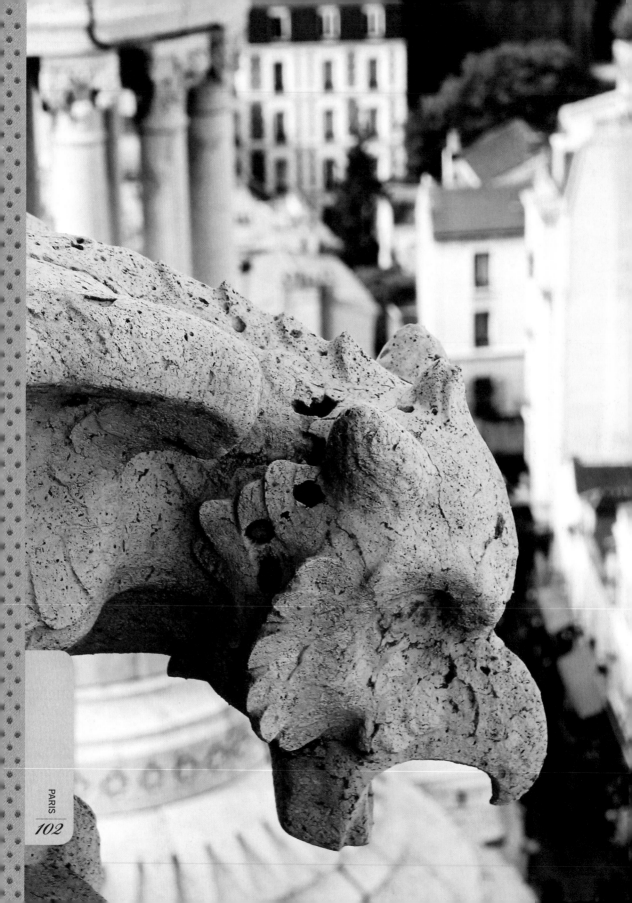

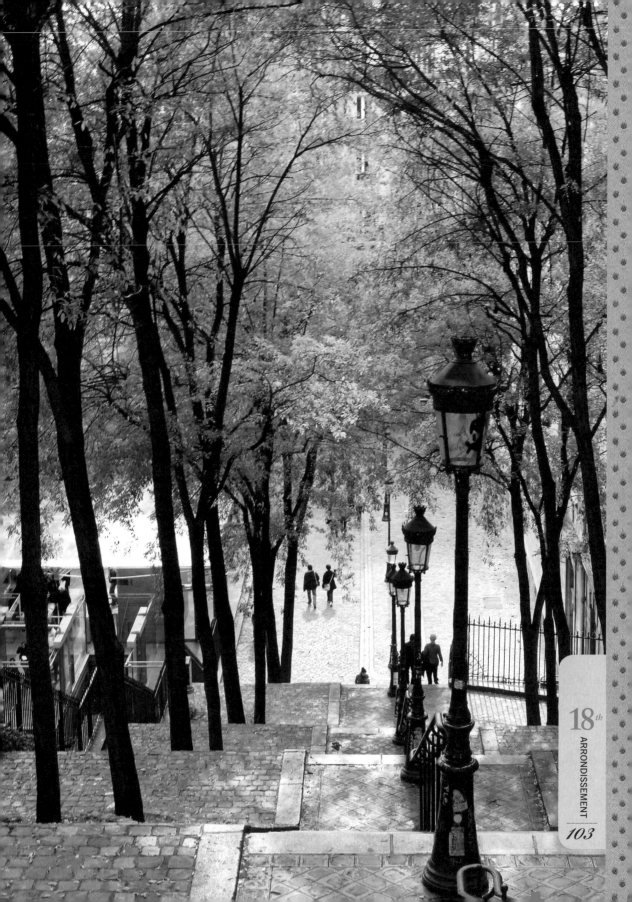

Paris handbook

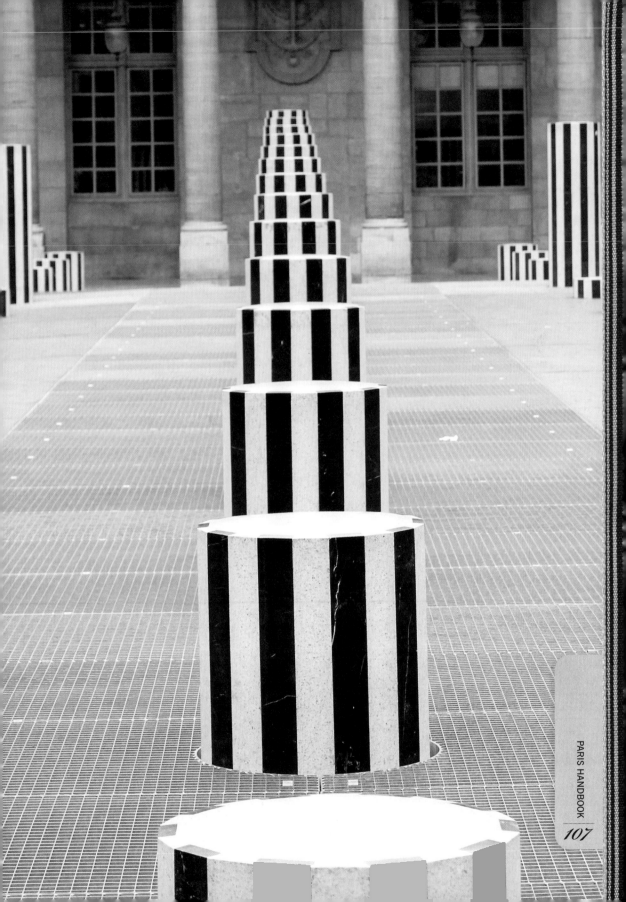

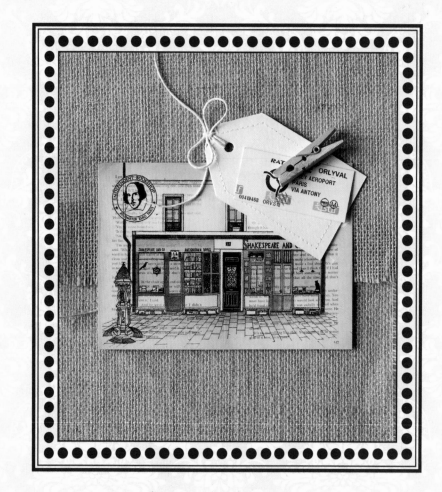

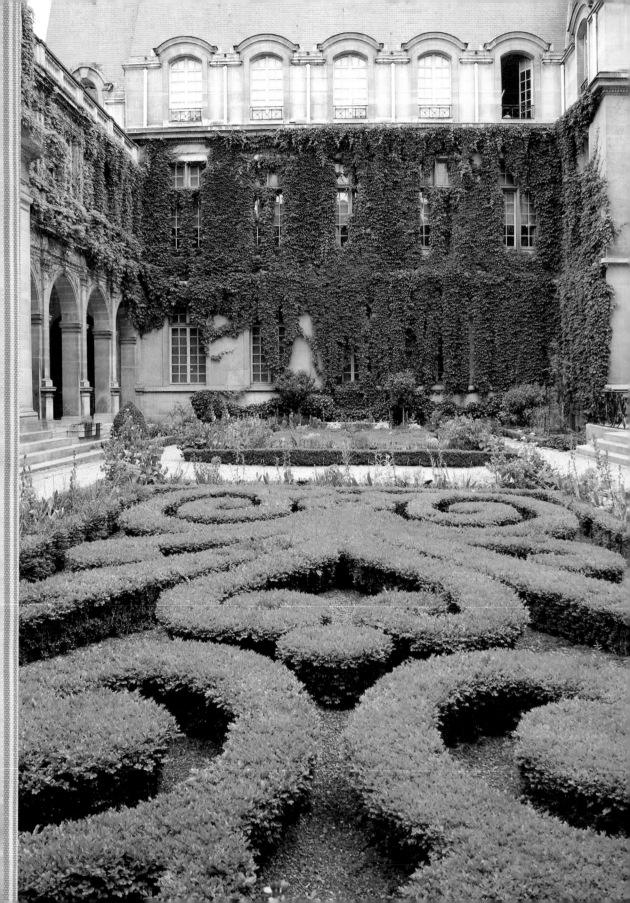

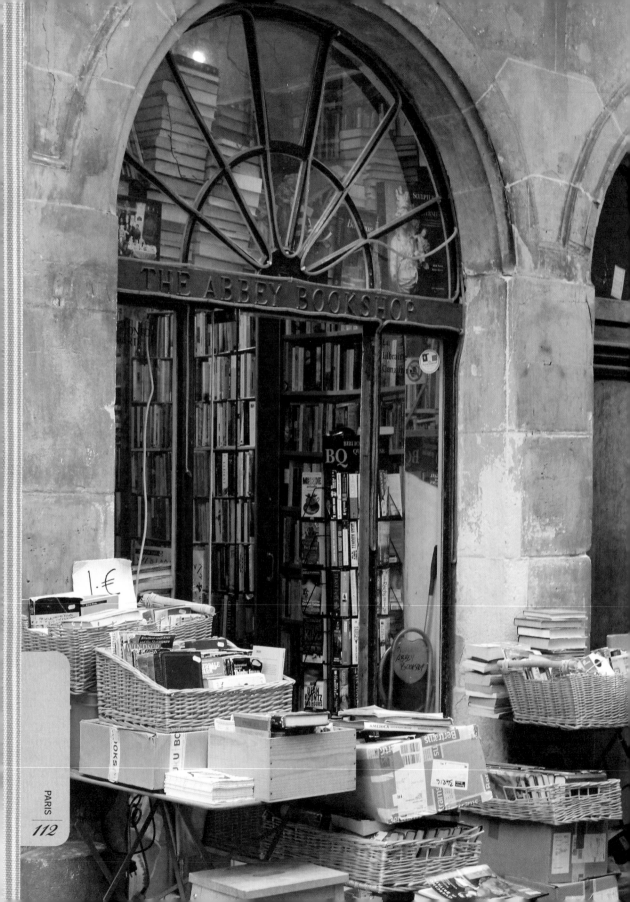

Bookstores

Paris is a literary city, where the written word is taken almost as seriously as couture and the mille-feuille. As such, there is a bookstore to suit everyone here, from books for cooks, gardeners and architects, to bookstores that are also bars (how very French!). Here are just a few of the great places where page-turning is a pleasure.

7L

Browsing for style

Karl Lagerfeld has turned his talented hand to just about everything in the design world, from gowns to galleries, so it was only a matter of time before he channeled his energies into the literary sphere. This exquisite store, 7L (pronounced *"c'est elle"*), is the result of his long-standing love of books and his realization that he hadn't made his (signature) mark on the publishing world. Located below his studio in Saint-Germain's Carré Rive Gauche, it's a tiny store and as difficult to find as a bargain vintage Chanel gown. But it's also wonderful when you finally search it out, in this neighborhood of exclusive art galleries and antiques dealers – a neighborhood that's quite fitting, really, because the store specializes in the decorative arts. Naturally it stocks books on fashion, but also on design and architecture, which are Lagerfeld's other great interests. The designer has a hand in selecting many of the titles, so the collection is as eclectic as it is interesting. (I was thrilled to find two of my books in there, although I didn't see Lagerfeld himself wandering around – that would have been too much excitement for one morning.) Apparently he's also often seen browsing in the nearby La Hune bookstore late at night, so if you miss him here, you could try the Boulevard Saint-Germain.

7 Rue de Lille, 7th; tel. 01 42 92 03 58

107 Rivoli

Design delights in printed form

I think this beautiful place is one of the city's best design bookstores, but then again, it is part of the fantastic Museum of Decorative Arts (Musée des Arts Décoratifs; page 164), so it was always bound to have credibility. It's a surprisingly spacious store (the front door belies the size) and is stocked with thousands of carefully selected titles on art, architecture, fashion, design, interior design and any other creative subject you can think of. Staff don't mind if you spend an hour browsing (it'll be hard to tear yourself away), and if you have any money left after you've bought half a dozen tomes, there are also lots of gorgeous gifts for all those design friends back home. These include exquisite cards with fashion illustrations, contemporary pottery, glass and ceramics, and pencils that are so beautiful you'll want to display them on your desk. It also sells limited editions of some of the artworks in the museum. All in all, a perfect store.

105–107 Rue de Rivoli, 1st; tel. 01 42 96 21 31 or 01 44 55 57 50

Also worth seeking out is the Louvre bookstore (Librairie Musée du Louvre), which is located in the "Hall Napoléon" under the Pyramid in the Cour Napoléon. It supposedly boasts France's largest selection of art history, although the crowds can be horrendous.

Artazart

Designer lines

Artazart is a far-flung but fabulous book-filled space that's so comprehensive it will make your head spin. It's one for the purists, especially those dedicated art or architecture book lovers who will walk a mile in search of the perfect title. If you're not in the area to begin with, it is a bit of a hike, but it's also in the cute Canal Saint-Martin neighborhood, so you could make a day trip of it and see the pretty waterway while you're here (which is right outside the store). The store is well stocked by knowledgeable and helpful book lovers, and the bulging

shelves mean there's always something new to find. I discovered so many great design titles on my last visit I could have blown my budget in one morning. It's particularly strong on photographic titles and often puts on great exhibitions of moving images. Look for the tangerine-colored facade, a fitting exterior for a creative and inspirational place.

83 Quai de Valmy, 10th; tel. 01 40 40 24 00; www.artazart.com

Assouline

Books as art

If you think books are beautiful things that should be displayed as objets d'art then come to Assouline. This super-stylish French publishing house has created a "gallery" of pages that really has to be seen to be properly appreciated. Using their own seductive titles on art, fashion, travel and lifestyle, the company has designed a "wall of spines" that is so sexy I always want to photograph it and re-create it in my own library at home. Those that haven't been placed in this fantastic still life have been packaged up in creative boxed sets, some with collectable timber cases, others with exquisite rolls of ribbon. They're expensive, but just try and resist. The company also has a line of candles called Leather, Wood and Books, designed by that cult French company Diptyque – just the thing to light up at your next private bathtub reading.

35 Rue Bonaparte, 6th; tel. 01 43 29 23 20; www.assouline.com

Galignani

Striking titles

Galignani is a terribly handsome store. Its interior is so distinguished it's almost intimidating. But don't let the dark wooden walls and gentleman's library atmosphere put you off: this is a great spot to find beautiful books in both French and English editions, particularly art, fashion, photography and other fine-arts titles. There's an extensive display of architecture and interior design magazines too, including the latest issues from the USA and the UK. It's the oldest English bookstore on the continent and has been run by generations of the Galignani family since 1801, so they know books. They also see them as precious objects of wisdom and aesthetic delights to collect and prize. The window displays are treated like a boutique and are changed every 15 days; the results are always enthralling. A lovely haven on rainy days, but wonderful at other times, too.

224 Rue de Rivoli, 1st; tel. 01 42 60 76 07; www.galignani.com

La Belle Hortense

Where wine and literature mix

I had read about La Belle Hortense in countless magazines and newspapers, and was keen to experience it for myself. Easier said (or read) than done. I had to go back three times before I could gain entry. If you do go, check the store hours; it's one of those places that seems to march to the beat of its own drum. On the upside, it is open in the evenings, and it's a lot of fun. Part bar, part bookstore, part exhibition space, there's a cute zinc bar at the front and bookshelves stretching down the side, so you can sip wine or coffee amid literary works or take in a lecture or reading in the back lounge. The name comes from the novel by Jacques Roubaud, which takes place in the same neighborhood (the Marais) that La Belle Hortense calls home. It's all very clever, really. The best time to go is in the evening, when you can chat with a friend at the bar and then browse through the shelves afterward. Books, wine and art – it's a winning combination. You can see why a lot of people love it! It's also opposite the cafe Le Petit Fer à Cheval, so you can pop in there afterward and make a night of it.

31 Rue Vieille du Temple, 4th; tel. 01 48 04 71 60

La Hune

La lovely

Intellectuals and book lovers adore this store, and not just because it's part of the history of Saint-Germain-des-Prés and they're following in the footsteps of a roll call of famous authors. They adore its location, right next to the Cafe de Flore. They adore its mezzanine, groaning with art, architecture and design titles. And they adore its sculptural staircase, although it's tricky to navigate when your arms are full of tomes. Restored in 1992 by the designer Sylvain Dubuisson, La Hune is one of the lasting legacies of this publishing-loving quartier. Its owner has been offered massive sums of money to "sell out" and let a luxury brand such as Cartier or Armani move in and take over the shelves, but for some wonderful reason, she has refused. Let's all applaud her now. Another reason to come here is that it's open late, so if you've got insomnia you can hang out until midnight with all the other intellectual night owls. You never know, you may even pick up a brooding Frenchman (or woman).

170 Boulevard Saint-Germain, 6th; tel. 01 45 48 35 85

Librairie de la Galerie

Lovely literature

This bookstore looks a little like a boudoir: intimate and enticing. Perhaps it's intentional? You do see it and think; Oh, I'd love to sneak a peek in there! There's even a lovely selection of Jacques Garcia armchairs to lounge around in. It's a fairly new addition to the Parisian bookstore scene, having only opened in Paris spring of 2010, so it's like a great little find that few others know about. The store specializes in photography, literature and travelogues, and has a well-considered selection of titles.

30 Rue Boissy-d'Anglas, 8th; tel. 01 42 65 24 40; www.lalibrairiedelagalerie.com

Librairie des Jardins

Books for green thumbs

The French love their gardens. They also love their books. So it makes sense that there are bookstores devoted exclusively to horticultural titles. This is one of them. Perfectly positioned in the Tuileries Garden so you can pop in while you're walking through the park, this pretty little place is tucked under a vaulted 17th-century chamber beneath the terrace of the Jeu de Paume, a space once used by Marie Antoinette's personal guard. Despite the coolness of the stone vaults, it is as enticing as a parterre garden on a summer's day. It's lovingly curated by botanist Françoise Simon, and there are more than 3000 titles on offer, making it one of the best gardening bookstores in Paris. There are books on Paris gardens (lovely for gifts), books on potagers, books on design and celebrated gardens in other parts of the world, books on botany and history, even books on the philosophy of gardening (so very French!).

Jardin des Tuileries (main gate), Place de la Concorde, 1st; tel. 01 42 60 61 61

Librairie Flammarion

Artful

Lots of design lovers visit the Pompidou, but many of them just explore the exhibitions, the top-floor terrace and Georges restaurant (where the views are some of the best in the city) and walk right past the downstairs bookstore. That's a shame, because the bookstore is as good as the rest of the place – and almost as big. Managed by French publishing house Flammarion but operated in collaboration with the Centre Pompidou, this extensive space has more than 12,000 titles on art, graphic arts, architecture and design. It's particularly strong on art books, so if you're looking for something particular and can't find it anywhere else, try here; it's most likely on the shelves. There's also lots of cool stuff, including the latest magazines, journals, stationery and the kind of cards you want to take home and pin firmly on your mood board.

Centre Pompidou, 19 Rue Beaubourg, 4th; tel. 01 44 78 43 22; www.flammarioncentre.com

Librairie Gourmande

Books for cooks

The perfect store for those who love to cook, this great little place stocks both old books and new ones on the culinary arts. One review said it's for *gastronomes sérieux* only, but anyone can come here and feel like Julia Child in an instant. There are books on food, books on presentation (so you can bluff your way through) and even books on the culinary lexicon. And there are also plenty of titles in English, so you don't have to translate at your kitchen bench with asparagus in one hand and a French–English dictionary in the other.

90 Rue Montmartre, 2nd; tel. 01 43 54 37 27; www.librairiegourmande.fr

Librairie Louis Vuitton

LV and the written word

Few shoppers browsing the monogrammed bags at Louis Vuitton's flagship store on the Champs-Élysées would realize there are more riches to be had in another part of the store – the bookstore, which is as lovely as anything else LV does. This glorious space features hundreds of titles on themes that are constantly changing, so you're never quite sure what might be in stock when you visit. (The bookstore's full stock of 3000 titles are kept out of sight, because they couldn't fit in the space.) Genres range from fine art to design. And there's a captivating curiosity cabinet featuring books designed by artists, too.

101 Avenue des Champs-Élysées, 8th; tel. 01 53 57 53 82

Ofr.

When size doesn't matter

Like its whimsical name, Ofr. is small but beautifully thought-out. Located near the design school École Supérieure d'Arts Appliqués Duperré in the lively and rapidly gentrifying Upper Marais neighborhood, this tiny bookstore and gallery is barely bigger than a copy of Proust's *Remembrance of Things Past,* but it's just as memorable as the madeleine he made famous. Around the perimeter are shelves groaning with serious literature; in the middle are tables stocked with lighter fare, including foreign magazines, esoteric fanzines and other irresistible, pick-up-able things. Everything is here, from exhibition catalogues and limited-edition art books from around the world to *Oyster, Spoon* and *Purple* magazines and long-extinct issues from the 1960s, along with curious drawings, notebooks, artistic postcards, T-shirts, vintage books and leather bags. I tell you, it's an ode to urban pleasures. There are also regular author readings, although how everyone squeezes into the store is a mystery. Perhaps they fill out the exhibition space in the back? Quirky but good.

20 Rue Dupetit-Thouars, 3rd; tel. 01 42 45 72 88; www.ofrsystem.com

Shakespeare and Company

The writers' favorite or a literary classic

To enter this legendary bookstore, you have to do a sort of "Shakespeare and Company shuffle" (handbag close to chest) in order to delicately quickstep past all the book piles and the American students browsing through Sartre. (Hemingway figures large here too: the old man would be proud of his towering piles.) Once you've reached the middle of the store without knocking any paperbacks over, you can breathe out, and then make your way to the staircase at the rear. You need to ascend this, even though you might be waiting a while for everyone else to come down. (It's like the Notre Dame towers: just be patient.) This is because the best part of this bookstore is upstairs, near the front windows. Again, you'll need to work your way through a maze of leaning shelves, secret cubbyholes and lingering readers, but please do, because you'll be inspired. When you're finally there, take a seat, lean back, and absorb the literary history. Feeling your writer's block leave you yet? Just wait. You will. I promise you. Note: if it's a Sunday, there will most likely be a poetry reading and tea. More lovely reasons to visit. Now, before you get too excited about the history of this fabulous store, I should warn you that it's not the original – the one that formed the center of social life for expatriate Americans such

as Ezra Pound and Ernest Hemingway and Irish writer James Joyce. That one was located a little way away, at 12 Rue de l'Odéon. Sadly, it was damaged by fire some years ago. But the new one is still to be admired. I don't care what the purists say: I love Shakespeare and Company on any given day.

37 Rue de la Bûcherie, 5th; tel. 01 43 25 40 93; www.shakespeareandcompany.com

The Abbey Bookshop

A hidden literary treasure

Tucked away behind the Saint-Sérverin church in the Latin Quarter, this bookstore is as fantastic as the discovery that your favorite author has just penned another novel. It's squeezed into the tightest space imaginable down the tiny Rue de la Parcheminerie, and finding it can be a challenge. However, the inevitable search for it simply adds to the excitement. An author friend calls it "The Tardis," because the exterior is barely more than a lovely old wooden door topped with a church-like arched window, with a few piles of books leaning precariously on either side. But inside there's an elongated space featuring rooms and rooms of floor-to-ceiling bookshelves groaning with titles. Honestly, it's the most wonderful space imaginable. Navigating past the overflowing rows can be tricky, but that's part of the enchantment. The bookstore is run by a friendly French-Canadian gentleman named Brian Spence. He stumbled upon the site by accident, after searching everywhere for a spot for the perfect bookstore, and knew immediately it would suit. The street, you see, used to be known for its concentration of medieval bookmakers. Abbey fits so comfortably in its spot it looks like it's been here for a century. There are more than 35,000 books in stock, and the store is famous for stocking titles that are difficult to find in the rest of Europe. A great find for those who like rummaging through boxes and piles for the perfect title.

29 Rue de la Parcheminerie, 5th; tel. 01 46 33 16 24

The Red Wheelbarrow

A well-red refuge

You can't miss this store; it has a cheery, tomato-red facade that's as joyful as the book selection inside. Staffed by the happiest people in Paris, it's the kind of place where authors drop by just to say hi, and locals pop in for a gossip and a flick through the front tables. And it's packed with tables. I'm always fearful I'm going to knock over something in this store – my camera bag has to be kept close so it doesn't swipe a pile of new releases – but that doesn't stop me from entering. It's so irresistible. Stocked with mostly English titles, it features a great selection, from biographies to history books to fab new releases. Even the boring books seem interesting in this place. Indeed, everything about it is fascinating, even the name, which was taken from one of the works of William Carlos Williams (such a great name), an American poet who wrote during the first half of the 20th century. Also check out the blog, where you can find out about the store's upcoming literary events, book reviews and new arrivals. Red Wheelbarrow, we love you.

22 Rue Saint-Paul, 4th; tel. 01 48 04 75 08; www.theredwheelbarrow.com

Village Voice

The expats' choice

A gem of a bookstore, this hidden place is squished down the atmospheric Rue Princesse in the 6th arrondissement. You have to hunt to find it, but once you're in the area, you'll be glad: there's so much in this quartier to enjoy, including the bars, jazz clubs and boutiques around the corner in Rue Guisarde and Rue des Canettes. It has a very American feel, but perhaps that's because it has lots of English and American titles. Americans are always in here, asking questions about Hemingway and such. But it's also loved by expats, including a fair few famous authors who live in the area. And the author events are always well attended.

6 Rue Princesse, 6th; tel. 01 46 33 36 47; www.villagevoicebookshop.com

Voyageurs du Monde

Foreign lands and literature

If you're looking for travel books, this place is fantastic. Some describe it as a travel agency like no other, and it is certainly far more than just a place to book a week in Morocco or Phuket. There is a cute restaurant and a carefully curated gift shop, specializing in goods and writings on far-flung destinations. But the best part about it is the bookstore, a wonderfully quiet place that offers an interesting selection of books to prepare for any journey, as well as lots of indispensable travel objects such as maps, atlases and stylish globes (great for gifts). Closed in August and during winter.

55 Rue Sainte-Anne, 2nd; tel. 0892 235 656; www.librairie.vdm.com

Paper, stationery and art stores

This section was partly inspired by the growing trend in "memory preservation" – a broad umbrella phrase that encompasses everything from journaling, scrapbooking, sketching, painting and making collages to collecting, particularly photographs, antique maps, prints and vintage postcards. Here's a little list of some inspirational places to help you in your search for beautiful preservation materials, be they sketchbooks, pencils, ink, paper, prints, photos or simply gorgeous journals (which you'll definitely need if you want to write about your time in Paris – laptops don't really feel quite right when you're sitting at a pavement cafe).

Benneton Graveur

Motifs to give

Not to be confused with the Italian clothing company that has cute advertisements with curly-haired kids, this century-old store specializes in engraved stationery, fine paper and writing cards. As you would expect of an engraver and stationery store in the wealthy 8th arrondissement, it is not only tastefully designed but also stocked with everything a good hostess could need, from stylish and whimsical gifts to cards with motifs to suit every madame (my favorites are the cards with snails on them, but there are also gentlemanly cards featuring cigars). Look for the beautiful old wooden drawers that have contained dyes for dozens of A-listers who have ordered their note cards here.

75 Boulevard Malesherbes, 8th; tel. 01 43 87 57 39; www.bennetongraveur.com

Calligrane

Chic pickings

Oh, Calligrane! What can I say about your masterful displays? Your perfect window merchandising? Your amazing handmade paper? No amount of superlatives could describe this tiny but oh-so-stylish place, which elevates paper into a work of art. If you are one of the millions of e-mail users who hasn't penned a handwritten letter for a while, then come here. You'll be so inspired by the displays you'll want to write to everyone you've ever known just to show off your lovely paper. This sleek store is one of the most sophisticated sources for pens, calling cards and personal stationery in Paris. The selection includes 200 handmade papers from all over the world. These enormous sheets of papers are displayed so beautifully on racks and in cabinets that you could be forgiven for thinking you're in a museum or archive. And some of them are truly exquisite. There are paper sheets with delicate patterns, paper crafted with tiny flecks of gold, paper from Japan, Brazil, China, India and Thailand, and paper you just want to take home and frame.

4–6 Rue du Pont Louis-Philippe, 4th; tel. 01 48 04 09 00 or 01 48 04 31 89

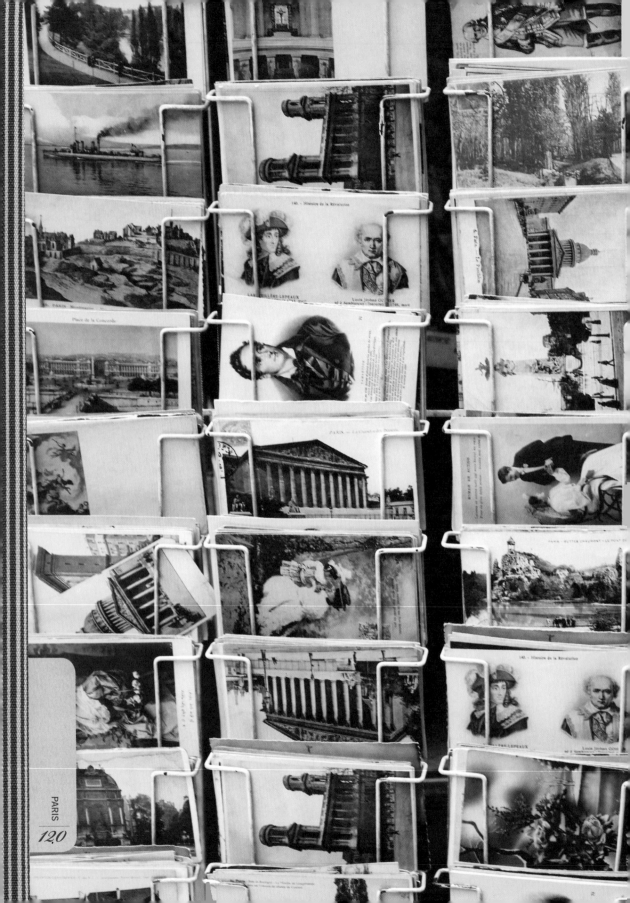

Charbonnel

Distinctive ink

I love the line that's often used to describe this splendid art store – *fabricant de couleurs pour les beaux-arts et les loisirs créatifs-décoratifs*. Doesn't that sound like something you want to explore more? Essentially it means this store is a manufacturer of colors for fine arts and crafts. However, Charbonnel is far more than that, as the countless artists who have come here over the years will attest. François Charbonnel opened his printmaking workshop in 1862, servicing artists such as Renoir, and it was so successful that he became something of a legend in the city's art circles. Almost 150 years later, Charbonnel is still here. It's a beautiful little shop on the Left Bank of the Seine, right near Notre Dame, and has a wonderful air of history and intrigue about it. It's obviously appealing to artists, but it's even enticing if you can't sketch to save yourself – one peek in here and you'll start wishing you paid extra attention in those art classes in school. There are all kinds of printing inks, including black ink in lovely glass jars, plus materials for gilding, other art supplies and of course *les peintures* (paints). Just try to walk out without buying anything.

13 Quai de Montebello, 5th; tel. 01 43 54 23 46

Marie Papier

Paper pleasures

Marie Papier's owner Marie-Paule Orluc worked at *Marie Claire* magazine and the Champagne house of Laurent-Perrier before she opened this store, and her artistic CV shows: the place is as carefully put-together as a magazine spread or a Champagne-drenched soirée. It's designed in a manner that can only be described as quiet sophistication and features stylish lighting and elegant wooden shelves that wouldn't look out of place in an architect's studio. The latter offer the perfect backdrop for the neat piles of paper that are stacked in orderly rows, sorted by weights and colors. There are also lots of lovely notebooks and albums with gorgeous bindings in cloth, paper and leather. You don't have to be an artistic director or magazine editor to come here and be inspired.

26 Rue Vavin, 6th; tel. 01 43 26 46 44

Mélodies Graphiques

Love at first writing

There is a cute story attached to this store. Loved-up couples keen to immortalize their passion in print sneak in here to write little messages of *amour* in the calligraphy book. If you go to the store and quietly peek through the pages, you'll see the entries: Sophia et Eduardo, October 2010. It's quite touching, even if it is a soft form of graffiti. This sublimely designed art and calligraphy store (even the facade is a beautiful inky shade of black) is part of a collection of art stores located within sketching distance of each other on this pretty Parisian street. The concentration of these places has prompted some people to wonder if this tiny *rue* is turning into the modern equivalent of a medieval bookmakers' street. All of stores are attractive, but Mélodies Graphiques is particularly appealing. There are colored pencils displayed like bouquets of flowers in glass jars and vases, handsome quill pens and pots of rich ink, gorgeous canisters of gold, silver, copper and bronze dust, and all manner of paper, cards and calligraphy things. It's all so gorgeous, no wonder lovers feel inspired to write notes of dedication. Drop in, and if you're with your loved one, sneak a calligraphy scribble in the tester book before anyone sees.

10 Rue du Pont Louis-Philippe, 4th; tel. 01 42 74 57 68

Moeti

Cute cards

If you're one of those people who's always looking for the right card to give friends for special occasions, then search out this sweet little place on the Rue Dauphine in the 6th. This vibrant paper and card store is quite different to many of the others in this city. It's a little bit Parisian and a little bit Japanese. You might think the two cultures and their art don't mix, but this store proves they do, with an elegant interior that's both sleek and colorful. But while the interior and its window displays are inviting, it's the cards that are the real draw here. There are boxes and boxes of them, filled with the most divine designs from the likes of Sandrine Fabre, Hérisson, Fifi Mandirac and Claire Fontaine. There are so many beautiful things to choose from that you'll be able to stock up on cards for years and years.

30 Rue Dauphine, 6th; tel. 09 79 72 70 64

Papier +

More, please

It's a fitting name because all you want to do when you walk in this store is order more, more, more. Run by a former book publisher with an eye for color, this shop sells brightly hued, cloth-covered notebooks, scrapbooks and photo albums in shades that are more dazzling than a collection of Sennelier pastels. There are Schiaparelli-pink ones, Kelly green ones, tropical turquoise ones, even tangerine ones, and all come in different sizes and shapes. There are also brightly tinted pencils to match all the flamboyant books and notepads. It's a perfect example of how well the French do color – with confidence and class.

9 Rue du Pont Louis-Philippe, 4th; tel. 01 42 77 70 49; www.papierplus.com

Sennelier

Perfect pigments

Like Charbonnel up the road, Sennelier has been selling art supplies to some of the biggest art names for more than a century. The store was established in 1887 when Gustave Sennelier, who was a chemist by trade, started dabbling in the paint business. Because of his talents as a chemist, his pigments were mixed with precision. It wasn't long before he gained a reputation for making picture-perfect hues. Artists far and wide heard of his meticulously mixed colors and started coming here for their supplies. Many considered his paints and pastels to be the best in Paris. More than a century later, Sennelier is still going, and its pigments are still as luminous (and as famous) as ever. Now managed by Dominique Sennelier, who's the third generation of Senneliers, this shop is wonderful for anyone who's interested in color. Artfully displayed in timber shelves and cabinets are rows and rows of vibrant oils, pastels, watercolors, acrylics, gouaches, inks and, of course, pigments, creating an absolutely dazzling display. There are also beautiful sketchbooks, albums, papers, pencils and brushes, so you can walk out with everything you need to tap into your creative spirit. A temple to artists and their all-important tools, it's a place that all budding Picassos should come to soak up the history and ambience.

3 Quai Voltaire, 7th; tel. 01 42 60 72 15 or 01 42 60 29 38; www.magasinsennelier.com

Whimsical stores

Paris does whimsy like no other city. It's the home of the quirky, the eclectic, the eccentric and the idiosyncratic. Here are a few stores where Parisian whimsy meets natural history, resulting in absolutely beguiling collections that you could easily spend hours poring over.

Claude Nature

Nature remade

Like Deyrolle up the road, Claude Nature is a startling cabinet of curiosities. The idea of devoting a store to taxidermied animals borders on being politically incorrect in many places, but in Paris it's seen as a beautiful thing. The French love their animals, after all, and what better way to pay tribute to them when they're gone than to mount them in stylish frames and put them on the wall? Paris has many of these fabulous *wunderkammer*-style places that cleverly replicate 19th-century curiosity cabinets – from Deyrolle to the Museum of Hunting and Nature – and Claude Nature is another. Even if you're not into the whole taxidermy craze, it's still difficult to resist peering in the windows at the boxed sets of iridescent butterflies. I wanted to take one of the petite white taxidermied chickens home to display in my library, but feared I wouldn't get it through customs. The owner (a former Deyrolle staffer) doesn't speak English, but his enthusiasm is contagious. A collection of beauty and wonder.

32 Boulevard Saint-Germain, 5th; tel. 01 44 07 30 79; www.claudenature.com

Deyrolle

De-lovely

Deyrolle has been variously described as whimsical, fantastical, magical and surreal. I prefer to describe it as a Lewis Carollesque tea party for naturalists, botanists and amateur entomologists. It is, without a doubt, one of the most unusual and beguiling stores in Paris, if not the world. Located in a 19th-century Beaux Art building on Rue du Bac, it's a heavily atmospheric, slightly cluttered and utterly nostalgic establishment that hasn't changed for centuries. To describe it as a taxidermy shop hardly does it justice. It's a veritable *cabinet des curiosités*, a *wunderkammer* of Mother Nature's most glorious creations. There are ancient wooden cases full of butterflies and insects, shells and botanical specimens, stuffed lions, ostriches, zebras, monkeys, elephants, polar bears, and birds galore. It's really a museum masquerading as a store. Even if you're an avid animal lover or have an issue with mounted butterflies (as I sometimes do), you'll still see the value (and magic) in this fabled purveyor of natural history. Truly enchanting. You won't be able to resist.

46 Rue du Bac, 7th; tel. 01 42 22 30 07; www.deyrolle.fr

Vintage and antique stores

All over France you'll see signs saying "brocante," and basically it means anything from a bric-a-brac store to a flea market to an antique store or fair. Originally, the term referred to roving flea market street fairs that sold secondhand goods and antiques, but it has become so popular in recent years (thanks to foreigners) that it has evolved to become a kind of generic word that encompasses stores as well as markets. It is worth noting that brocante *shops vary widely from one to the other. Proper antique stores, or those serious dealers that specialize in high-end period furniture, consider themselves to be a little above the* brocante *fray, and they probably are. (Professional dealers take their antiques very seriously in Europe, and understandably so.) But people still use the umbrella term to describe antique hunting on a weekend. Here are a few vintage, secondhand and antique places that are worth browsing around in. (Note: flea markets are immediately following.)*

CE SAC PEUT CONTENIR votre bol,
vos interrupteurs, sonnette de vélo, **votre bougie**

**VOTRE ... **, vos disques,

vos dés... ...gasse, vos aimants,

VOTRE C... ...houtons, vos torc...on

vostre eye-line..., ...s élastiqu...,

vos brosse... ...on, votre médaille

VOS... ...s, *vos barrettes*,

votre ri... ...e à dents, **vos bas...**

vos ba... ...e, *VOTRE AIDE*,

votreoupons de tissus,

VOTRE C... ...illons, **votre bague...**

... ...e baladeuse,

vos lunettes de... ...re, *VOS ESPOIRS...*

votre pinceau, **votre...** ...ette, votre cravate, *vos r...*

votre cr... ...rpentier, votre tablier,

VOT... ...vos douilles en porcelaine,

... ...e, votre casquette,

... ...ne, votre collier,

votre thermos, vo... ...iques torsadés, *votre mont...*

votre cadeau... *VOTRE AMITIÉ...*

...erci.

PARIS
126

merci

Au Bain Marie

Delicious tableware

The French really know how to create items that are as stylish as they are practical, especially when it comes to tableware. This delicious little store stocks a selection of irresistible offerings, ranging from cute eggcups that you want to use everyday, to 18th-century saltcellars and elegantly rustic, country-style ceramics. It's the kind of place you wander into and don't leave again for the next 20 minutes. Great for gifts as well as enchanting French goods for your own home, it's a real find. There are lots of stores that specialize in unusual, unique, old or sophisticated tableware in Paris, but this would have to be one of the most beguiling. See if you don't emerge laden down with bags of goodies to dress up the table at your next family gathering.

56 Rue de L'Université, 7th; tel. 01 42 71 08 69; www.aubainmarie.fr

Au Bon Usage

Bon chaise longues

I first noticed this cute furniture store in the inner-city village of Saint-Paul when I stayed in the charming hotel opposite for a night and glimpsed its intriguing shopfront from my hotel window. The next morning I bypassed breakfast and headed straight for the store. Specializing in bentwood furniture such as Thonet's famous range, it's filled with some of the most beautiful tables, chairs and decorative objects around. Its owners believe in a back-to-the-roots philosophy and love taking old timber classics and restoring them. They also source some of Europe's best and most authentic 19th- and 20th-century bentwood and vintage timber pieces. Even the store's logo is borrowed from the renowned shape of Thonet's *Chair No. 14*. The highlights, however, are the chaise longues – woven romantic pieces that would look glorious on a classic verandah. Like the timber it sells or restores, this place is simply ravishing.

21 Rue Saint-Paul, 4th; tel. 01 42 78 80 14; www.aubonusage.com

Au Petit Bonheur la Chance

Cute kitchenalia

Part of the charming, rather hidden village of Saint-Paul, between the Marais and the Seine, Au Petit Bonheur la Chance is rather petite and quaint but full of wonderful, quirky things. It's known for its unique kitchenalia, and those with country houses love to come here to pick up antique rolling pins, decorative cafe au lait bowls and other vintage things. (There's something beautiful about mismatching cafe au lait bowls that has everyone buying them with great excitement.) The place is also jam-packed (no pun intended) with jam jars, vintage postcards, old wine labels, faded signs and even old school supplies. And when you're finished here, pop over to Cuisinophilie (nearby at 28 Rue du Bourg Tibourg), which has more lovely stuff for cooks and collectors, including cute milk jars and sweet-as-cake plates.

13 Rue Saint-Paul, 4th; tel. 01 42 74 36 38

Au Progrès

Lock, stock and key

Like the best things in Paris, I stumbled upon this strange store by accident, while wandering the back streets of the 11th one sunny September weekend. I noticed the crowded but intriguing collection of door handles and drawer handles in the window and, wanting something French and frivolous for our newly renovated kitchen, rather cautiously opened the old door and faced the stern woman behind the equally cluttered counter. It's the kind of store that you hesitate to enter, in case you're admonished for something you didn't do, but it's also the kind of store you can't help but enter, because it's so alluring. Since then, I've read a lot about this place in various guidebooks and newspaper articles. It's obviously a much-loved destination for architects and design aficionados. Dating from 1873, the store is filled with shelves and

shelves of amazing vintage and contemporary ironware and handles, from doors to drawers, as well as locks and other mysterious things. Apparently people come from all over, lugging old chests and inherited steamer trunks, to ask the owners to help them find a way in to them. There's nothing these people don't know about locks, you see, especially old ones. It's like a wonderful old hardware store that's been stuck in a time warp for decades. If you're after one of those ornate gold Parisian door handles or some classic French knobs, this is your place. Don't be intimidated. Just open the door.

11 Bis Rue Faidherbe, 11th; tel. 01 43 71 70 61; www.auprogres.net

Higgins

Declassé Art

I love the cheeky tagline that Higgins Vintage has adopted for itself: *"Mobilier Declassée."* Yes, its stock may be vintage and some of the styles may have fallen in status on the furniture social rankings, but that doesn't necessarily mean it's déclassé. Not at all. In fact, most of the furniture in this store has a great deal of class. As far I could see, it's all thoroughly lovely. So lovely, in fact, that you could be forgiven for thinking you were in a museum of design. It's a crowded space, but it's also thoughtfully curated, well organized and very well displayed. Overall, pieces are more on the posh side than the shabby chic one, and there are many expensive pieces (I spotted a mirror with a price tag that made me gasp). However, there are also affordable pieces, too. And the location, in the heart of the Marais, means it's easy to pop in as you're mooching around the 4th.

3 Rue de Mauvais Garçon, 4th; tel. 06 11 03 03 73

Le Village Saint-Paul

A colony of vintage lovers

I've spoken about many of the individual stores in this hidden little village, but it's worth wandering through the entire quartier if you have time, because there are bound to be stores that I've missed, stores that have opened or closed down, or simply things you may be interested in that I haven't covered here. The village is essentially a colony of antique and vintage dealers centered around a series of small interlinked courtyards. The trading hours are meant to be 10 am to 7 pm, but some of the dealers keep irregular hours, so you may have to come back later if you find some stores are closed. However, it's so centrally located (right near the Marais and the islands) that it's a lovely detour as you're walking home, or on to somewhere else. Be sure to watch out for stores that specialize in kitchenware and wine gadgets; they're the ones loved by foodies and foreigners.

Rue Saint-Paul, Rue Charlemagne and Quai des Célestins, 4th

Les Curieuses

Curious and curiouser

Could there be any better name for this place? It's the perfect title for this delightful store. Located on Rue Oberkampf, which is becoming a surprisingly stylish little street with some gorgeous florists and vintage stores, Les Curieuses is an ode to inspiration. Owned by architectural associates Bruno Tin and David Gaillard, it has one of the most intelligently chosen collections of vintage furniture and salvaged pieces I've ever seen – and is loved by interior designers, architects, stylists and aesthetes for that reason. It's more difficult than it looks to arrange spaces with old things, and Les Curieuses shows us how it's done. In this beautiful, old, untouched 19th-century atelier, industrial trestle tables are married with polished metal chairs, and steel cabinets sit happily alongside pretty textiles. The owners firmly believe in saving and restoring salvaged pieces, and it's a nice philosophy, but what they also do is show you how you can incorporate them into your spaces (there is also a design service available). Even if you're not into vintage, this place will make you rethink your style. If they didn't call it "Les Curieuses," they could call it "Stuff to Fall in Love With."

4 Rue Oberkampf, 11th; tel. 01 47 00 97 65; www.lescurieuses.com

L'œil du Pélican

Look and ye shall find

This hard-to-pronounce place is located near the Palais Royal, which is fast becoming a haven for vintage places (Didier Ludot and several others have also set up shop on the Palais's arcades). Established by a former accountant who adored old things, it features all sorts of precious pieces, from antique hat blocks to wooden rocking horses, cast-iron rabbit gardens and old industrial files from lawyers' offices. There's even a lovely collection of vintage luggage. Unfortunately, it's only open from Tuesday to Friday (from 11 am to 6:30 pm) and on Saturdays, but it's well worth a peek if you're in the area.

13 Rue Jean-Jacques Rousseau, 1st; tel. 01 40 13 70 00; www.loeildupelican.fr

Mandarine

Luminous beauty

Mandarine is the kind of place you could easily miss as you're wandering through the Village Saint-Paul, which has so many great antique dealers and vintage stores you're likely to feel like a puppy in a dog park. To find it, look for the window full of art deco lights. You'll see it; it's a kind of wonderful silver still life. This store specializes in art deco furniture and lighting from the 1930s to 1940s, but it's the lighting that stands out. These beautiful art deco lamps are the perfect pieces to finish any elegant room. The prices of these luminous beauties can sometimes make you wish you'd been more frugal over the years (so you'd have money for investment pieces such as these). But they're so stunning, they're almost irresistible.

25 Rue Saint-Paul, 4th; tel. 01 42 71 51 45

Pudding

Simply delicious vintage

What a darling shop Pudding is! I'd heard about this place, or more specifically this quartier, from a friend who loves her vintage stores, and so I trekked up here one day to investigate. It's in a quiet, out-of-the-way village, and stumbling upon it is like coming upon a great neighborhood find. The main thoroughfare of this village is Rue Oberkampf, which is actually turning into a hip little street with lots of great cafes and vintage stores. But set off Rue Oberkampf, near the Parmentier Metro, is a cluster of smaller streets and passageways that are just as fascinating. One of them is Rue Ternaux. It's here that you'll find Pudding. Run by Sabine Tucci, it stocks an array of vintage accessories and clothing from various eras, and walking into it is like entering the dressing room of a rich old aunt who hasn't bothered with it for years. I saw gorgeous electric-blue coats, cute little hats, sweet shoes, elegant dresses you could easily wear to the races or parties, chic 1950s sunglasses and even Polaroid cameras. There's also furniture, much of which is just as covetable. Simply adorable. There is also an online Etsy shop – see website below.

24 Rue du Marché Popincourt, 11th; tel. 06 76 12 14 72; www.etsy.com/shop/thepuddingstorevint

Rickshaw

Indian chic

Isn't the name fabulous? Rickshaw Textiles. I adore this shop, which is set in the highly atmospheric Grand Cerf covered arcade – the perfect place for a treasure trove such as this. The first thing you'll notice about it is the vibrant color, which is everywhere, in blankets and bed linen and quilts and throws. It's a medley of the most fantastic shades, the kind that only India can dream up. But then you notice the smaller things – the door handles (also in all different shades and patterns), the old metal advertising signs, the wooden clubs, the mirrors and the lacquered bowls. There are cabinets and even doors for sale. It's a veritable bazaar of gorgeous bargains.

7 Passage du Grand Cerf, 2nd; tel. 01 42 21 41 03; www.rickshaw.fr

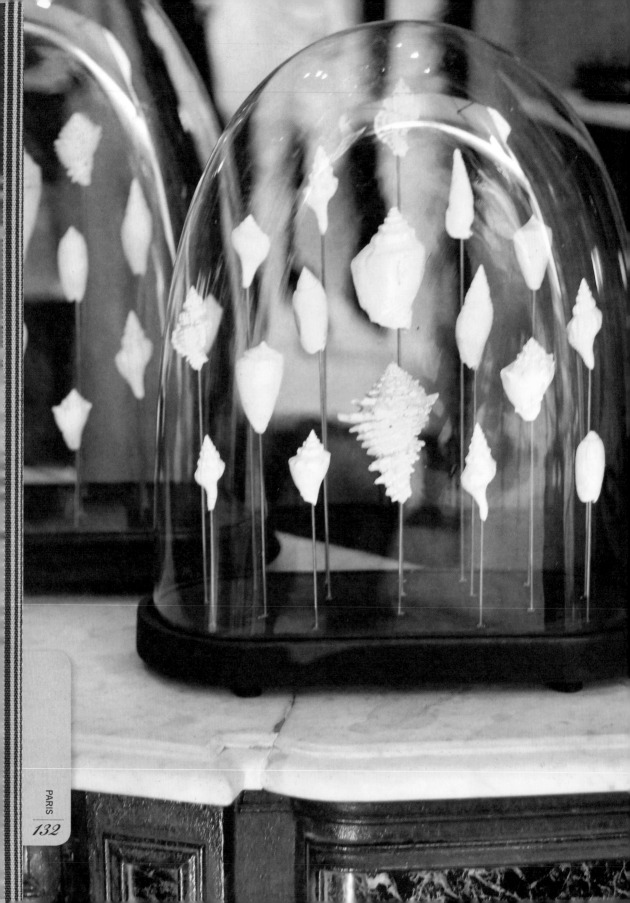

Antique and flea markets

Many tourists fly to Paris just to get up at the crack of dawn in order to scurry to the flea markets in search of a vintage bargain. Paris's flea markets are legendary, and rightly so. Some of the world's best secondhand, vintage and antique goods can be found here, and at prices far lower than elsewhere in the world. The only problem is that you need to be early on the trend curve of a product's life or know what you're looking for – and whether it's a bargain or a splurge – to truly take advantage of these places. For example, years ago when they were less popular, it was possible to pick up vintage Louis Vuitton steamer trunks for $1,000 or less; now they're $8,000 and up. But there are still great buys in abundance. Hunt and ye shall find.

Brocante de la Rue de Bretagne

Mooching the rues

One of the city's most authentic *brocantes*, and the favored Paris *brocante* for many foreigners, this flea market is now held twice a year, in June and November. It's set on and around the Rue de Bretagne in the Haut Marais, including the streets around Temple and adjacent arteries. There are professionals and flea market vendors alike, all of whom sell good-quality stock of varying prices. Winter is a particularly lovely time to go, when the atmosphere is festive and both the stall holders and shoppers cheery with seasonal bonhomie. (The Christmas market is generally held the last week in November.)

Rue de Bretagne, 3rd

Le Louvre des Antiquaires

Antique heaven

Located right next to the Louvre, this three-story antique haunt is often overlooked by the design crowd, although I can't imagine why: once you step inside, you realize it's gargantuan. The space actually consists of 250 little rooms, and in each of them is an antique dealer (some more friendly than others; some more wizened and miserable). It's a bit like a museum where you can buy things. There are bouquets of candelabras, cute boule cabinets, precious art, amazing armoires, old tapestries, interesting militaria (think full suits of samurai armor) and just about everything else you could imagine seeing in a museum. It's a great place to wander around for an hour, but if you're going to buy, know your styles and their appropriate prices.

Place du Palais Royal, 1st; tel. 01 42 97 27 27; www.louvre-antiquaires.com

L'Entrepôt

Stately gates and other grand things

If you've just bought your first château (or simply a sizeable manor house in the countryside) and need to furnish it with suitable architectural pieces, then head straight to L'Entrepôt. This rather curious name heralds an even more curious place – a market of extraordinary goods collected by traders with an eye for the grand and the gorgeous. There are spectacular staircases, amazing castle gates, elegant woodwork from stately homes, and enormous libraries and bookcases (just the bookcases: you'll have to buy the first editions yourself). I once spotted a garden pavilion here that I would have loved for our country cottage but then realized it would have been larger than the cottage. It's a magical place that specializes in out-of-the-ordinary and oversized items, particularly classical pieces of extraordinary dimensions. Even if you're not in the market for a staircase, it's still an eye-opening experience.

80 Rue des Rosiers, 20th (Saint-Ouen)

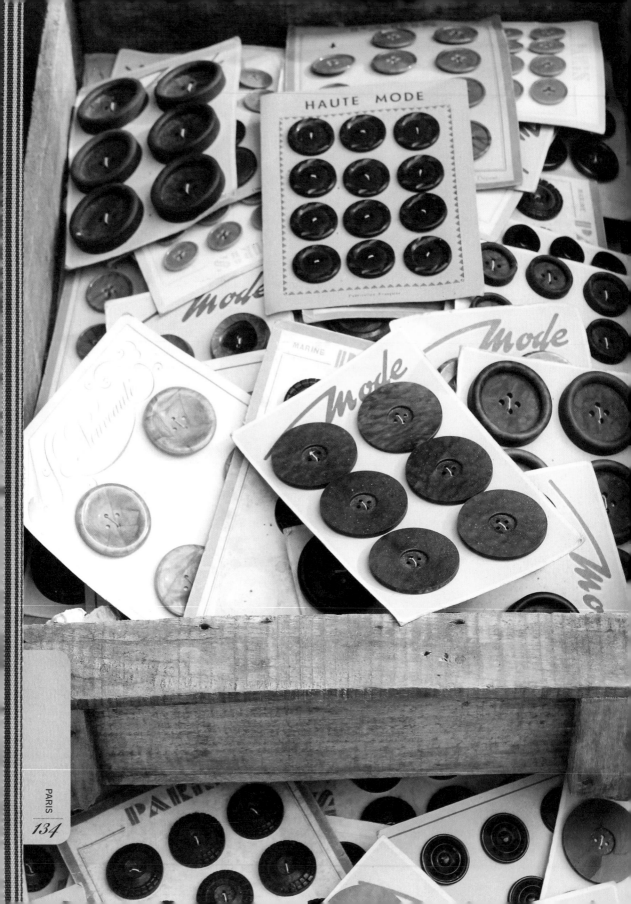

Marché aux Puces de Vanves

Trés fab flea bits

All regular flea market visitors have their favorites. Professionals love Serpette and Paul Bert. Browsers just adore idling through them all. And those who are very keen to snatch a vintage bargain know to head south rather than north, to the Puces de Vanves at the southern edge of Paris in the 14th arrondissement. Here, at sunrise on a Saturday, there are some of the best antique and vintage bargains to be had in Paris – but you need to be quick (or keen) because the best picks go quickly, destined for other stores and locations. Many of the city's upper-class denizens shop here, and you can bet that they know their stock. And there's a lovely atmosphere that is sometimes missing in the other, overcrowded markets: it's full of cheer and characters and good-humored fun. Lots of people prefer it to the more congested Saint-Ouen market.

Avenue Georges-Lafenestre and Avenue Marc-Sangier, 14th

Marché du Livre Ancien et d'Occasion

Secondhand books galore

If you love secondhand and vintage books, with their beautifully aged covers, charming designs and timeless narratives, then head along to this fascinating market underneath the former horse slaughterhouses in the 15th arrondissement. Open on Saturdays and Sundays, it's dedicated solely to antique and used books (*livres d'occasion*) and is frequented by book lovers of all ages and reading inclinations. There are always between 60 and 80 *bouquinistes* (book dealers) who gather here every weekend, and they're always happy for book lovers to browse through their boxes – although ask before you pick up any delicate titles or first editions.

Parc Georges Brassens (under the Pavillon Baltard), 104 Rue Brancion, 15th

Marché Paul Bert

Flea chic

Many designers and decorators love Paul Bert, which is part of the larger Saint-Ouen flea market. It always has some of the best pickings in Paris. It's also renowned for having an eye for what's likely to be fashionable or sold/reproduced in overseas stores the following year. (On my last visit, taxidermied animals, hessian-covered wing chairs and trestle tables were everywhere.) Because of this visionary talent for vintage things, some of the world's most famous interior decorators and designers come to Paul Bert regularly in search of The Next Hot Thing – or something that is simply fab, full stop. Unfortunately, its popularity means it's often a) crowded on Saturday mornings and b) had the best bits plucked out of it before you get there. But these things shouldn't prevent you from going. Just go very early on weekends and know what you're looking for, and you'll have every chance to find the perfect buy. And while you're in the area, don't miss Rue Paul Bert and three enchanting houses at No. 8, No. 10 and No. 14 that house lovely antique stores. (I love the all-black shop at No. 14.)

18 Rue Paul Bert and 96 Rue des Rosiers, 20th (Saint-Ouen); Paulbert.french-antique-dealers.com

Marché Saint-Ouen

The Queen of flea

Although it's formally known as Le Marché aux Puces de Saint-Ouen, or Les Puces de Saint-Ouen, Parisians simply call it Les Puces. At more than 17 acres in size, this is the world's largest flea market, and it has a well-deserved reputation for quality goods. It's really a collection of more than a dozen smaller flea and vintage/antique markets, including Paul Bert (see earlier entry), and the 3000 or so open-air stalls can feel overwhelming for the first-time visitor without a map or directions at hand. But don't let that put you off: the best thing here is to simply get lost. You can always find the Porte de Clignancourt railway station again at the end of the day. There's everything you could possibly want here and things you don't but end up buying anyway, from vintage clothing to taxidermy collections. Monday is traditionally the best day for bargain seekers because attendance is smaller and merchants want to sell the stock to make way for more the following weekend.

Avenue de la Porte Montmartre, 20th

Marché Serpette

Superb antiques

Another much-loved market at the Saint-Ouen camp of traders, Serpette is conveniently located near Paul Bert, so you can do both in one go. It's regarded as one of the best flea markets in Paris, with the most luxurious and often the most original stock. As such, there is an enormous range of gorgeous antique and vintage pieces to choose from, including prints, paintings, mirrors, antique luggage, art deco furniture and hardware, kitchen goods and clothes. I love the armchairs, with their ripped edges and hessian/burlap underclothes. Bill Gates of Microsoft comes here (he obviously loves a bargain as much as the next antique hunter), so you know it has good stock. Don't forget to rummage through the corners, too. I've found adorable footstools and lovely garden chairs that were missed by the rampaging crowds.

110 Rue des Rosiers, 20th (Saint-Ouen)

Arcades and covered passages

The city's glorious passages and arcades offer a delightful glimpse into a past way of life, when shopping was leisurely and glamorous. These covered passageways retain most of their original architecture, ornate ceilings and charming facades, and although the shops have changed from those that were here a century ago, the ambiance is still the same. Don't go to Paris without visiting at least one of these.

Galerie Vivienne

Oh, Vivienne!

The Kate Moss of Paris's covered arcades and passageways, Galerie Vivienne is cute, everyone loves it and it never goes out of style. It's certainly more popular than its twin Galerie Colbert next door, which has gorgeous architecture but is seemingly devoid of personality. The Galerie Vivienne is defined by its spectacular mosaic floor, which is one of the prettiest in Paris. But the floor isn't the only lovely thing about this place. Its sense of aesthetics and design extends right through the arcade. Jean Paul Gaultier loved it so much he set up shop here. There are two bookstores on the corner trading in old books and postcards, a divine modern art gallery opposite them called Martine Moisan, a fabulous florist and a fine wine store called Legrand Filles and Fils. There's also a lovely, well-known tea salon called A Priori Thé, and even a bistro, Bistro Vivienne, should you wish to have lunch and a glass of something wicked before you continue on your way.

4 Rue des Petits-Champs, 6 Rue Vivienne and 5 Rue de la Banque, 2nd; www.galerie-vivienne.com

Passage du Grand Cerf

Deer-lightful

Passage du Grand Cerf (curiously the name means "The Big Deer") is located in the neighborhood of Montorgueil, so you can easily pop by here after you've wandered through the gourmet shops and food markets of Rue Montorgueil nearby. Unlike some of the arcades in Paris, which have an air of decaying grandeur about them, this passage has been completely and expertly renovated, and is as beautiful as the year it was built (1825). It's famous for its 325-foot-long, glass-roofed arcade and 40-foot-high windows, which are among the tallest in Paris, but its shops are just as mesmerizing. There is a firm emphasis on creation and innovation here, and the traders are a little different from the normal antique- and book-dealing set. There are 20 or so boutiques in all, so you could easily wander for an hour or two. There's a terribly cute pink space called La Parisette that deals in whimsical, girly things, stores that offer glorious fabrics, shops that restore homewares, boutiques that deal in jewelery and others that sell Indian- and African-inspired objects and design. There's even a furniture shop where I found cute French door handles to pretty up the kitchen of our country cottage. Essentially, it's a showcase for young designers selling original pieces. In May and October, the passage and surrounding neighborhood hosts Les Puces du Design, a kind of upscale market selling furniture from the 1960s and 1970s.

145 Rue Saint-Denis and 8 Rue Dussoubs, 2nd; www.passagedugrandcerf.com

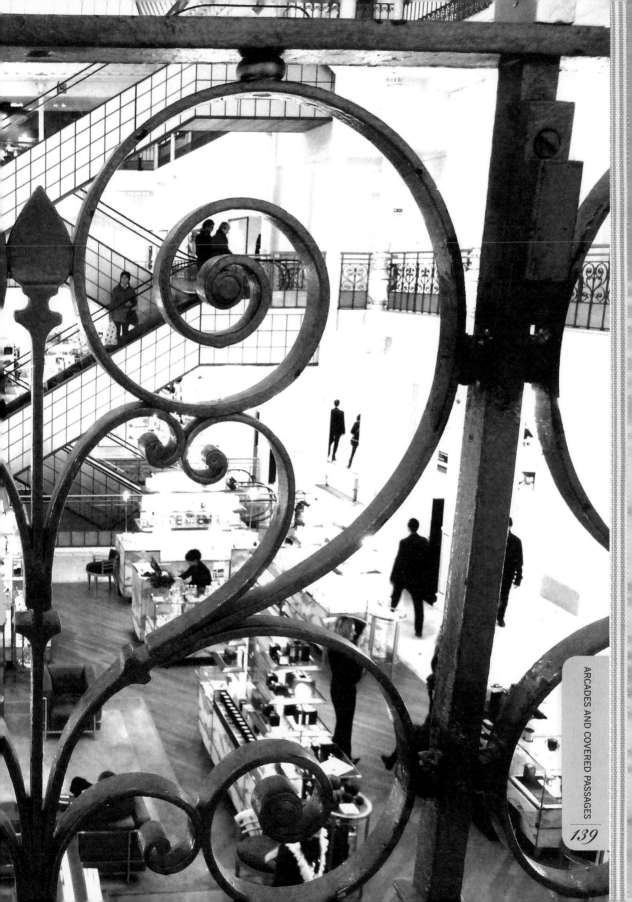

Passage Jouffroy

Joy in an arcade

Passage Jouffroy (even the name is uplifting) is a charming covered passageway. First opened in 1846, it is an extension of Passage des Panoramas, so you can idle through both at once. The first storekeepers to occupy its quaint interior were secondhand booksellers. These were later joined by toysellers. Now, there's a glorious mix of both, making it a great place to take kids. Don't miss Inter-Livres, which has a good selection of discounted art books, and Pains d'Épice, which has marvelous antique toys. There is Cinédoc, a fab store stocking film books for cinephiles, and a shop selling every conceivable fitting and furnishing for doll's houses. And if you're into fabrics, don't miss Au Bonheur des Dames, at No. 39, which sells enthralling embroidery.

12 Boulevard Montmartre, 9th

Passage Verdeau

Verd-iful

Set across from Passage Jouffroy, this lovely, old, character-filled covered passageway dates from 1848 and offers a wonderful mix of antique and intriguing shops beneath its glorious 19th-century architecture. Its proximity to the Drouot auction house means it has become somewhat livelier than some of the other Parisian passageways, but that has only increased its charm and the strength of its businesses. It's a particularly good stop for those who like rare books, antique postcards and prints, old photographic equipment and other lovely visual things. There's a marvelous photography shop that restores and sells old and new photographs and cameras, beautifully atmospheric bookstores specializing in antique titles, a gallery/store selling enchanting engravings and a gorgeous boutique that trades in old newspapers, almanacs and postcards. And after you've finished, you can indulge in a proper Parisian tea in the cafe. Passage Jouffroy continues on the other side of the boulevard, and Passage des Panoramas is nearby for continued shopping opps.

4–6 Rue de la Grange Batelière, 9th

Design, homewares and decorating stores

Paris has no shortage of design and decorating stores. The city has always been obsessed with great design and style, even before Baron Haussmann was commissioned to redesign the place and its architecture and boulevards. Over the last couple of years, however, the concept of the home and design store has changed dramatically. A great many shops no longer confine themselves to one retail genre but choose to be hybrids, mixing home stores with florist shops, bookstores, cafes and restaurants. Even fashion boutiques have expanded to become "concept and lifestyle spaces" (à la Merci and Colette). Museums and galleries, meanwhile, have also jumped on board the hybrid bandwagon by introducing in-store shops that double as design stores, bookstores, exhibition spaces, creative boutiques or even publishing houses. It's all part of the ever-evolving creativity that thrives in this wonderful city.

Astier de Villatte

Simply exquisite

This unusual, age-worn store is housed in an old atelier that was once home to Napoleon's silversmith. But rather than ripping out all the old walls and the creaky timber staircase, the owners decided to embrace the history, retain the beautifully worn patina of the shelves and fixtures and the building's general air of faded grandeur and refit the new shop around it. As such, Astier de Villatte's interior is just as appealing as its stock. And the interior highlights the beauty of the wares, which also have a kind of imperfect perfection to them. Astier de Villatte produces its own range of handmade terracotta tableware, glazed in the company's signature milky finish, and using a technique that leaves deliberate imperfections on the surface, which adds to the charm of the pieces. Each plate, bowl or platter is like something you'd find in a glorious old farmhouse in the country, handed down from generation to generation. They're much more appealing than many of the factory-made pieces released on the market today that all look the same. The vintage-style designs, which range from soup tureens to unusual urns, are inspired by 18th- and 19th-century tableware and are a little different from anything else on the market. Not surprisingly, they've been popular ever since the store opened its doors. It is one of the most amazing shops in Paris and cute as a macaron, too.

173 Rue Saint-Honoré, 1st; tel. 01 42 60 74 13; www.astierdevillatte.com

Baccarat

Crystal thrills

Many designers love Baccarat, as much for its shimmering displays of glass and glamour as for its elegant restaurant. This spectacular mansion on Place des États-Unis was the former home of art patron Viscountess Marie-Laure de Noailles, a hostess with the mostess noted for her parties (guests included artists Man Ray, Jean Cocteau and Salvador Dalí). These days it's the stunning backdrop for Baccarat's gorgeous goods. Against the eye-poppingly beautiful interior created by celebrity designer Philippe Starck are some of the most fabulous exhibits in France: a 6-foot-high glass chair, a crystal chandelier sunk in an aquarium of water, "talking" Baccarat vases and Russian Tsar Nicholas II's candelabra. There is also a restaurant called the Cristal Room, which is worth the price of the dishes on the menu just to see the dazzling decor. Glittering, glamorous and very French, as only the French can do.

11 Place des Etats-Unis, 16th; www.baccarat.com

BHV

Be still my beating heart

Visiting BHV is almost a religious experience, particularly if you're into building design and architectural hardware. Short for Bazaar de l'Hôtel de Ville, BHV (pronounced "bay-ahsh-vay" if you need to ask someone the way) has a basement level filled to the cornices with everything you could want to address, or "dress," the architecture and interior of your home, whether it's a tiny *pied-a-terré* garret on the top floor or a grand, high-ceilinged Haussmann apartment on the coveted second level. As such, it's where all the well-dressed denizens of the city buy their bricolage (isn't that a fabulous word?), including all those gold door knockers, blue house numbers and even ornate, château-sized gold keys used to open the ornate, château-sized gates to those secret courtyards. It's great for unusual gifts or something to smarten up your own modest abode back home. There's also a great selection of office, craft and art supplies on the second floor, where they often give tutorials. And it's conveniently located, right opposite the Hôtel de Ville and near the Marais and the Seine, so you can finish a day of exploring with a purchase or two on your way home. Fight the crowds: it's captivating when you get there.

14 Rue du Temple, 4th; tel. 01 42 74 90 00; www.bhv.fr

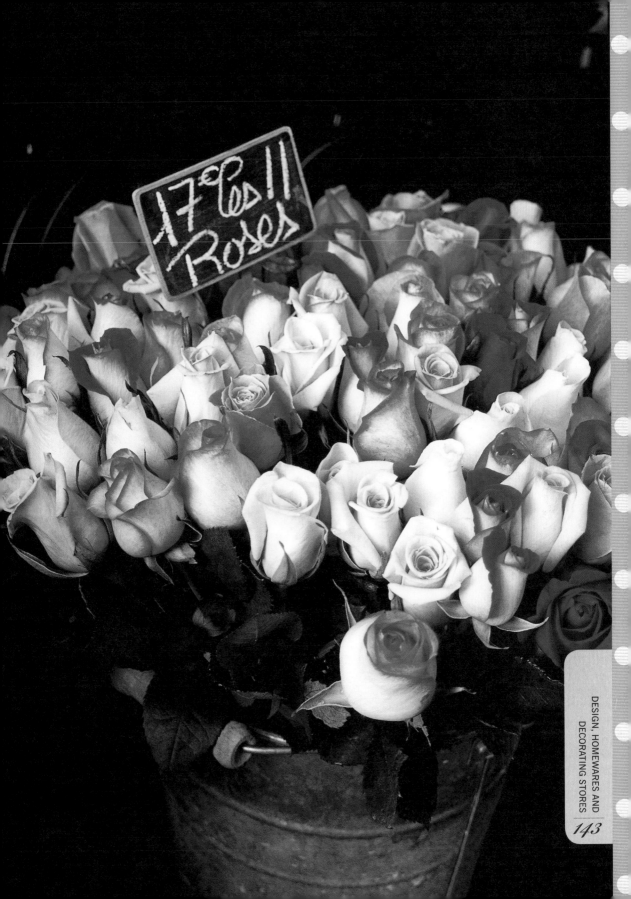

Blanc d'Ivoire

All white on the night

Blanc d'Ivoire is rather canny when it comes to marketing and merchandising. This store sets up its stock as though it's part of a stylish room in a Parisian apartment, so that all you want to do is buy the whole lot and transplant it back to your own home. Of course, Parisians are famous for their love of neutrals (they love quiet, classic, pared-back shades in both fashion and design), and this store epitomizes the Parisian aesthetic. But what it does is take the neutral look to a new level of chic. It's neutral with a modern kick. There are cute wooden trays, painted wooden furniture, armoires and quilts and other gorgeous homewares and accessories in white, cream or neutral tones. Some of it is French-inspired; some of it is more reminiscent of Swedish designs. All of it is lovely. No wonder half the decorating world comes here for their bits and pieces.

104 Rue du Bac, 7th; tel. 01 42 22 87 12 (see website for other stores); www.petitblancdivoire.fr

Carré d'Artistes

Affordable art

Carré d'Artistes is a great concept. It's a group of galleries spread over six cities, including Paris, that stocks original art from leading and up-and-coming artists, and from traditional oils to acrylics to collages. Instead of doing it the old-fashioned way, however, these galleries offer this art in a neat, easy-to-browse, help-yourself way. You simply browse through the selection (all work is original), decide from three different sizes, and debate whether you want matting or not. It's a friendly, affordable way of buying art. (The smallest size is approximately 4 inches square and is less than $100.) Now, some purists poo-poo the idea of a store full of ready-made art. They believe you have to go along to a gallery (where the art is chosen by a subjective curator) and then wait for the exhibition. But the times are a-changing and art needs to keep up. We are all busy. We cannot always go to our favorite galleries. I think this is a marvelous idea. Anything that makes art accessible, and is a way for artists to sell their work, is great. And this is Paris, after all! Art has always been a part of the fabric of life here and should continue to be.

29 Rue Vieille du Temple, 4th; tel. 01 44 61 73 23 (see website for other stores); www.fr.carredartistes.com

Catherine Memmi

Sophisticated minimalism

Catherine Memmi is one of those Parisian interior designers who does monochromatic minimalism so well that she makes me want to get rid of all my clutter and redecorate my house in coolly glamorous shades of black, white, gray, beige and chocolate. Ever since she opened her first shop on the Left Bank in 1993, Memmi has been loved by the city's chic set who go to her and her counterpart Christian Liaigre for all their sexy, low-slung furniture and sophisticated homewares. It's a look that says "modern" but still "sexy." One reviewer called it a French woman's take on Calvin Klein. Catherine Memmi prefers to refer to it as elegant simplicity. It is certainly sophistication with a capital S. And if you can't afford an oak dining table, there are lots of smaller items, including table and bed linens and cashmere throws – much easier to pack in the carry-on bag.

11 Rue Saint-Sulpice, 6th; tel. 01 44 07 02 02; www.catherinememmi.com

Charvet

Where masculine meets maison

Founded in 1838, Charvet claims to be the world's first shirt shop, and it may be true – it certainly seems to have been around for a very long time. What isn't in doubt is that it's dressed a fair few of the world's dandies, celebrities, royalty and other sartorial types in some of the finest shirts around. Now the legendary haberdashery has decided to diversify into fabrics for the home. It's a clever move because Charvet already has a reputation for quality, design and color, so people will inevitably assume the same high values will move across to the maison range. There are all kinds of fabrics to choose from, but perhaps the best collections are

the elegant linens, which come in stunning colors including nougat, lime, gray and pomegranate shades – and all are very affordable.

28 Place Vendôme, 1st; tel. 01 42 60 30 70; www.charvet-editions.fr

Christian Liaigre

Utter luxury, pared back to its essence

Christian Liaigre is the master of minimalism. Like his female counterpart Catherine Memmi, Liaigre designs sharp, sleek, super-contemporary interiors and furniture pieces that are sensual and sexy. Difficult task, I know, but Monsieur Liaigre manages to achieve it with aplomb. He began his distinguished career by persuading many Parisians to drop their flea market–meets–Louis antiques aesthetic and go for a look that was more austere yet luxurious. Surprisingly, like children following the Pied Piper of Design, they did so with delight, paring back their living spaces until they were fiercely simple – almost monastically so – and then selecting new "statement" pieces from Liaigre's sexy range. A solemn daybed here, a sinuous sofa there – all to create a sense of drama. The look was so effective that more and more people became seduced by Liaigre's style and decorating finesse. Soon, the man was not only being asked to redesign Calvin Klein's apartment, Karl Lagerfeld's house, Rupert Murdoch's triplex and the Mercer Hotel in New York, but copied all over the design world. The result? A new decorating aesthetic, which Liaigre has been largely responsible for. Think black, white and charcoal gray, and spaces that don't so much shriek glamour as murmur it in suggestive tones. There's no doubt about it; the man is a design meister.

42 Rue du Bac, 7th; tel. 01 53 63 33 66; www.christian-liaigre.fr

Cire Trudon

Couture candles

Imagine ordering your own signature candles in one of your top-10 favorite scents. Would you choose the smell of vintage paperbacks in a secondhand bookstore? Or the aroma of wet roses on a summer's morning? Or perhaps the scent of your partner's neck when they say good bye to you at the airport? (Although I'm not quite sure how they'd condense this down into scent form.) Whatever your desire, Cire Trudon will be able to create it for you. They will also put it into a candle, ready for you to light up and scent the room at any time. This curious company has been doing it for centuries, you see, and for picky French fashion houses such as Guerlain, Hermès and Dior, so not only do they know what they're doing, but also there's no scent they haven't come across before. Except, perhaps, your boyfriend's sweaty neck. All you do is specify the color, shape, size and scent of your custom candle, and they'll make it to order. Or, if that's too difficult, they'll bring out one of their own predesigned models, which also smell divine.

78 Rue de Seine, 6th; tel. 01 43 26 46 50; www.ciretrudon.com

Colette

Style pioneer

Colette is edgy, there's no doubt about it. Some may smirk at the Water Bar; others may shake their heads at the wall of running shoes displayed like a mini gallery of art; and still others may question the relevance of it all. But whatever you think of it, there's no doubt Colette has broken new ground in the retail world, and continues to do so, even as competitors spring up around it. Established in 1997, this unique emporium was one of the first concept stores in the world and was an immediate hit with the global hipoisie for its cutting-edge products and visionary style. Some designers and stylists still fly in and come straight here before checking in to their hotel in order to feel the pulse of Paris style. The store's philosophy is to showcase the new, the hip, the very hip and the too-hip-to-touch in fashion, high tech and lifestyle, and does it all through merchandising that is, well, edgier than edgy. There are beauty products from Kiehl's and Nars displayed alongside unique homewares and Leica cameras. There are clothes by Pucci, Marni, Lucien Pellat-Finet and Veronique Branquinho, and tables full of limited-edition books and start-up magazines, along with design must-haves like *Monocle* and all sorts of odd design-ery things. (One day I found a strange brand of Icelandic

soap here.) Some people adore it. Others (like me) are slightly perplexed. But Colette doesn't care what you think. It knows its stock is irreverent but that's what it aims to showcase. You want meaning? Go to the Louvre. It's difficult to resist – even if you're slightly cynical. I don't understand a lot of what's stocked (the selection of books mystifies me, and I've never really been in the market for an avant-garde fashion magazine from Romania), but I'm still sucked in by the sexy merchandising. Every time I walk in I have to refrain from purchasing completely stupid things simply because they look gorgeous and are perfectly displayed. There might be other shrines to design popping up over the globe in the wake of Colette's success, but this store still cuts it sharp.

213 Rue Saint-Honoré, 1st; tel. 01 55 35 33 90; www.colette.fr

Diptyque

Delicious wicks

Diptyque was one of the first to do beautifully scented candles in beautifully dressed packaging, and although other companies have since emulated the designs, this French brand still produces some of the best. Although Diptyque's scented candles are available elsewhere in the world, it's worth stocking up in Paris since everything is cheaper here. Figuier (fig) is the bestselling fragrance, but Pomander is also popular.

34 Boulevard Saint-Germain, 5th; tel. 01 43 26 77 44; www.diptyque.tm.fr

Dominique Kieffer

Natural selection

Dominique Kieffer's witty tagline is "*Broderie Captivante.*" Doesn't that sound fabulous? And she does create captivating fabric. Kieffer is known as the queen of linen – and other fabrics for that matter. Her original textiles are all created using natural fibers, linen and silk and are some of the most beautiful fabrics you could want for your home, particularly if you're into that neutral French look that pairs subtle palettes with classic textures to create an elegant and timeless interior.

6 Rue de l'Abbaye, 6th; tel. 01 56 81 20 20; www.dominiquekieffer.com

Flamant

Belgian sophistication

Parisians don't use the words "beige" or "gray" to describe beige or gray. After all, this is a city that not only knows its design and style like the back of its leathered glove, but also appreciates a little more definition. Instead, Parisians use synonyms like straw, string, malt, aniseed, camel, champagne and oyster-shell gray. If you want to know the difference between these delicate shades, and how they should be used to define elegance in the home, just go to Flamant. This Belgian company, which seems to be taking over the European design world as much as Sir Terence Conran did in the 1990s, has one of the most stylish stores in Paris. It's tucked away on beautiful Rue de Furstemberg in the 6th, and seems to have taken its design cue from the stately grays and beiges in the architecture outside. Winding over multiple rooms, each set up like a different room in a grand manor house, the store mixes Scandinavian and Provençal influences with the modern Belgian look. Think simple country: rustic, yet quietly sophisticated. Each room will tempt you with inviting wooden dining tables, vintage-style leather club chairs, gorgeous linens and cute flea market finds, such as old-fashioned toys, baskets and even leather rugby balls. There is also a cafe, a garden room and a paint room, where custom colors are blended. Although the company has branches all over Europe, including two in Paris, this is undoubtedly one of the best stores. Go and be seduced.

8 Place de Furstemberg, 6th; tel. 01 56 81 12 40; www.flamant.com

Goyard

Picnic chic

Well-known for its luggage, Goyard has now opened a very cute *salon de chien*, a boutique devoted to accessories for pets and picnics. What, you may think, have pets and picnics got to do with cases and travel? Well, the same kind of detailed craftsmanship that goes into beautiful luggage translates well to picnic baskets. You can easily imagine these beautifully solid picnic cases at Ascot, Wimbledon, the Melbourne Cup or any F. Scott Fitzgerald–esque summer soirée in the south of France. And as for pets, don't they deserve lovely carriers, baskets and beds? Once you enter this enthralling store you realize why Goyard has taken the step: the idea is marvelous. What's more, the interior is as adorable as any Cavalier King Charles spaniel, with canine wallpaper and mahogany panels. You may find yourself tempted to pick up a divine diamanté dog collar and a straw picnic basket (complete with crystal glasses), and begin planning your next weekend in the country, even if you don't have a spaniel to take.

352 Rue Saint-Honoré, 1st; tel. 01 55 04 72 60; www.goyard.com

Images & Portraits

Photos to cherish

As slender as a photograph but as interesting as an Annie Leibovitz portrait, Images & Portraits is owned by a former Paris- and New York–based photojournalist, and as you would expect, it's a photographer's dream. Full of vintage cameras and boxes and boxes of old black-and-white photographs for sale, many revealing the glamour of earlier eras, it's the kind of place you can spend an hour browsing through the monochromatic memories of other travelers, other families, other times. Flick through the wardrobes of wealthy women traveling the world in the 1930s, their steamer trunks full of gloves and gowns. Smile at moustached men on safari in Africa in the 1920s, their guns as big as their egos. And be moved by the portraits of Edwardian children from the turn of the century, perhaps the most poignant and touching of all. Any of these images would look beautiful framed in a library, Ralph Lauren–style. An adventure through photos, this store is great for a rummage to raise the spirits and kick-start the inspiration again. It makes you remember why you fell in love with photography in the first place.

35-37 Rue Charlot, 3rd; tel. 06 65 23 95 03

India Mahdavi

Fine interior design

Since she left Christian Liaigre and went solo, India Mahdavi has established herself as one of the world's most-watched design names. She has been asked to design interiors and/or furniture for the Hotel on Rivington in New York, the Joseph store in London and various rising hoteliers in Miami, among other clients. And her transformation of the Coburg bar in London's Connaught hotel raised eyebrows in the design world – in a good way. Her limited-edition furniture is as sleek as Liaigre's but has its own distinct style. The *New York Times* described her graphic, whimsical and lacquered pieces as sexy and chic – "sensual shapes done with masculine materials."

3 Rue Las Cases, 7th; tel. 01 45 55 67 67; www.indiamahdavi.com

La Cabane de l'Ours

American-style rusticity

This place has the feel of a rustic cabin in New Mexico or Montana, which immediately sets it apart from the hundreds of toile-and-Louis stores in this city. Think of it as an outpost of America, with a firm US-of-A feel (although there are European textiles, furniture and objects as well). Specializing in bespoke pieces made from iron and recycled timber, it features funky benches carved from horn and cow's hide, furniture made from raw pine, armchairs created from tree trunks and Navajo-style rugs and cushions, plus many other restored or restyled antique pieces, American flags, rustic frames and mirrors and wooden folk carvings.

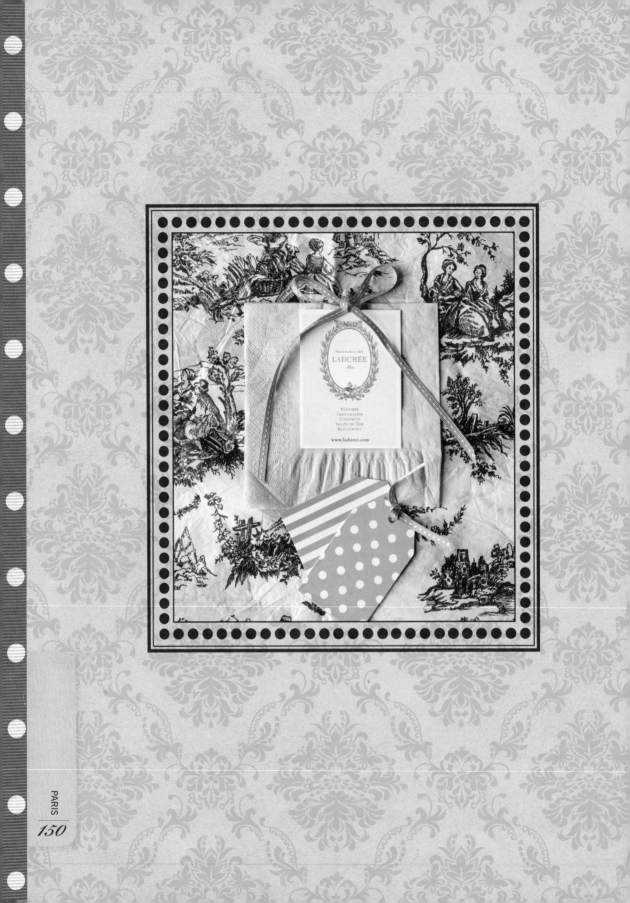

The creation of journalist Patricia Fontaine and costume designer and decorator Nicolas Harlé, La Cabane is as much about authentic craftsmanship as it is simple and beautiful aesthetics. I loved the Hudson Bay blankets. Thoroughly unique pieces.

23 Rue Saint-Paul, 4th; tel. 01 42 71 01 49; www.lacabanedelours.com

Le Bon Marché

Bon pieces for the bon vivant

The historic Gustave Eiffel–designed Le Bon Marché is sometimes referred to as the most beautiful department store in the world. It's owned by LVMH, those stylish people who also own Louis Vuitton, so you can imagine how chic this emporium is. Part of its appeal comes from the spectacular glass architecture designed by Monsieur Eiffel and his partner Louis-Charles Boileau. The highlight is the central hall, a magnificent space topped by an ornate ceiling that makes most first-time Bon Marchérs lift their heads and gasp. Then there are the exquisite wares found within. There are so many beautiful things here, from Louis Vuitton (there is a boutique here) to Chanel stilettos, Maison Martin Margiela clothes and even Repetto ballet flats. But perhaps the most interesting part is the newly refurbished homewares and design level, a visually rich floor full of fabulous French furniture, lots of cute stationery and a calm, quiet, inviting book section that is almost like a store in itself (it's a welcome respite from the wonderful but sometimes crowded La Grande Épicerie food hall down below).

24 Rue de Sèvres, 7th; tel. 01 44 39 80 00; www.lebonmarche.com

Le Petit Atelier de Paris

Petit gifts

This is possibly one of the cutest shops in Paris. The store is gorgeous, the wrapping is even more adorable (think crumpled brown paper and string ties) and the selection in store so fantastic you won't know what to buy first. I love the Shaker-style wooden boxes, but the beautiful handmade ceramics are just as enchanting. It's also fantastic for gifts, and not just because of the packaging. Personally, I can't bear to part with things I buy from here – the last was a *petit déjeuner* set comprising a delightful bowl and mug that fits neatly into a small tray – but if you need a thoughtful gift for your mother/sister/BFF/boss, then head straight to this place. Simply sublime.

31 Rue Montmorency, 3rd; tel. 01 44 54 91 40; www.lepetitatelierdeparis.com

Les Fleurs

Small pleasures

This charming boutique has established a firm following on the Internet – its online store is a portal to a pleasure trove of pretty things, many of them handmade pieces. The street store is just as sweet, a divine place full of feminine beauty and unique accessories. There are candles, cushions, postcards, kitchen things, calendars and diaries, floral accessories and jewelery galore. However, be sure to check the address before going as the business has recently expanded and changed location.

6 Passage Josset, 11th; tel. 01 43 55 12 94; www.boutiquelesfleurs.typepad.com

L'œil Ouvert

Picture-perfect

The first thing that attracted me to this store, which I found as I was wandering around the Marais one day, was the spectacular photographs in the window. There was one of a native woman in Africa, her splendid headdress as elegant as her face, and another of a zebra beneath a tree, with a black-and-white striped wing armchair beside it. They were the kinds of shots you only see in magazines like *National Geographic* or

American *Vogue* (I'm still not sure if the wingchair was part of a styled fashion photo or not). Curiosity piqued, I had to go in. I was not disappointed. This store deals in superb photographs and art, ranging from the most beautiful black-and-white prints of old India during the colonial days to exotic shots of African safari camps in the 1920s. There are more modern images, of course, including fashion shoots and urban scenes, but it was these travel photographs that really stood out. And the staff was lovely.

74 Rue François Miron, 4th; tel. 01 83 62 05 86; www.loeilouvert.com

Maison de Famille

Magnificent things for la maison

Few things matter more to Parisians than the way they live their lives, and this includes their homes. Style is as integral to them as etiquette and charm, and there is a certain *qualité de vie* in everything they do: an obsessive perfection with not only *la bonne table* but also *le bonne salon, le bonne boudoir, la bonne salle de bains* and even *le bonne toilette*. It doesn't matter whether their taste veers toward luxury and glamour or bohemianism and art: if something's not positioned correctly, it can make them physically ill. Maison de Famille is testament to French people's fixation with their homes. It is a showroom of taste where even the candles and rugs seem to have been artfully placed. Many people love this company, which has several stores, and it's easy to see why. Everything looks effortlessly elegant; it's not excessive or over-the-top but is just right for the modern abode. There are sleek four-poster beds in rich chocolate shades, simple armoires in textured wood, stylish silver lamps, lovely textiles and other hard-to-resist bits and pieces. The color palette is the same muted, neutral one that Catherine Memmi and many other French designers and consumers love so much. But it all works together beautifully.

10 Place de la Madeleine, 8th, and 29 Rue Saint-Sulpice, 6th; tel. 01 53 45 82 00 and 01 40 46 97 47; www.maisondefamille.fr

Merci

Thank you, Merci

Ah, Merci. It's a concept store, but geographically and aesthetically it's about as far as you can get from Colette, which I find to be a little too minimalist. A huge, converted, 5000-square-foot showroom, Merci is tucked away on the edge of the Haute (Upper) Marais in an up-and-coming part of Paris, close to another gorgeous store called Les Curieuses. It's part secondhand bookstore/cafe, part interior design store, part craft market, part fashion emporium and part garden. There's also an Annick Goutal laboratory to create your own fragrance, an old-fashioned haberdashery shop stocking buttons, ribbons and zippers and a flower shop by Christian Tortu. It's fun and playful, creative and chic, cheeky and whimsical. There's also a little of the eclectic, the vintage, the handmade and the unusual. All in all, it's so different and so beautiful it's difficult to know where to look first. Brands stocked include Chloé, Marni, Paul & Joe, Stella McCartney, Christian Tortu and YSL, while much of the furniture and home goods are custom-made. And when you've finished shopping for furniture, gardening and cooking accessories, ribbons, fragrance, chairs, Martin Margiela decals and clothes, you can rest with a coffee in the New York–style bookstore-cafe, where most of the books are second-hand but look as good as new. Merci, we love you.

111 Boulevard Beaumarchais, 3rd; tel. 01 42 77 00 33

Palais Furst

The prince of gardening

The Prince de Broglie is known for his Loire Valley château, the Château de la Bourdaisiére, and the garden of tomatoes he grows there (showcased at an incredible tomato festival each year). He's also known for his style and taste – and not just in vegetables. Having operated a swish gardening store, the Prince Jardinier in the Palais Royal arcades (now sadly closed), and resurrected the famous taxidermy store, Deyrolle, he has now branched out with his latest offering, Palais Furst. This delightful space on Rue de Furstemberg opened in January 2010 and is as lovely as the prince's other creations. It has been called a *wunderkammer*, or

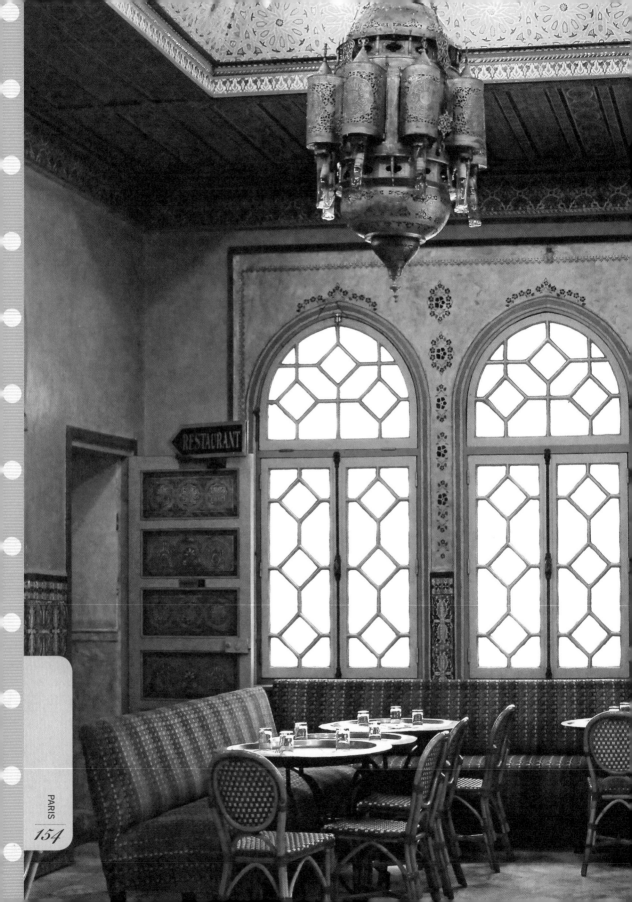

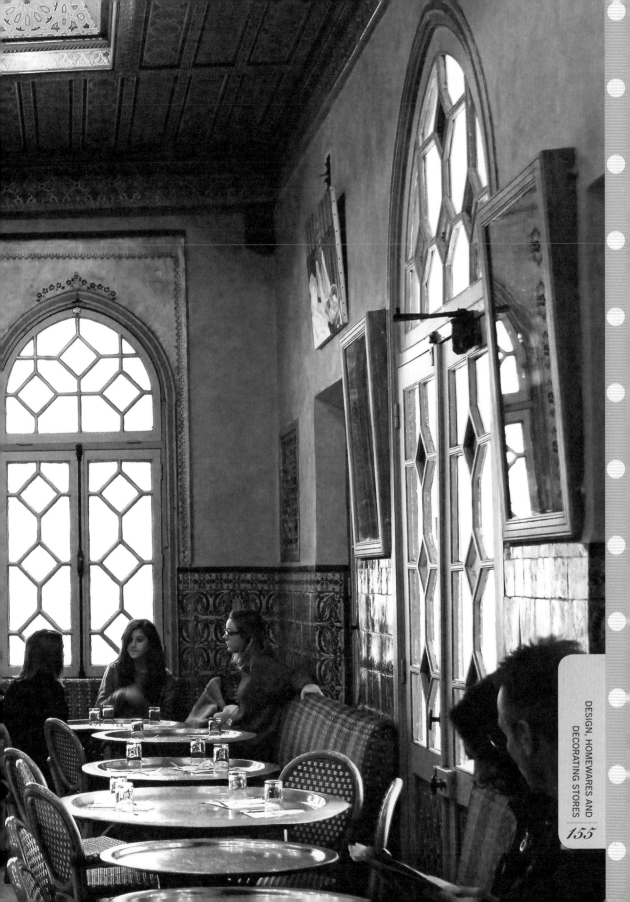

cabinet of curiosities, and it is similar to Deyrolle in that it's filled with extraordinary and unique things. Even the building that houses it has a wonderful provenance: it was once the home of artist Eugène Delacroix and then later the studio of noted Parisian decorator Madeleine Castaing. Today it's filled to the brim with glorious garden and homewares pieces, although its stock is so beautiful you almost want to avoid taking it out into the dirt and rain and cobwebby corners of your own grubby backyard. Unfortunately, it's only open by appointment, but that shouldn't deter you. All good things are worth the adventure.

6 Rue de Furstenberg, 6th; tel. 01 55 42 98 81

Pierre Frey

Pretty in pink

One of the best sources for seriously sophisticated textiles, Pierre Frey is the first name on many Parisian madames' lips when it comes to redoing their second-floor *maisons* (which are always the biggest apartments in Paris, next to the penthouses). The showrooms are filled with lush patterns and rich textures, and the fuchsia pink designs are particularly popular with ladies of the 6th. Just ravishing.

2 Rue de Furstenberg, 6th; tel. 01 46 33 73 00 (see website for other stores); www.pierrefrey.com

Roche Bobois

Where fashion meets the home

One of the first things you notice when you enter Roche Bobois is the enormous, blue-and-white Breton stripe–style rug by designer Jean Paul Gaultier covering much of the floor. It's paired with a whimsical button-and-stripe sofa that's lower slung than a pair of Eminem's pants. The collection, by Gaultier, epitomizes the forward-thinking attitude of this highly regarded company, which started as an interior specialist but is fast morphing into a gallery of great design. Dubbing itself as a place "where design never takes itself too seriously," Roche Bobois is a space where fashion and interiors combine in an explosion of style. Gaultier, with his distinctive pieces done in classic French patterns, is just one of the names represented; other design talent includes Sacha Lakic, Christophe Delcourt and Vladimir Kagan. It's surprising how the collections of chicer-than-chic white furniture sit so well against vintage-style cabinets and industrial-style trestle tables, but they do.

207 Boulevard Saint-Germain, 7th; www.roche-bobois.com

Rue Hérold

Unique fabrics for wearing and living

Named for the street it sits on in the prestigious 1st arrondissement, this stylish store sells remarkable fabrics. And for a city that's famous for its fabrics, that's saying something. Launched by interior designer Charlotte de la Grandière, Rue's speciality is utter simplicity. Showcased in an ample, sleek space painted matte white, the home and fashion fabrics will have you oohing and aahing and wondering how you could use them in your own home. The selection encompasses aged linen, rare calico, fine striped wool and cashmere and even paper and cotton fabrics. And they're wrapped in packaging that is as cute as the goods. It's not as expensive as you'd imagine for a store in the 1st, either.

8 Rue Hérold, 1st; tel. 01 42 33 66 56; www.rueherold.com

Sentou

Seriously fun

Sentou loves color. It also loves form, fabric, sculptural shapes and furniture that could almost be described as modern art. All of these wondrously vibrant things come together in this quirky little gem of a store, which is part gallery and part shop. Everything about it is cheery and fun, from the work of Parisian design duo

Tsé & Tsé Associées to the textiles by Maison Georgette, the lamps of Isamu Noguchi, the ceramics by Brigitte de Bazelaire plus furniture and homewares by many other leading and up-and-coming design names.

26 Boulevard Raspail, 7th; tel. 01 45 49 00 05; www.sentou.fr

Talmaris

Smart art

When I heard that this was one of Diane von Furstenberg's favorite places in Paris, it piqued my interest. Then I learned that Tom Ford pops in too, and that was enough to send me running to the 16th! Hidden away in a part of Paris where mainstream tourists rarely go, this exquisite little place dubs itself as the world's smallest department store. Or perhaps that's the smartest? In any case, it's certainly a cute little emporium. Run by the amazing Alain-Paul Ruzé, who spends six months a year traveling the world picking up treasures to bring back to Paris and sell, it's the kind of place where you're never quite sure what you'll find. And that's just how Alain-Paul likes it. One day you're likely to spot an American flag from the 1700s, another a selection of hand-painted plates too precious to use. There are also exquisite Fabergé eggs and Herend porcelain pieces. Most of it is traditional (it *is* in the 16th arrondissement, after all), but it's still beautiful. Enchanting classics.

71 Avenue Mozart, 16th; tel. 01 42 88 20 20; www.talmaris.com

The Collection

Wall art

The Collection is classic Marais: a divine store that deals in whimsy. Located near Christian Lacroix's fantastically designed Hôtel du Petit Moulin, this mini-boutique of all things cute is run by English designer Allison Grant, and adored by stylists, bloggers and decorators from all over. It stocks all kinds of intriguing objects, with the most popular being wallpapers, wall stickers and vinyls. These are not just ordinary products, but spectacular handmade rolls with spectacular patterns by various European artists. (I saw one design featuring a delightful black-and-white image of a pile of white plates stretching to the ceiling – perfect for the wall of a cafe.) There are also silkscreen prints, unusual plates with motifs cut out of them, chunky vases that are great for big armfuls of flowers and even kids' toys. In fact, the whole store is a little like a kids' store for adults. As sweet as a button.

33 Rue de Poitou, 3rd; tel. 01 42 77 04 20; www.thecollection.fr

Florists

Paris is famous for its florists. This is a city that can take a flower and arrange it into a work of art that even Mother Nature would be proud of. Here is a selection of some of the best.

Abacard

Bouquets with an edge

Many Parisians, particularly those who live in the 3rd and 4th arrondissements, nominate this place as their favorite florist in Paris. Tucked away in the Marais, where it seems to complement the visionary stores and funky boutiques nearby, it specializes in contemporary posies. However, they're not so contemporary and edgy that they're merely sticks in a vase, as some florists' posies are. Oh no. These are adorable posies, put together with thought and innovative craftsmanship. The displays are amazing, and the choice of flowers is always eclectic and different. I like to pop in just to see what they've thought of this week.

12 Rue Oberkampf, 11th; tel. 01 47 00 78 80

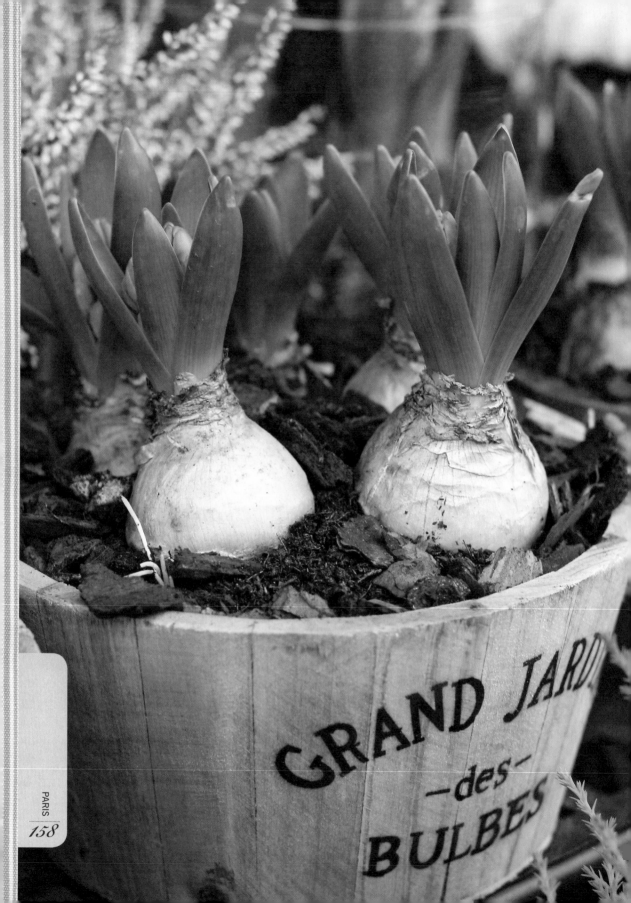

Hervé Gambs

Faux flowers

You may think that fake flowers are tacky and cheap, the preserve of grannies and down-on-their-heels hoteliers who can't afford (or won't pay for) the real thing. But this place proves that faux can be fab. Hervé Gambs is a world-renowned Parisian designer with a background in architecture/textile design. He's taken that experience and opened a florist that is a little different from the other posy people on the Parisian block. Here, the self-titled "plant designer" creates displays that are miniature works of horticultural art. There are arrangements made with (fake) olive branches, fig leaves, pine trees and classic roses, among other things. It's a brilliant idea because you can take your bouquet or display and keep it for as long as you like, and it will never look as terrible as the old silk-flower displays did. You can even get the bouquets sprayed with a fragrance, including one that smells of cut grass in summer. Truly unique.

21 Rue Saint-Sulpice, 6th; tel. 01 70 08 09 08; www.hervegambs.com

Moulié

Pretty picks

Regarded as one of the best classic florists in Paris, this upmarket little boutique, which is set in a delightful square in the 7th arrondissement, supplies perfectly arranged posies to some of the city's fussiest people, including film stars, politicians and stylish businessmen and women in the design and fashion worlds. It chooses the best stems, ranging from bunches of Yves Piaget to Frédéric Mistral roses, and then arranges them in displays that make their recipients gaze upon them for days. There is also a branch at 8 Rue de Bourgogne, in the 7th.

8 Place du Palais-Bourbon, 7th; tel. 01 45 51 78 43; www.mouliefleurs.com

Odorantes

Simply sublime

Celebrities, movie stars, directors, photographers, magazine editors and models all flock to this florist like mosquitoes to a candle lantern on a summer night. It's partly because it's such a beautiful store, designed like a gallery with Dior-gray walls to complement the bright bouquets, but it's also because it specializes in sublime arrangements. Flowers are arranged by scent or color and range from unusual black roses to sweet lavender snow peas. Furthermore, each posy is packaged in sophisticated black paper with a poem tucked inside. No wonder people such as Catherine Deneuve, Sofia Coppola and the fashion houses of Chanel, Givenchy, Gaultier and Céline love it. It's classic Paris.

9 Rue Madame, 6th; tel. 01 42 84 03 00; www.odorantes-paris.com

Vertige

Perfect petals

With a tagline of *"Design et végétal,"* you can tell that this florist is going to be sharp, and it is. In fact, Agathe Braconnier creates flowers in architectural forms that are almost too beautiful to throw away when they begin to wither and go brown. Chosen according to season, the bouquets are arranged by shade and fragrance, and each flower and stem is selected for its beauty and uniqueness. It's like a theatre for Mother Nature.

11 Rue de Sévigné, 4th; tel. 01 42 71 99 38; www.vertigemarais.com

Galleries and museums

Here are some of my favorite galleries and museums to seek out. Remember that many museums in Paris are open on Sundays, when lots of other places are closed, making them a great destination when the rest of the city seems to be sleeping in or doing the family thing.

Arabic World Institute *(Institut du Monde Arabe)*

Arabic chic

This startlingly beautiful building is famous for its extraordinary architecture. Designed by Jean Nouvel and Architecture Studio in 1986 to inspire dialogue, it has certainly done that. People are still talking about it, decades later. The facade is a captivating high-tech design that filters daylight through changing lenses, while the interior features a somewhat transparent floorplan where even the elevators are astonishing. There is also a must-see rooftop terrace that has some of the most magical views in Paris. The institute hosts constantly changing exhibitions, so check the website before you visit Paris to see what's on. Or just wander along and take in the architecture in open-mouthed awe.

1 Rue des Fossés-Saint-Bernard, 5th; tel. 01 40 51 38 38; www.imarabe.org

Architecture and Heritage Museum *(Cité de l'Architecture et du Patrimoine)*

Divine design

Set inside a magnificent space that's a fitting backdrop for the various architectural and design exhibitions that are held here, the Architecture and Heritage Museum is the largest architectural museum in the world. And its location – on a hill overlooking the Seine, with views of Paris in all directions – isn't too shabby either. Though the museum is dedicated to architecture and is a magnet for professionals and amateur enthusiasts alike, it also covers interior and home design, so it's worthwhile if you're a designer, decorator or someone just interested in beautiful spaces. Reopened by President Nicolas Sarkozy in 2007 after a decade-long makeover, it covers 12 spectacular centuries of French architecture. Exhibitions range from a replica of Le Corbusier's mid-20th-century Cité Radieuse in Marseille to buildings from the Middle Ages and modern architecture from far-flung places like New Caledonia in the South Pacific. But one of the best exhibitions is the Elle Décoration Suite, a regular exhibition put on by the museum in collaboration with *Elle Decoration,* the highly respected design and decorating magazine. Each year a new designer is asked to create a suite, and they can also make changes from month to month. In 2010, it was Christian Lacroix's turn. It will be interesting to see who takes the reins in the future. This is a long-term partnership, so you are guaranteed something fabulous every time you come to Paris.

1 Place du Trocadéro, 16th; tel. 01 58 51 52 00; www.citechaillot.fr

Carnavalet Museum *(Musée Carnavalet)*

History with French flair

I can't say enough about this place, which occupies two neighboring mansions in the heart of the Marais. "Stunning" doesn't quite cover it. It is engaging like no other museum or gallery in Paris. Essentially, it's a museum dedicated to the history of Paris, but rather than showing the city's history through dusty old rooms and dull exhibits, it shows them in a way that immediately captivates: through glorious full-sized replicas of rooms (complete with gorgeous interior design) and compelling architectural models and maps of the city as it evolved through the centuries. The history of Paris is literally laid out before you. If you're into interior design or architecture, you'll love it. The miniature-scale architectural models of the city are particularly fascinating. One room is devoted to Louis XVI and his wife Marie Antoinette, another shows a full-sized replica of the beautiful art nouveau Boutique Fouquet, and yet another shows Proust's cork-lined room in which he

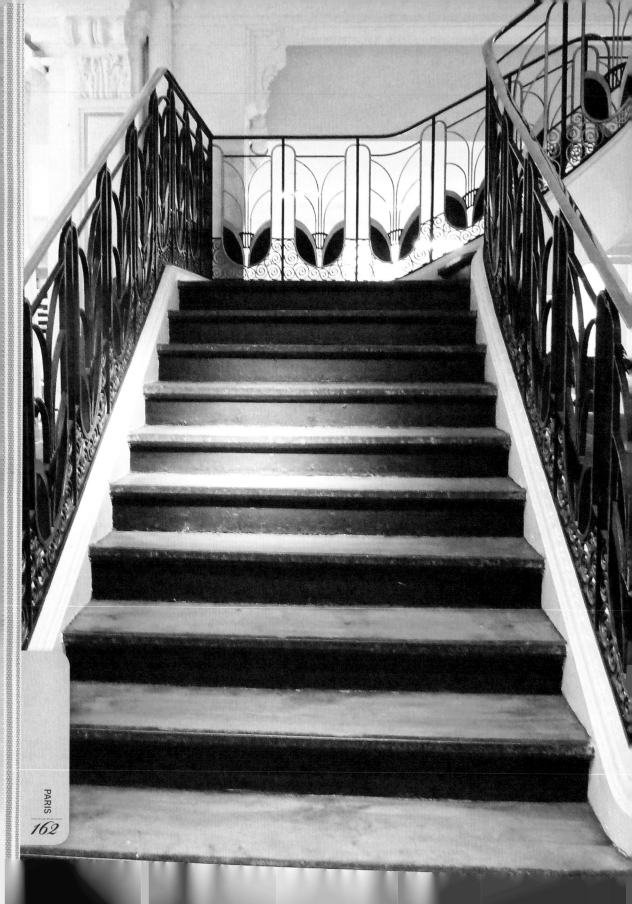

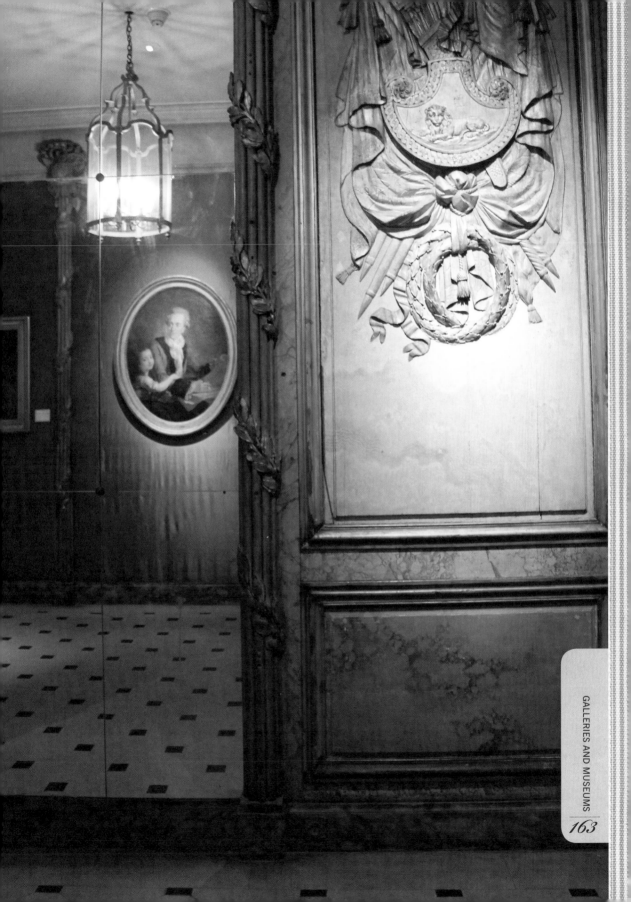

wrote *À la Recherche du Temps Perdus* (*A Remembrance of Things Past*). It's all in French, but there are translation services available, and you don't need to understand a lot of French to comprehend the models, maps and room designs. It's truly inspirational. And when you're finished, there's a delightful monastery-style parterre garden in the inner courtyard, perfect for picnics, and a well-stocked bookstore to browse through. The museum also plays host to interesting exhibitions; at the time of writing, there was a superb one on the history of Louis Vuitton and its travel trunks.

23 Rue de Sévigné, 3rd; tel. 01 44 59 58 58; www.carnavalet.paris.fr

Cluny Museum/National Museum of the Middle Ages *(Musée de Cluny/Musée National du Moyen Age)*

Gothic gorgeousness

A beguiling museum set on top of the remnants of ancient Roman baths (an astounding feat of architecture that you can see as part of the museum's exhibits), the Cluny is a place many people miss on their march through Paris, and that should really be corrected. It's one of the city's gems. Converted into a public museum in 1843 to showcase relics of France's Gothic past, this lovely old mansion (and its 3rd-century Roman foundations) houses an incredible collection of medieval art, artifacts, gold, ivory, antique furnishings, tapestries and other precious pieces from the Middle Ages. It's inspired many authors in its time, including G.K. Chesterton and Herman Melville, who alluded to it in his classic novel *Moby-Dick*. Even if you're not a museum person, you'll be swept up in the history of it all. And don't miss the gorgeous, medieval-style gardens here either.

6 Place Paul Painlevé, 5th; tel. 01 53 73 78 00 or 01 53 73 78 16; www.musee-moyenage.fr

Henri Cartier-Bresson Foundation *(Foundation Henri Cartier-Bresson)*

Iconic imagery

Considered the father of modern photojournalism, Henri Cartier-Bresson was one of France's (and the world's) greatest photographers. This foundation was created to preserve the independence and keep alive the spirit of his work, but it also stages exhibitions of other leading names. (A recent show featured the sublime style of Irving Penn.) Every 2 years, the foundation awards a prize to an up-and-coming photographer in the emerging phase of his or her career whose work comes under the reportage genre. Their images are then shown in the gallery here. All the exhibitions and shows are as respectful as any given to Henri.

2 Impasse Lebouis, 14th; tel. 01 56 80 27 00; www.henricartierbresson.org

Jacquemart-André Museum *(Musée Jacquemart-André)*

A special collection

Located off the tourist track, this sublime, beautifully designed mansion is worth the small trek it takes to get here. Built in the mid-19th century by passionate collectors Edouard André and Nélie Jacquemart, a wealthy couple who loved Italian art, the showpiece residence features pieces by French artists such as Fragonard and Boucher, as well as Dutch and Italian Renaissance paintings. Equally gorgeous is the building's unique architecture. And the cute and rather ornately decorated tea salon/cafe is popular with well-dressed Parisians of a certain age.

158 Boulevard Haussmann, 8th; tel. 01 45 62 11 59; www.musee-jacquemart-andre.com

Museum of Decorative Arts *(Musée des Arts Décoratifs)*

A feast of decoration

Many design aficionados head here before they see anything else in Paris, and it's easy to see why. It's a treasure trove of fabulousness, from fashion to interior design. There are more than 150,000 objects of French craftsmanship and decorative art on rotating display, each chosen carefully to represent the French

"Art of Living." There are collections of wallpaper, stained glass, wood, enamel, plastic, even dollhouses, among other mediums of craftsmanship. One of the most intriguing parts of the museum is a series of 10 period rooms given over to the styles of a specific age. Another beautiful permanent exhibit is Jeanne Lanvin's reconstructed apartment, including her sweet boudoir, *chambre de coucher* and *salle de bain*, all of which were at her apartment at 16 Rue Barbet-de-Jouy. (The black-and-white bathroom is to die for.) And then there's the museum's bookstore, which is a draw in itself. A vast space full of carefully picked design, fashion, art and architecture books, it's so appealing that sometimes I don't even bother entering the museum. Note: the museum's position – just next to the Louvre along Rue du Rivoli – means it's a great stopover as you're wandering home or on the way to somewhere else.

Palais du Louvre, 107 Rue de Rivoli, 1st; tel. 01 44 55 57 50; www.lesartsdecoratifs.fr

Museum of European Photography *(Maison Européenne de la Photographie)*

Photographic pleasures

Devoted entirely to contemporary photography, this museum is tucked away in the Lower Marais and is a fabulous destination for photography lovers. Set inside the beautiful Hôtel Henault de Cantobre, which was built in 1706 and then restored in the 20th century, it is designed around three photographic media: exhibition prints, the printed page and film. While the building itself is a glorious example of classical architecture, with its period ironwork and stunning staircase, the exhibitions showcase the magic that happens when the modern eye meets the modern lens. Past exhibitions have included such inspiring subjects as Irving Penn, Robert Mapplethorpe and *Vogue*. Along with the exhibition center, there's a great photographic library, an auditorium, and even a video-viewing facility with a wide selection of films, so you can discover – or rediscover – the delights of this truly amazing medium. You can't help but leave this place inspired and ready to concentrate on your own photography again.

7 Rue de Fourcy, 4th; tel. 01 44 78 75 00; www.mep-fr.org

Museum of Fashion and Costume *(Musée de la Mode et du Costume)*

A History of Fashion

Also known as Musée Galliera because that's the name of the Renaissance-style palace it's housed in, this wonderfully inspirational museum collects and displays creations that mark the development of fashion through the ages. It has more than 90,000 items of clothing and accessories from the 18th century to the present day, and each year it presents two exhibitions on a specific theme or a single couturier. Sadly, the museum is open only during the temporary exhibitions, but check the Paris tourist magazines and the Internet to see if there's something on when next you visit. Its collection includes Brigitte Bardot's Dior wedding dress, 1930s Chanel wool suits, outfits worn by Princess Grace of Monaco, the Duchess of Windsor and Baronne Hélène de Rothschild and other items by Balmain, Givenchy, Balenciaga and Jean Paul Gaultier. The museum also has thousands of etchings, engravings and fashion photographs, plus jewelery, hats, gloves, parasols and umbrellas.

10 Avenue Pierre Ier de Serbie, 16th; tel. 01 56 52 86 00

Museum of Fashion and Textiles *(Musée de la Mode et du Textile)*

Style archives

Located next to the Louvre, this museum perplexes me. For some reason it doesn't seem as carefully curated as other museums in Paris, and certainly isn't what you'd expect for a city that prides itself on its mastery of fashion. But that's perhaps because its star curator has left to go and manage the Musée de la Mode de la Villa de Paris. Whatever the reason, they need someone with gusto and Diana Vreeland–style drive to come and reorganize this place. Even so, it is worth a pop-in visit. There are regularly changing displays of fashion and textiles, taken from the museum's 19,000 costumes, 38,000 accessories and 31,000 textiles, all of which were formerly housed at the Musée des arts Décoratifs. There is also a collection of amazing personal gifts donated by various couturiers during the 20th century.

107 Rue de Rivoli, 1st; tel. 01 44 55 57 50

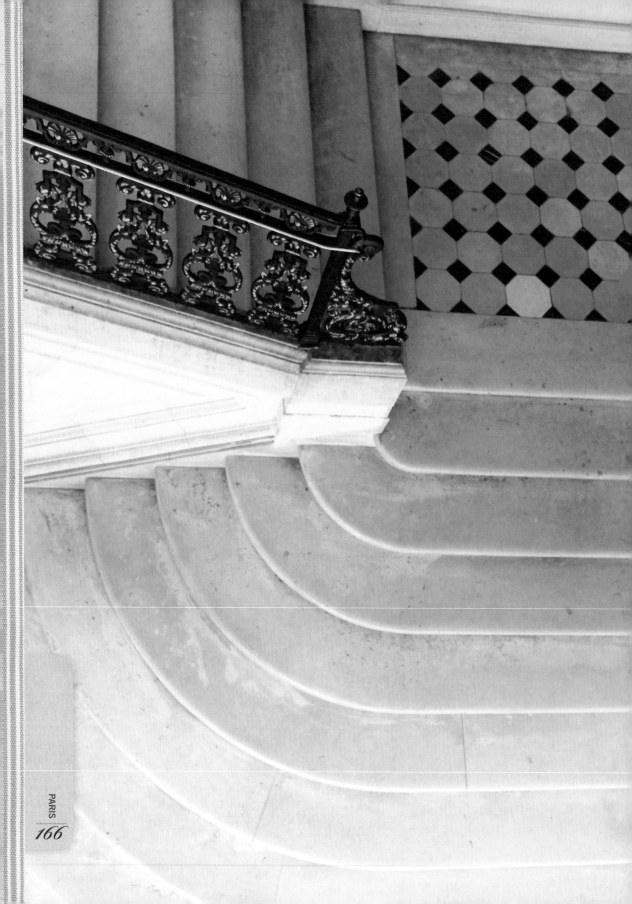

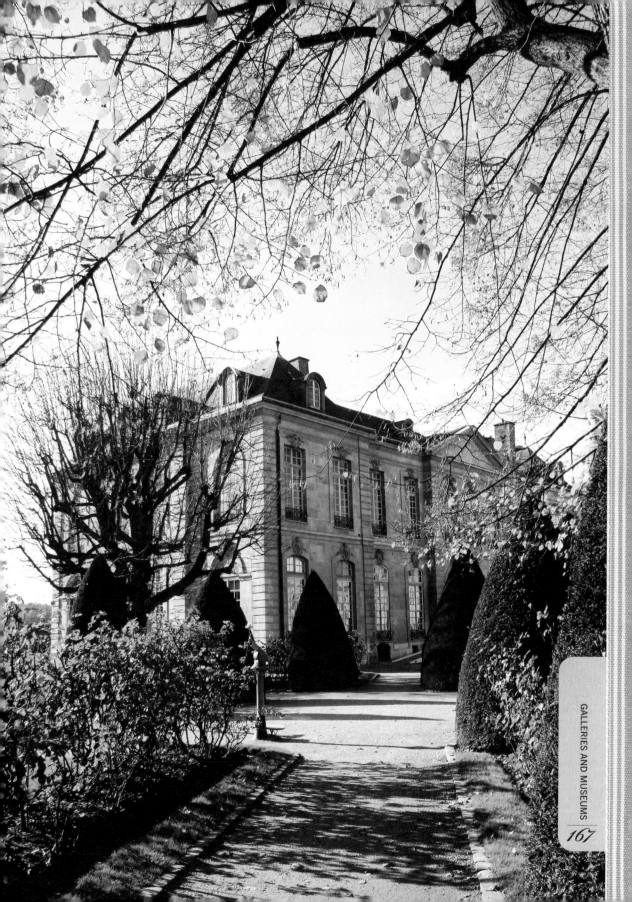

Museum of Hunting and Nature *(Musée de la Chasse et de la Nature)*

On the hunt

Despite the rather scary title, this museum is actually lovely – and makes for a pleasurable interlude on a wander through the Marais on a sunny day. It's a private museum of hunting and nature housed within the Hôtel de Guénégaud (1651–1655), which was designed by architect François Mansart, although it's also extended to the historic Hôtel de Mongelas (1703) as well. The mansion was one of the first of the majestic old buildings in this area to be restored under a scheme instigated in the 1960s to preserve the historic Marais quartier. And thank goodness it was. It's a delight to detour through the many corridors and exhibits here, which have the atmosphere of a fairy-tale forest with the many animals in residence. Its collections are organized into several sections, all of which are equally intriguing. There is the Image of the Animal section, which includes paintings, hunting horns, taxidermy and trophies, a cabinet of curiosities and exhibits featuring wolves, falcons and other birds, horses and dogs. There is the section called Art and the Hunt, which features hunting weapons including crossbows and arquebuses. And there is a Regency-style room with sculpture. There are also rooms dedicated to specific animals: the Dog Room, the Deer Room and so on. It's better than you might imagine.

62 Rue des Archives, 3rd; tel. 01 53 01 92 40;

Orsay Museum *(Musée d'Orsay)*

Art with class

A formerly deserted train station that's been converted into a spectacular space, the impressive interior of the d'Orsay houses art that was formerly displayed at the Jeu de Paume before it closed in 1986. It features significant works of impressionism, neo-impressionism, naturalism, symbolism and art nouveau, including masterpieces by Van Gogh, Cézanne, Renoir, Delacroix, Degas and Monet, Daumier, Rousseau and Gauguin. There are also some wonderful decorative arts, including a collection of art nouveau furniture downstairs. However, many people simply go for the architecture. Don't miss the view of Paris through the clock's face: it's absolutely magical.

1 Rue de la Légion d'Honneur, 7th; tel. 01 40 49 48 14; www.musee-orsay.fr

Perfume Museum *(Musée du Parfum)*

History through scent

What could be lovelier that a museum devoted to perfume? You could almost walk through it blindfolded and still have a memorable experience. Created by perfumers Fragonard, this enchanting place occupies a mansion from the era of Napoleon III, and the architecture and interior design, with its parquetry floors and ornate staircase, is as lovely as the scented display. The museum features a series of beautifully proportioned rooms with a mixture of period furnishings and perfume exhibits. Displays show the history of perfume manufacturing and packaging, and how natural ingredients are combined with other substances to create modern perfumes.

9 Rue Scribe, 9th; tel. 01 47 42 04 56; www.fragonard.com

Pompidou Center *(Centre National d'Art et de Culture Georges Pompidou/ Musée National d'Art Moderne)*

Surprising delights

The Pompidou Center has aged gracefully since its rather controversial birth. Fewer people criticize it now, although its exterior can still shock, even when you're seeing it for the third or fourth time. The center was the brainchild of President Georges Pompidou, who wanted to create an original cultural institution (it's certainly that) where the visual arts could rub shoulders with theatre, music, cinema, literature and the spoken word. Whatever you think of its architecture, its core mission – to spread knowledge about all creative works from the 20th century – is to be applauded. As we ease into the 21st century, it has become one of the world's finest museums of modern art. There are more than 65,000 pieces in the collection, ranging from Picasso to Matisse and Kandisky, which are rotated several times a year. There is also a public library and a great bookstore on the ground floor. And don't forget to take the clear escalators on the exterior of the building up to the top floor for some of the best rooftop views of the city.

19 Rue Beaubourg, 4th; tel. 01 44 78 12 33; www.centrepompidou.fr

Rodin Museum *(Musée Rodin)*

Sculptural sophistication

This swish museum, housed in a pretty 18th-century château called Hôtel Biron, is just as appealing as the art inside. Originally a popular destination for Parisian high society, the building changed hands several times until it eventually became a convent run by the Sacred Heart of Jesus. Sadly, the nuns found the sumptuous decor a little too frivolous, and had much of the froufrou removed. The garden was turned into an orchard to serve the convent, and the mansion became a rather austere space. Then, in 1904, the sisters were evicted (due to a rather complicated law) and the property reverted to lodgings for creative types, including artist Henri Matisse, dancer Isadora Duncan and the poet and filmmaker Jean Cocteau. In 1908, Rodin visited the hotel and loved it so much he decided to rent four rooms for a while. He became so fond of it he organized to stay until his death in return for the donation of his works. Don't miss the gardens and the pretty tearooms – great for a light lunch and a rest beneath the trees.

79 Rue de Varenne, 7th; tel. 01 44 18 61 10; www.musee-rodin.fr

Romantic Museum *(Musée de la Vie Romantique)*

A fine romance

The walk to the Romantic Museum is almost as romantic as the museum itself. To reach it you need to navigate a series of charming narrow streets at the base of the hill leading to Montmartre, then turn off and wander down a cobbled lane. At the end of this lane, facing a divine little garden, is one of the most magical museums on the Right Bank. It's the perfect setting for a place that captures the artistic, literary and musical life of the romantic period. The house is formally known as the Scheffer-Renan mansion and was once an artist's home and studio built more than 150 years ago for court painter Ary Scheffer, who once taught the children of King Louis-Philippe. However, it's better known as the house of author George Sand. Inside this bucolic place (which looks like it should be somewhere in the countryside), there are all sorts of lovely reminders of Sand and the rest of her creative contemporaries who have passed through here, from composer Chopin to artist Delacroix. The main room is devoted entirely to Sand and exhibits a selection of the novelist's personal belongings, from watercolors to lockets and jewelery. On the other side of the courtyard is Ary Scheffer's workshop, where he received Chopin, composer Liszt, Delacroix and other luminaries of the cultural scene at the time. But while the interior is pretty it's the garden that's the real escape. Perfect on a spring or summer's afternoon, it lets you pretend you're a 19th-century romantic, if only for an hour or so.

16 Rue Chaptal, 9th; tel. 01 55 31 95 67

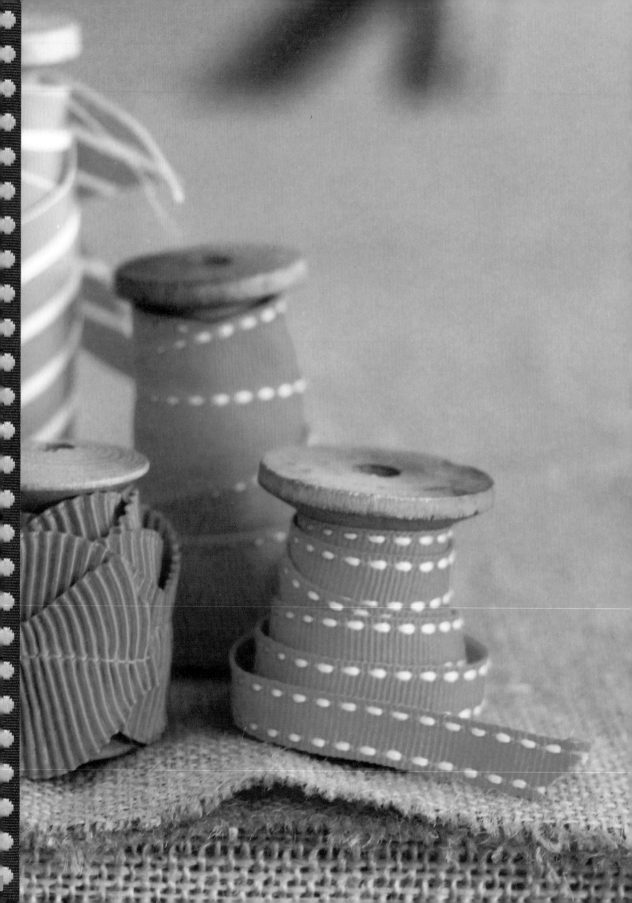

Style

Fabrics, ribbons and trims

If you're a seamstress, Paris is your city. This was, after all, the home of Coco Chanel, a woman who used to spend hours sewing and resewing the armholes of her jackets so that the cut and fit was perfect. Here are a few of the city's best fabric stores.

Dam Boutons

Out, dam button!

Cute name. Cuter shop. This adorable little place sells buttons and ribbons and trims and things. (My friend calls them "the fiddly bits.") You'll find everything here, from snaps to hooks to pins to buckles. If that's not enough, the owner is now designing buttons. Well worth a visit, especially if you want some *passementerie* that's a little left of center, or left of buckle. *Trés* cute.

46 Rue d'Orsel, 18th; tel. 01 53 28 19 51; www.damboutons.com

La Droguerie

Dressmaking heaven

With walls of ribbons and trims, jars full of beads lined up like a candy store display and little felt baskets for customers to collect all their purchases in, La Droguerie is a delight to visit. The name actually means drugstore, and this place has the feel of a good, old-fashioned American drugstore. You know, the kind where the timber shelves have the patina of old age, where the counter is a big long wooden benchtop and where the owner wears a big khaki apron, smiles and listens to Nina Simone a lot. Okay, so that doesn't happen here, but the ambience is almost the same. There are even wooden drawers to hold all the buttons. It's technically a yarn and craft store, and there are certainly great yarns here for creating gorgeous scarves, jumpers and other creative things, but there are also craft supplies such as jars full of cute buttons and hundreds of spools of brightly colored ribbons and threads.

9–11 Rue de Jour, 1st; tel. 01 45 08 93 27; www.ladroguerie.com

Marché Saint Pierre

Fabric madness

Run, don't walk to this store. Quickly now, so you get there before the crowds do. If you don't hurry, don't blame me when you emerge, bruised, shaking and blinking, into the Paris sunshine. Seriously, this place gets super-congested, so be prepared to bump and jostle with lots of women – both French and foreigners. It's a multistory madhouse (six floors in total) full of fabrics in every color, style, weight and texture a fanatical sewer could wish for. Some of these fabrics are admittedly a bit worn after dozens of women have pawed over them but others are actually quite lovely. I found an entire section of wonderful French cottons and drill canvases that would have looked gorgeous on a revamped wicker setting on an Australian veranda. (My veranda, for example.) There are also tickings, linens and hessian – which is becoming almost impossible to buy elsewhere in the world as interior decorators snap it up to cover antique armchairs. And there are fashion fabrics, too. The slightly old-fashioned interior exudes the feel of a 1950s department store, but on the upside there are lots of *Are You Being Served?*–style salespeople wandering around each floor to assist with cutting yardage. I know. I kept tripping over them. Or perhaps that was the other customers?

2 Rue Charles Nodier, 18th; tel. 01 46 06 92 25; www.marchesaintpierre.com

Tissus Moline

Tissus bliss

Moline is actually a brand rather than a single fabric shop, and its stores are dotted all along Rue Livingstone in Montmartre, in the same quartier where all the other fab fabric stores are. (*Tissus* means fabric.) Frequented by serious seamstresses, this spectacular series of stores contains all the fabric you'd ever want – and some you didn't realize you needed. (I was seduced by lots of layers of chiffon, for example.) The only downside is it's so popular you need to fight everyone else to the bolts. The toile seems to be particularly popular. I ended up buying so much decorating fabric in this and the other stores nearby I had to buy another carry-on bag the next day to fly it all home.

2–6 Rue Livingstone, 18th; tel. 01 46 06 14 66

Tissus Reine

A seamstresses' sanctuary

I stuck my head in this store after being tempted by two tables full of Chanel-style bouclé outside and expected to be nonplussed by the goods on offer. How wrong I was! No wonder all the fabric aficionados I know adore this fabulous place. It's beautifully ordered with different fabrics organized into different sections, so the shirt materials are in the front (divine silks for lovely business shirts), the silk taffetas to one side (perfect for dressing the windows on your home) and the chic French linens (for everything else) elsewhere. The store is tidy, the bolts are easy to see and the staff are lovely and so, so helpful with their scissors. I bought some hot-pink silk taffeta to whip up some French-style curtains for our library, but I could have fallen in a heap on some periwinkle-blue toile and stayed there all day. Lust away.

3–5 Place Saint-Pierre, 18th; tel. 01 46 06 02 31; www.tissus-reine.com

Ultramod

Just marvelous

This store, or *mercerie* as the French call it, is just too, too marvelous for words. Apparently Jean Paul Gaultier shops here for his trimmings and things, and that alone is credibility enough for me. If JP's here, mooching about the grosgrain and sizing up the buttons, I'm here, too. Dating from 1890, the store gives you the distinct feeling of stepping back in time. There are floor-to-ceiling wooden drawers filled with threads, loomed silk ribbons dating to the 1940s, silk fabric rolls from the 1930s and hats that are half a century old. There are also rolls and rolls of lovely ribbons, lined up like sweets. There are two boutiques, directly across the road from each other. But the millinery boutique, with its hat blocks and French netting, is perhaps the more beautiful of the two. The business keeps odd hours, so perhaps ring before you traipse up here. Or you can simply stare through the window as I did and ogle the goods, and then be thankful you've saved the money you would have spent had you stepped inside.

14 Rue Monsigny, 2nd; tel. 01 42 96 98 30

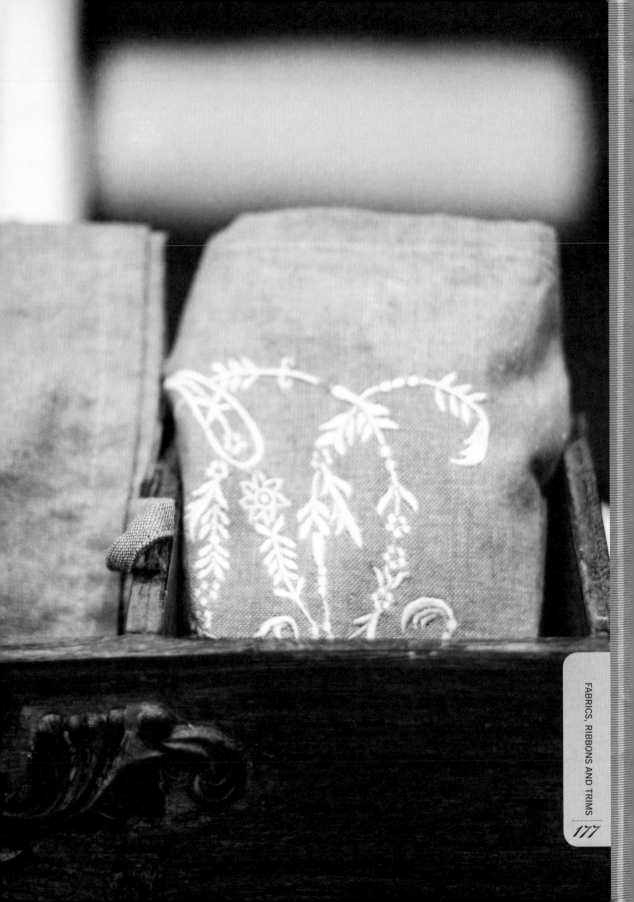

Vintage and affordable French style

Paris is full of stores that specialize in either vintage couture and clothing, or what's known as dépôt-ventes, *where people offer their gently worn designer outfits to be sold for less-than-retail prices. However, many of these stores open and close again faster than a rich woman snapping shut her Hermès clutch at the end of an expensive luncheon. There are also many books and websites on fashion and style that detail where these stores are, if you're keen to do a vintage trail. Here are a few stores that are not only solid businesses but also have established a reputation for quality stock.*

Catherine B

Affordable elegance

Call me shallow, but I have always longed for a Chanel jacket. (I have always longed to be taller and to have a good singing voice, but since they're impossible to buy on the streets of Paris, the Chanel dream seemed a more attainable wish.) After years of being in Paris, for both short and extended periods, I finally decided to do the French thing and buy my first Chanel. Easier dreamed than done. New Chanels, of course, are priced out of reach, so the only alternative was going to be a vintage or softly worn Chanel, perhaps kindly passed down from some celebrity or royal who had too many of them. So, one morning on the Left Bank, I found myself gravitating toward Catherine B. Catherine B is where old Chanel and Hermès outfits go when their owners buy a wardrobe of new ones. It is a tiny store but an immaculately curated one, where these outfits are given their rightful respect. Handbags and outfits are not only in pristine condition but also displayed in an elegant fashion: handbags carefully lined up on dust-free shelves, jackets color-coordinated in sizes, shoes here, earrings there. One look at it all and you begin to think: this might be out of my league. But amazingly, prices here are ... well ... almost affordable. For instance, I discovered a perfect, barely worn black Chanel suit for $1,000, which was one-fifth of its original price. It was so perfect I was almost tempted. Unfortunately, $1,000 is still a lot of money for me and indeed for many people with a mortgage, so I bravely thanked the owner and, with enormous discipline, walked out of the store. Be warned. You'll be tempted too. The Hermès handbags are particularly irresistible. You could dress like a Frenchwoman here for very little, and nobody would know you hadn't been shopping on the Avenue Montaigne. Note that the boutique is divided into two storefronts: a smaller one dedicated to jewelery, watches, scarves and handbags and a larger one next door for clothing, shoes and luggage.

1 and 3 Rue Guisarde, 6th; tel. 01 43 54 74 18 and 01 43 25 64 92; www.catherine-b.com

Dépôt Vente de Buci Bourbon

Chic on the cheap

Located in the heart of the wealthy 6th arrondissement neighborhood, a Louis Vuitton handbag's throw from the upmarket stores of Boulevard Saint-Germain, this business is perfectly situated for sourcing and selling vintage, secondhand and gently used designer clothes that are cast off from wealthy Parisians and resold for a fraction of their original retail value. Much of its stock comes from the women who reside in the area, and much of it is then rebought by women who reside in the area, so it's all very economical, really. There are two stores side by side: one focusing on classic vintage designs by the likes of Yves Saint Laurent, Dior and Chanel; the other dealing in clothes from designers like Yamamoto and Gaultier. Both stores are highly regarded by those in the know, although – as with anything secondhand – check the items carefully before you buy to ensure they're original.

6 Rue Bourbon Le Château, 6th; tel. 01 46 34 45 05

Didier Ludot

Vintage couture

Didier Ludot operates arguably one of the world's most famous vintage stores. His eye for style is so sharp, and his stock so sublime, that celebrities have used this store to find show-stopping gowns for the Oscars and other red-carpet events for years. (Apparently he keeps the best stock hidden away, so ask if you're after something truly spectacular, and have the money to pay.) There are vintage Hermès handbags in perfect condition, classic Chanel suits with classic Chanel glamour, gorgeous gowns, coats and dresses from the likes of Dior and Givenchy, and all kinds of lovely shoes and jewelery to accessorize your outfit with. Many of his pieces are collector's items, and priced accordingly. But it's still a wonderful experience to wander around and dream.

24 Galerie de Montpensier, Jardin du Palais-Royal, 1st; tel. 01 42 96 06 56; www.didierludot.fr

Gaïa

Gorgeous goods

One peek at its intimidating carved wooden facade and its doorbell, which you have to ring for admittance, and you soon begin to think that Gaïa is perhaps too pricey, or too exclusive, or just too scary to enter at all. But looks can deceive. Inside, in a space that's enhanced with cute boudoir mirrors and winking fairy lights, there is one of the best places to source fantastic clothes at unbelievable prices.

7 Rue de Crussol, 11th

Mistigriff

Designer style for very little

Several bloggers have started to write about the cutely named Mistigriff, where you can buy some of the best-known names in men's, women's and children's wear for discounts of up to 85 percent. It's the kind of store that fashion assistants, models and magazine people sneak into to dress up their wardrobes for red-carpet events without spending their monthly salary in the process. While the labels have been removed, the signature designer styles are very clear. You can pick up Dolce & Gabbana, Kenzo and other top labels here for hugely reduced prices.

83–85 Rue Saint-Charles, 15th; tel. 01 53 95 32 40; www.mistigriff.fr

Neila Vintage and Design

Va-va-voom

Neila is well-known to those who are in the know about such things, but for the rest of us she has somehow eluded us. How could we not have known about this gratifying place, with its gallery-style walls and gorgeous bargains? But it's not too late. Neila is still selling sublime clothes in her sleek store, the interior of which makes the outfits look far from aged and vintage. Chanel, Yves Saint Laurent, Dior: Neila has it all.

28 Rue du Mont Thabor, 1st; tel. 01 42 96 88 70

Réciproque

Still dressing the best for less

One of the oldest vintage and consignment stores in the city, and arguably the largest, Réciproque is still going strong, and is loved by Hollywood celebs (and their wives). There are several stores, each specializing in something different (the largest is dedicated to women's clothing). The best room is possibly the upstairs space in the women's store, which is given over to evening gowns and couture labels.

89, 92, 93, 95, 97 and 101 Rue de la Pompe, 16th; tel. 01 47 04 30 28; www.reciproque.fr

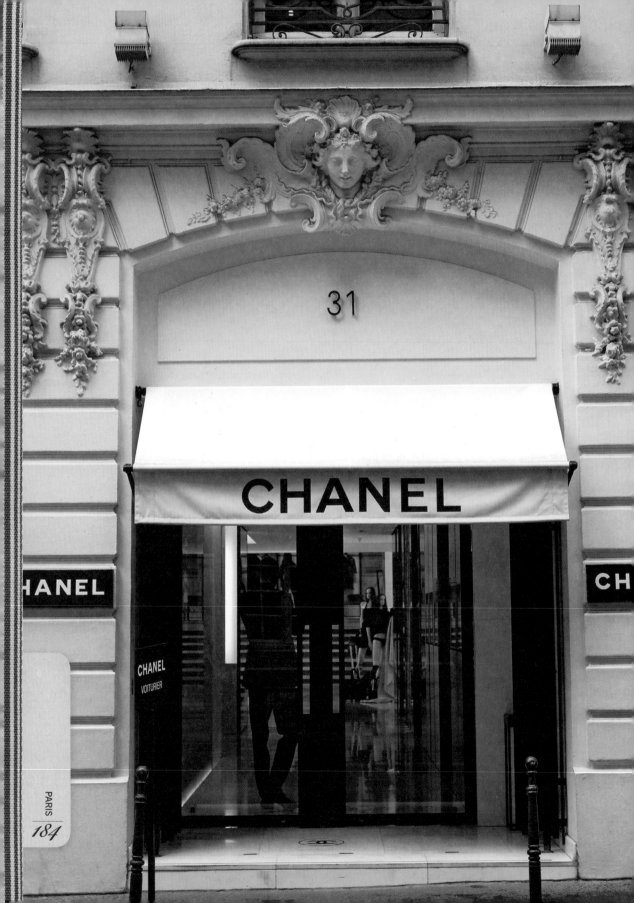

Fashion and accessories

Paris is famous for its fashion, and there are many fashion books and magazine articles that show you where the best stores are located. This book can't compete with those lists, nor is it designed to. Instead, I want to showcase a small selection of stores that are either classic Paris or a little different in some way, either through their distinctive style, their interior design or architecture or simply their notable history. If you only have a short amount of time to take in some Parisian stores, try these first for a true taste of French style. They are inspirational.

Antoine et Lili

Just too, too pretty

Most people know this store by its distinctive pink facade – although there are also Antoine et Lili stores that are banana yellow and bright tangerine. The location in the 10th is best, but the others are just as delicious. It's a place that celebrates color – in both homewares and clothing – and stocks everything from bright orange tea coats to cute pink homewares. Warning: don't go if you're fond of monochromes. The carnival-style aesthetics might be too much for your minimalist senses. Then again, you might rediscover, as I did, the sheer pleasure of bold, cheeky shades.

95 Quai de Valmy, 10th; tel. 01 40 37 41 55 (see website for other stores); www.antoineetlili.com

Balmain

Beautiful with a capital B

I made a point of visiting the redesigned Balmain store on a work trip to Paris in late 2010, after it had received pages of media coverage on its shimmering new interior. After being slightly scared by the troops of saleswomen who followed me around (no one else was in the store), I managed to take in the new design. And I was astonished. Never have I seen a more beautiful interior (and as an architecture and design journalist, I see more than my share). It is gorgeous. Strangely, the classical interior design is as far from Balmain's contemporary approach to fashion as you can get, but perhaps that's what makes the combination so mesmerizing. While the clothes may suit the Party Girl circuit ("Balmania" was a very real affliction in 2009 and 2010), the interior is as quiet and as refined as a stately Parisian mansion. To see it, you have to walk up a magnificently ornate staircase (just ignore the staring sales girls), then through a series of elegant rooms, each of them redesigned in classic white paneling and a mix of stone and parquet floors. There are simple antique busts, sophisticated Louis-inspired sofas re-dressed in black and quietly glamorous chaises and marble tables, all set under an elaborately detailed ceiling. It's understated but luxurious. And very Parisian.

64 Rue Pierre Charron, 8th; tel. 01 47 20 01 56; www.balmain.com

Chanel

The cult CCs

What can one say about the iconic, black-and-white Chanel flagship store that hasn't already been said before? Nothing really. Just go along and stare in awe. This gorgeous place on the Rue Cambon was Chanel's first store, and for that reason it should be included on every serious stylista's to-do list. It's adjacent to the Chanel couture house and behind the Ritz, where Coco Chanel once lived, and although it seems tucked away, the interior opens up to a Chanelesque wonderland. Service here is surprising friendly, so don't be intimidated. And try to see the beautiful staircase of the house before you start browsing through the two-story boutique. It's where Chanel used to sit to supervise all her shows. See if you can feel her ghost.

31 Rue Cambon, 1st; tel. 01 44 50 66 00; www.chanel.fr

Christian Louboutin

Seeing red

Christian Louboutin's shoes are instantly recognizable, at least by serious shoe fetishists. Their sexy red soles can be spotted at 60 paces. The signature soles are just a small part of the way Louboutin shows his humor in his design. Other comic touches include creating a shoe with a heel made out of a Guinness can and another, called a "Trash Mule," containing rubbish. Thankfully most of his designs are wearable – and are coveted by shoe lovers all over the globe.

19 Rue Jean-Jacques Rousseau, 1st; tel. 01 42 36 05 31; www.christianlouboutin.com

Hermès

Heavenly

Oh, Hermès. You make my heart beat faster every time I walk past. In fact, such is your allure that I can't help but pause and enter, even though I can barely afford the perfume. Hermès was founded as a harness shop in Paris in 1837 and has evolved to become the height of sophistication. It is famous for its silk scarves and handmade bags, namely the Birkin and the Kelly bag, but it is also skilled at making other things. Perfume, for example. And saddles. And clothes. Oh, the clothes! They're all impossibly gorgeous, and impossibly expensive, of course. But walking through the store is free. And if you can gain access to the private museum upstairs, you'll be one of the fortunate few. And you won't forget the experience for a long time.

24 Rue du Faubourg Saint-Honoré, 8th; tel. 01 40 17 47 17; www.hermes.com

Lanvin

Smooth operator

Ever since the Casablanca-born Israeli fashion designer Alber Elbaz was appointed artistic director of the legendary French fashion house of Lanvin, the label has become one of the sexiest in town. Fans of his simple, feminine style include Nicole Kidman, Kate Moss, Chloë Sevigny and Sofia Coppola, and there are a number of red-carpet regulars who think he makes the best dresses in the world. (One fashion editor told me that this is where you come to pick up some serious frock.) Elbaz had a challenge on his hands when he took on the job – Lanvin is one of the oldest fashion houses in the world, having been founded in the early 20th century by Jeanne Lanvin (whose apartment has been reconstructed at the Decorative Arts Museum next to the Louvre). Lanvin was famous for her love of forget-me-not blue, which has now been dubbed Lanvin blue, and Elbaz obviously noted and respected this because he introduced new packaging featuring the delicate shade with an illustration of Lanvin and her daughter Marguerite. He also designed new shoe boxes that look like antique library files, tied with black ribbons, to emphasize the precious nature of the product. *Time* magazine nominated him as one of the 100 men and women transforming the world. With quips such as "Wear flats. You're short. It's much cooler not to pretend," we can see why. Ah, Alber. We adore you.

22 Rue du Faubourg Saint-Honoré, 8th; tel. 01 44 71 31 73; www.lanvin.com

Louis Vuitton

Logoed luxury

Some people might look down their noses at the LV monogrammed handbags and over-publicized wallets, but Louis Vuitton is still one lovely label. Let's not forget this was originally a company that produced the world's most beautiful traveling cases and steamer trunks when it was first established in the late 19th century. And its products are still first-class. The label may be best known for its bags, but it's not all about leather goods. The company also produces shoes, accessories, jewelery and even books, including the well-written City Guides. But I still love the steamer trunks. If only I had a spare $10,000 for a vintage version. The window merchandising, particularly in the Saint-Germain store, is impressive. Last time I peeked in, they'd erected an enormous replica of the Eiffel Tower out of travel trunks. See what I mean? This label's still got it.

6 Place Saint-Germain des Prés, 6th; tel. 01 45 49 62 32; www.louisvuitton.com

Repetto

Classic ballets

The cult of Repetto is easy to understand when you visit this ballet-shoe company's store, which is handily located within a pirouette of the Paris Opéra house. Ballet shoes are perfect for Paris: you can wear them dashing between fashion shows or walking up the eight exhausting flights to your top-floor apartment. The brand's cult status dates back to the 1950s, when Rosa Repetto created an iconic ballet flat for Brigitte Bardot, who trained as a ballerina and who wanted an everyday shoe that was as easy to wear as a slipper. Today, most self-respecting Parisiennes have at least one pair in their closets. Annual collections are always eagerly awaited and always limited, so you know the whole world isn't going to be wearing them, which adds to the exclusivity factor. The store is also rather lovely, with red velvet banquettes, crystal chandeliers, hardwood floors and an immense wall mirror to admire your new shoes in. There is also a store in the 6th, if you can't manage to get up up to the 2nd arrondissement.

22 Rue de la Paix, 2nd, and 51 Rue du Four, 6th; tel. 01 44 71 83 12 and 01 45 44 98 65; www.repetto.com

Sabbia Rosa

Lingerie to linger on

Many Parisian women adore Sabbia Rosa, or their partners do, anyway. She's the go-to girl for sexiness in this city. Here, in this little lingerie haven, there are all sorts of silk knickers, pretty bras and corsets that whisper of seduction. Celebs like Cindy Crawford and Kate Moss love them. It's not hard to see why.

73 Rue des Saints-Pères, 6th; tel. 01 45 48 88 37

Tea salons

What would Paris be without its tea salons? Many associate this city with its famous cafes and bars, but the tea salons are just as enchanting. Places like Ladurée have become famous the world over (Sofia Coppola loved its pastel color palette so much she replicated it for her film Marie Antoinette*), but there are dozens of others that are wonderful to while away a few hours in. Order a tea and some delicious macarons, write that postcard and experience Paris at a different pace.*

A Priori Thé

Elegant to a T

There is something reassuring about this charming, peaceful place located under the elegant, 19th-century glass roof of Galerie Vivienne (page 137), one of the most beautiful covered passages in Paris. It's so comfortable, so easy to be in, that it feels like you've known the owners and have been coming here for years. The decor is pretty, the staff friendly, the atmosphere relaxed and the beautifully presented teas are perfect for reviving you after an exhausting morning of walking. Many in the media and fashion worlds adore it. (You can often see faces from French TV here.) Packed on Sundays, when it seems as though all of Paris comes here for brunch, it's also popular every other day of the week, so bookings are recommended. Save room for the fruit crumble; it's the salon's signature dish. Old-fashioned loveliness, indeed.

35–37 Galerie Vivienne, 2nd; tel. 01 42 97 48 75

Angelina

Hot chocolate worth flying to Paris for

Angelina tea salon is an institution and is perhaps the most celebrated tea parlor in the city. Chanel used to love wandering down here from her atelier on Rue Cambon to indulge in a few quiet moments to herself. Audrey Hepburn frequented here when she filmed in Paris. Marcel Proust used to love dunking his madeleines in lime-flavored tea. American students studying in the city come here to revel in the ornate Parisian atmosphere and order a famous Mont Blanc gateau. And even locals like stopping by for one of Angelina's legendary signature hot chocolates (known as a chocolat l'Africain). The salon opened in 1903 and remains ensconced in a kind of fin-de-siècle timewarp, with its marble-topped tables, glamorous mirrors and gilded sumptuousness. In fact, the slightly faded Belle Epoque–style glamour is as over-the-top as the piles of whipped cream served with your hot chocolates. But that's why it's famous. If you don't have time to linger in the salon, then choose from the delicious pastries, cakes and chocolates served by frilly-aproned waitresses in the store at the front of the salon.

226 Rue de Rivoli, 1st; tel. 01 42 60 82 00

La Grand Mosquée de Paris

Exotic stop

There is nothing else in Paris quite like the Mosquée's tea salon. It feels as if you've blinked and traveled to Marrakech on a magic carpet. Hidden away behind the mosque in a quiet street in the 5th arrondissement, just outside the Jardin des Plantes' walls, it's reached via an enormous, ornate wooden door and a wonderfully decorative Arabic-inspired courtyard. Both of these are so beautifully designed, with richly hued blue tiles and gleaming brass tables, that you're immediately intrigued as to what could possibly follow. Well, it's just as good. Indeed, the pleasures of both the cafe and the hammam (bathhouse) beyond are legendary. Try the hammam if you have time; it's a once-in-a-lifetime experience. Otherwise, you can take a seat in the serene walled courtyard or the pink tea salon and order a delicious lunch of lamb couscous or chicken tagine or an afternoon tea of baklava and sweet mint tea. Whether you choose the ravishing pink restaurant or a cushion on a lounge in the open courtyard, you will feel magic.

39 Rue Geoffroy-Saint-Hilaire, 5th; tel. 01 43 31 38 20

Ladurée

Piped dreams

The British writer Toby Young once described the Ladurée as a little like an "S&M dungeon designed by a wedding cake manufacturer." Okay, so he's exaggerating somewhat, but it's true that Ladurée is rather over-the-top. Or a little *de trop*, as the French would say. But that's exactly why everyone adores it. Blame it on the boxes but I was a Ladurée convert from the first glance at the window displays. It is impossible not to be. Most of those who come to Paris fall in love with this sexy patisserie before they even walk in the opulent doors. Ladurée is, indeed, a patisserie, but calling it that is like calling Deyrolle a mere taxidermy store. It is a sweet, sweet wonderland. Mostly famous for its delicate, dainty macarons, which come in Marie Antoinette–style shades, it is also renowned for its interiors (and there are several stores, with different interior styles). In the historic Right Bank salon, for example, which is the oldest Ladurée cafe, the opulent dining room is designed in a style called "barely restrained excess" – which I believe was quite big in the time of Versailles. Think paneled walls, wainscoting, gilt accents, frescoes, oil paintings of maidens and cherubs, and ceilings dripping with splendid chandeliers. And then embellish that thought a little more. It's the kind of glamour that only Paris can get away with. All this interior decadence is, of course, the perfect backdrop for the pastries that are presented each day: irresistible offerings that are so tempting, you won't stop at one. Trust me. You'll be lining up like all the rest to spend a small fortune on a box. My favorites are the rose and the pistachio macarons, but then again, I'm so taken by the pretty interiors, the pastel colours, the photo-perfect merchandising, the packaging and the whole, extraordinary atmosphere of the place that I barely know what I'm buying.

75 Avenue des Champs-Élysées, 8th; tel. 01 40 75 08 75 (see website for other stores); www.laduree.fr

Mariage Frères

Tea to impress

If you're a tea connoisseur, this is your scented mecca. Founded in 1854, this famous establishment has done for tea what Ladurée has done for macarons. It is almost a gallery to this little drink. The first thing that strikes you when you enter is the displays of tea canisters artfully arranged on walls and vast wooden counters. The second thing that strikes you is the scent. Both serve to entice you to drink. (And of course buy.) At the back, a colonial-style tea salon with linen-clad waiters, potted palms and rattan matting transports you to Sri Lanka. A menu of fine blends does the rest. A truly refreshing place.

30 Rue du Bourg-Tibourg, 4th; tel. 01 42 72 28 11; www.mariagefreres.com

Bistros, cafes, bars and restaurants

There are so many fantastic bistros, cafes, bars and restaurants in Paris – from the simple and rustic to the glamorous and celebrity-packed – that you could go to a different one every night for a year. And there's one to suit everybody. My favorites are the classic places with zinc bars, gilt mirrors, wooden tables and red and white napkins, but all of them are superb for people-watching, and all are great to escape the rain on a drizzly Parisian day. Use them liberally: they're quite possibly the best thing about this city.

Anahi

South American flavor

Now, it's a little off the beaten track, but this Argentinian restaurant is worth a visit. Try to get here before it gets dark: you need to see the exterior in all its, er, glory. At first glance this place looks as if the facade has been attacked by an incompetent tradesman, a tradesman who's then packed up his dodgy tools and left. The exterior is so shambolic and run-down you wonder if it could possibly be a real establishment. But the facade is actually part of the philosophy – and the appeal. It's a no-style statement that signifies these people are more into food than fancy decor. And the dishes are indicative of it. Curiously, the antifashion approach has hit a chord with Parisians and the likes of Karl, John and Marc have all come here to dine in (anti)style.

49 Rue Volta, 3rd; tel. 01 48 87 88 24

Au Petit Suisse

As sweet as sweet

Named after Catherine de Medici's Swiss guards, this is an adorable little place located in a prime position near the Luxembourg Gardens, so you can drop in for a reviving tea or lunch after a wander around the fountains and formal paths. It's quite unassuming from the outside – blink and you could miss it – but inside it opens up to a double-story delight. Downstairs there's a classic Paris cafe, with huge, glorious arched windows, traditional wooden chairs and gorgeous mirrors. Upstairs, there's a mezzanine level with a view looking over it all. It's even lovely sitting at the terrace outside, watching the Parisians pass by, which isn't something that can be said for cafes on busier thoroughfares. The food is great and surprisingly good value for a bistro in the 6th arrondissement. And it's cute to boot.

16 Rue de Vaugirard, 6th; tel. 01 43 26 03 81

Bouillon Chartier

Classic Paris dining

Another Parisian institution, and a favorite among locals and tourists alike, this restaurant dates from 1896 and made an appearance in the Audrey Tautou film *A Very Long Engagement* (2004). It's still as atmospheric and as authentic as it was in 1896, with its Parisian mirrors, glass-globe fixtures, tightly positioned tables and bustling, aproned waiters. In fact, some believe there isn't a more perfectly preserved relic of old Paris in the city. The no-frills food isn't, well, frilly, but it is cheap. It's the kind of place you go to order a classic French dish of soup (served in a rustic tin bowl) and then sit back and enjoy the scene. Everything here is delightful, from the orders, which are written down on your tablecloth, to the experience of sharing your table with other spirited customers; it's a great way to meet new friends. Unfortunately they don't take reservations, so be prepared to wait. But be patient: it's worth it.

7 Rue du Faubourg, Montmartre, 9th; tel. 01 47 70 86 29; www.restaurant-chartier.com

Cafe Charbon

Chock-a-block with character

If you're looking for a lively Parisian place to catch up with friends, this is a great pick. Full of character, it's set within a former 19th-century coal merchant's premises in the now ultra-fashionable Oberkampf district. The interior design is divine, with high ceilings, large mirrors and period features. And even though it has been incredibly popular since the boho and bobo crowds discovered and descended upon it, it's still a great little place for a night out. There are also lots of jazz clubs in the neighborhood, so you can continue on through the night.

109 Rue Oberkampf, 11th; tel. 01 43 57 55 13

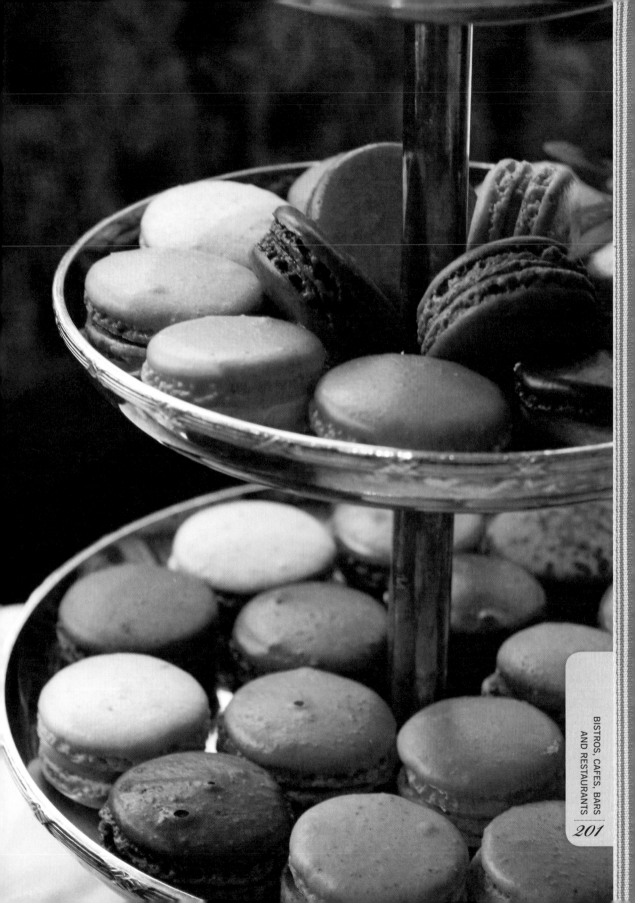

Cafe Charlot

New York in Paris

Cafe Charlot is considered the unofficial epicenter of the 3rd arrondissement's hipster little village, or one of the epicenters anyway. There's no doubt it's a buzzing beehive of activity. It's also considerably appealing; some might say sexy even. Indeed, many people view Charlot as a place to pick up over your tarte tatin (it does have a reputation for customers that are as delicious as its dishes), but I suggest you go for the architecture instead. It's classic Parisian: black-paneled counters and curved zinc bar. It also feels a little like New York's Lower East Side, with its cooler-than-cool vibe. But it's not so cool that you can't drop in and feel at home. Order up an espresso and read the left-wing *La Liberté* paper and you'll look like a local.

38 Rue de Bretagne, 3rd; tel. 01 44 54 03 30

Cafe des Deux Moulins

A touch of Amélie

This cafe achieved an enormous level of fame when it was featured in the Audrey Tautou film *Amélie* (2001). It has become so popular that the *tabac* had to be removed to make more room for tourists. It looks just the same as it did in the movie, and you almost expect the characters to come waltzing out of the bathrooms. The fruit and vegetable stall from the film can be found nearby at 56 Rue des Trois-Frères.

15 Rue Lepic, 18th; tel. 01 42 54 90 50

Cafe Ruc

Fashion pick

A favorite with the fashion pack during fashion week, this cutely decorated, centrally located, much-hyped meeting place on Rue Saint-Honoré reportedly has the best French fries in Paris, not that the fashion pack would know. Lots of people flock here; others are disappointed by the pricey menu and service. I'm still not sure why it's a favorite with the cool set. Go along and judge for yourself.

159 Rue Saint-Honoré, 1st; tel. 01 42 60 97 54

Champagne Bar at Le Dokhan's

Utterly lovely

The Radisson Blu Le Dokhan's Hotel is rather special. The interior design is possibly the most stylish in Paris. An elevator created from Louis Vuitton steamer trunks, a baroque-style sitting room embellished with gray and green paneling, antique mirrors, Dior-gray and gold slipper chairs and rooms decked out in black-and-white stripes all combine to create a chic haven in the prestigious 16th arrondissement. But perhaps the most beautiful part of this delightful hotel is the Champagne Bar, which is decorated in the prettiest, lightest greens and golds imaginable. Here, bubbly lovers come to taste the range of Champagnes and wines served each night, or to retreat after a dinner date nearby. They'll even offer you a selection of Champagne glasses to drink your bubbles from. I love this place so much I could move in and never leave. Many big-name fashion designers feel the same.

117 Rue de Lauriston, 16th; tel. 01 53 65 66 99

Hemingway Bar at The Ritz

A moveable feast

Forbes voted the Hemingway's bartender Colin Field as the best bartender in the world, and they weren't wrong. He is a legend, a famed creator of delicious cocktails. Hemingway would have loved him. As with Le Fumoir (below), this interior is modeled on an English private club, but this one's full of real soul and history; sit at the back and soak the atmosphere up over a Bloody Bullshot.

15 Place Vendome, 1st; tel. 01 43 16 30 30; www.ritzparis.com

Hôtel des Costes

Still serving up style

For a long time this place was the top spot in Paris, particularly for models, photographers and magazine editors. It was super-cool, until some of the varnish rubbed off and many of the fashion VIPs drifted elsewhere. However, it still holds its ground, and still attracts its share of celebrities, particularly during Fashion Week, when the buzz is palpable. If you haven't been, do pop in; the courtyard garden is worth a peek.

239 Rue Saint-Honoré, 1st; tel. 01 42 44 50 00; www.hotelcostes.com

Le Bistrot du Peintre

Belle Epoque beauty

With an art nouveau interior and facade like no other in Paris, this deservedly famous Belle Epoque beauty, built in 1902, is possibly one of the city's most beautiful. It's certainly in my top 10. It was renovated in 1997 but lost none of its turn-of-the-century charm and character, and its regulars love the owner for it. There's a lovely terrace, a delightful bar and, best of all, a captivating restaurant with an elegant carved wooden staircase and glamorous mirrors. The service is friendly, wine is great and the clientele don't even mind when you bob up to take a photo because you're so taken with it all.

116 Avenue Ledru Rollin, 11th; tel. 01 47 00 34 39; www.bistrotdupeintre.com

Le Fumoir

Cool, club-style

I love Le Fumoir's old-fashioned, clubby atmosphere and old-fashioned clubby leather chairs, both of which are so intimate you're likely to find a date by the second drink. I love its location, right beside the Louvre (perfect for a pick-me-up drink after an exhausting day of walking.) And I love its library-style restaurant at the rear of the interior, which allows you to dine in the shadows of spines, with the cool sounds of Parisian jazz wafting in the background. Seriously, it's smoother than Michael Bublé. Okay, the service isn't great and some Parisians think it's a has-been, but tourists still love it. And so do I. A great place to take friends – but book before you go. It's very popular.

6 Rue de l'Amiral Coligny, 1st; tel. 01 42 92 00 24; www.lefumoir.com

Le Grand Colbert

Something's gotta give

Featured in the Jack Nicholson and Diane Keaton film *Something's Gotta Give* (2003), this is the classic Parisian brasserie. It looks exactly the same as it did in the film, with its magnificent Belle Epoque interior, so you might get a sense of déjà vu when you sit at your table. The food isn't terrific, but then you come here for the experience, the atmosphere and the architecture. You can always grab something from the grocery store on your way home, should you be disappointed with the soup. (As I was.) As timeless as Jack and Diane themselves.

2 Rue Vivienne, 2nd; tel. 01 42 86 87 88; www.legrandcolbert.fr

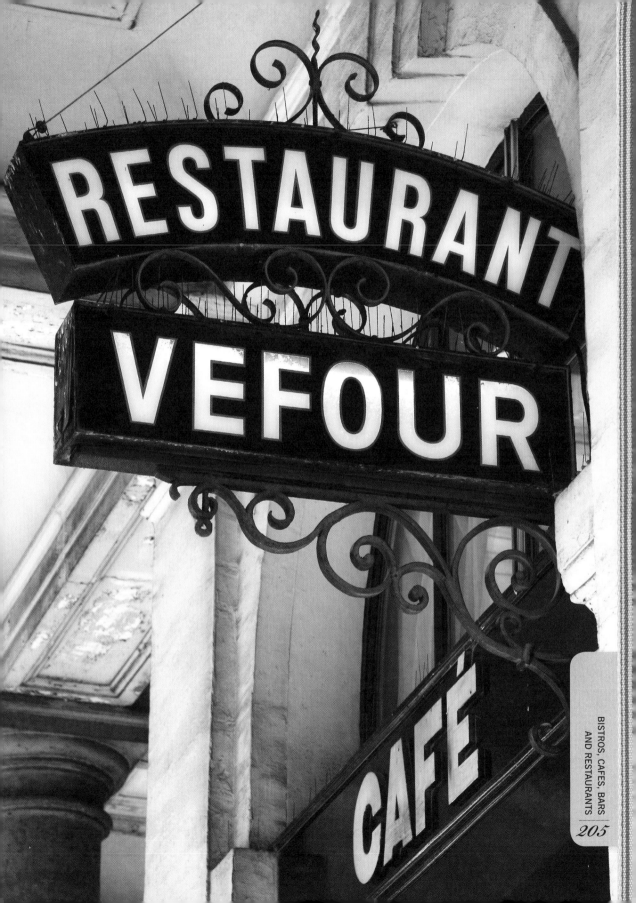

Le Petit Fer à Cheval

Petit and sweet

An institution in Paris and beloved by locals and foreigners alike, this tiny, tiny hideaway, whose name means "little horseshoe," is terribly hip and yet not at all pretentious. It's probably too small to be too full of itself. And its decor is about as far from a Costes brothers production as croutons are from croissants. Everything about it is appealing, from the beguiling, salad-green facade with its old-fashioned signs to the tempting little horseshoe-shaped zinc bar inside, where pulling up a stool and ordering a coffee feels as easy as it sounds. There's also an alluring area in the back, which is quieter than the front terrace and roomier than the bar, but devoid of the atmosphere and clatter and chat of the front, so why would you bother? Order a tarte tatin and watch the locals walk in. This is Paris as you imagined.

30 Rue Vieille du Temple, 4th; tel. 01 42 72 47 47

Restaurant Bon

A Starck surprise

The French star-architect (or Starckitect, as some people call him) Philippe Starck was responsible for the design of this startling restaurant. Set in an impressive old flower market, it's an extraordinary space: modern, whimsical and utterly surprising, as only Starck can do. The interior consists of various salons, each meant for a different purpose and each distinct in style and ambience. There's the Vinothèque, the Fireplace Room, the Library and the Boudoir. There's also an all-white room with towering piles of books, given over to smokers. The food, which leans to pan-Asian, is just as original. It's not everyone's cup of tea, but it's astonishing all the same.

25 Rue de la Pompe, 16th; tel. 01 40 72 70 00; www.restaurantbon.fr

Boulangeries, patisseries and chocolateries

What can I say about Paris's boulangeries, patisseries and chocolateries? This is a city that treats its sugar seriously. The window displays are just the start of the experience. Try to resist the goodies when you step inside – I warn you, it's not easy. The best way to approach the temptation is to do what the locals do: buy a small cake, pastry or chocolate and find a park or Seine-side seat to eat it. It truly is one of the best ways to see – and taste – Paris.

Aurore-Capucine Patisserie

Like a fairy tale

Like something from a fairy tale, this place attracts people from far and wide, like children to a pastry-making Pied Piper. The exterior is charming and pretty, with navy awnings etched in white writing, and the interior is mesmerizing. Even the proprietress looks like a jollier version of a character in a story. It's whimsical, delightful, calorific and fabulous. If you're a gardener, try the rosemary and thyme macaron. Or the violet one. Or the rose-with-chocolate-filling concoction. On second thought, perhaps you'd better leave before you eat the lot.

3 Rue de Rochechouart, 9th; tel. 01 48 78 16 20

Chocolaterie Joséphine Vannier

Chic chocolates

Trust the French to make chocolate so exquisite you want to frame it and put it on a wall. Josephine Vannier's rich creations are far from Cadbury's versions. They're so incredible that you almost want to buy a suitcase-full

to take home as gifts. There are chocolates shaped like little totes and handbags, chocolates that resemble painter's palettes, chocolates formed into elegant stilettos (complete with ribbons) and even chocolates artfully arranged in little chocolate boxes. They're far too beautiful to eat.

4 Rue du Pas de la Mule, 3rd; tel. 01 44 54 03 09; www.chocolats-vannier.com

Gérard Mulot

Breathtaking cakes

Every time I walked past this patisserie in the 6th arrondissment, I find myself slowing down, just to gaze in fascination at the cakes on dazzling display. Sometimes I even get out my camera and take photos. They're the kind of cakes you'd imagine a rich Parisian woman in the 6th would buy for a soirée with her rich Parisian friends; the kind of cakes that would impress jaded rich women who'd seen every cake there was to see. Once, tempted by these window displays, I ventured in. I ordered and tried one of the peach tarts. I don't even like peach, but it looked so good. It was the best dessert I've ever had. Gérard, you are marvelous.

76 Rue de Seine, 6th; tel. 01 43 26 85 77; www.gerard-mulot.com

Pierre Hermé

Amazing macarons

Monsieur Hermé has a reputation for making marvelous macarons. He's also adept at other sugary things, but it's the macarons that have made him famous. (I love the pistachio and passion fruit one.) Every year, from a boutique that looks like the interior of a jewelery shop, the former pastry chef for Fauchon brings out these amazing creations, along with dozens of other sweet things with curious names like *mousseline aux fruits de la passion*, *confit de rhubarbe aux fraise* and *eclates d'armandes*. There's also something called *carrément chocolat*, which I've been admiring for years. Pierre Hermé has become so successful that he now has several shops in Paris, several in Tokyo and one in London.

72 Rue Bonaparte, 6th; tel. 01 43 54 47 77 (see website for other stores); www.pierreherme.com

Poilâne

Sexy bread

Everyone should pop along to Poilâne, just to see how elegant a Parisian bakery can be. I don't know how you make bread look sexy, but this place does it. From the traditional shopfront to the chic interior, which looks like it has been styled by *Vogue,* everything here is enthralling. And the various offerings taste amazing, too. One of the best breakfasts I've had was an almond croissant from Poilâne, which I ate walking through the Luxemboug Gardens early one summer's morning. Just beautiful. Try the *pain aux noix* or the *pavé au raisin*: perfect for impromptu picnics in the park.

8 Rue du Cherche-Midi, 75006, Paris. Ph 01 45 48 42 59; www.poilane.com

Richart

Rich lickings

The thing about Parisian chocolatiers is they know how to make chocolate look even more delicious than it already is. It's not good news, of course. We don't need to be tempted any more. The sublime designs of Richart are particularly enticing. Presented against a strikingly minimalist decor, the elegant squares of deliciousness include basil, curry and, of course, classic flavors such as strawberry.

258 Boulevard Saint-Germain, 75007, Paris. Ph 01 45 55 66 00; www.chocolats-richart.com

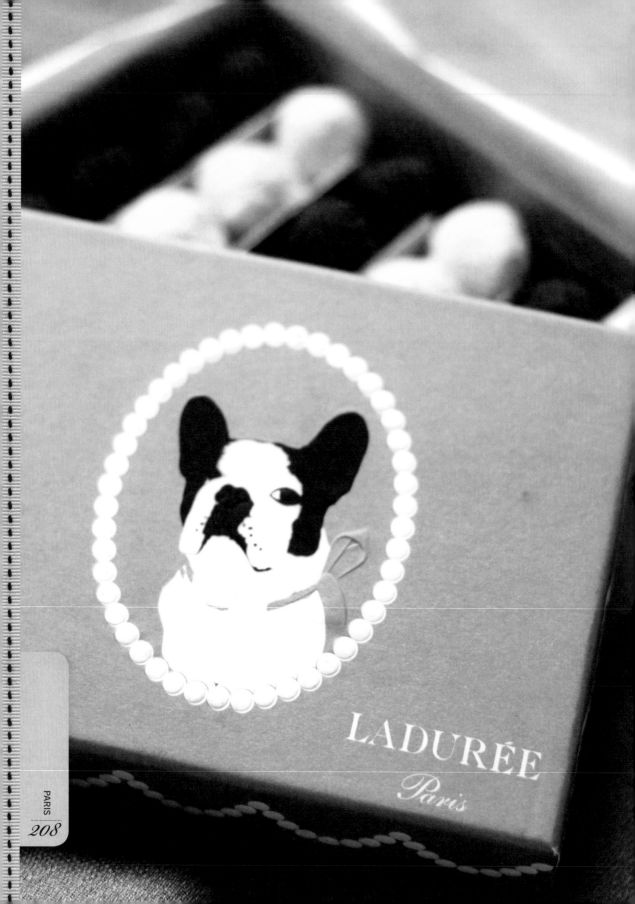

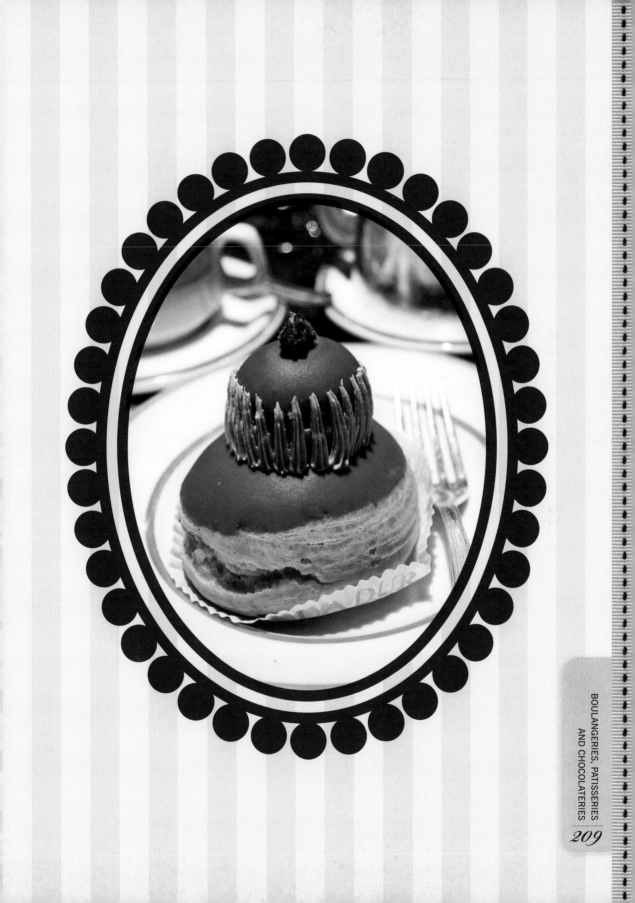

Gourmet stores and food markets

Food markets are hugely popular in Paris, particularly on Sundays when locals spend their mornings browsing for the best produce and checking out what's on special or in season. The French know their food, you see, and can't stand buying their groceries from a supermarket when there is so much glorious fresh produce in the street markets. And of course, the atmosphere of these markets and gourmet stores is always fabulous!

Fauchon

Think pink

If you love gourmet food, then head for this department store, one of the world's most famous foodie stores. The branding is impeccable (think Schiaparelli-pink walls and glossy black accents), the merchandising is fantastic (glass display cases and counters of pink and gold packages containing all sorts of scrumptious goodies) and the potential for addiction is very real. For more than a century, this store has sold luxury goods to the rich and famous, including the Duke and Duchess of Windsor when they decamped to Paris. It's famous for its pretty gold canisters of teas, which make perfect gifts, but it's also good for caviar, crackers, chocolate, olive oil and sauces ... the list goes on. Most of it is clever packaging, but it works. You'll walk out with a bag of Fauchon goods before you've had a chance to steel yourself against spending.

24–26 Place de la Madeleine, 8th; tel. 01 70 39 38 00; www.fauchon.com

Hediard

Luscious treats that are ooh-la-la

Like Fauchon, the brilliance of Hediard lies not only in its range but also its packaging. Hediard's branding is bright red, and boy, does it stand out in the store. Where Fauchon is pretty, Hediard is more handsome, and the red contributes to that. Indeed, it almost feels like one of those old-fashioned grocers; you know, the kind where the proprietor wore a long white apron over black trousers and was forever up a tall wooden ladder getting gourmet goods down from the top shelves. With its bags of spices and beautifully presented groupings of fruit and vegetables, it even looks like an old grocery store, though it's a hundred times as big.

21 Place de la Madeleine, 8th; tel. 01 43 12 88 88; www.hediard.com

Marché Biologique Raspail

Organic bliss

Perhaps the most famous food market in Paris and certainly the most famous organic one, the highly regarded Raspail is where the foodies flock on Sunday mornings. You see them here early, browsing through the figs, peering at the strawberries, inspecting the artichokes. Local celebs such as Gérard Depardieu and Catherine Deneuve adore it. It can get crowded, but the ambience is wonderful.

Boulevard Raspail, 6th

Flavour and history under one market

Despite its rich history, Paris's oldest covered market is one of those places that many people miss. It's tucked away in the Upper Marais and is almost an insider's place. But serious food lovers know of it, and make the pilgrimage here for the experience. At this small but friendly market you can choose what you want from the various stalls and eat the dishes at tables set up within the market – something other markets don't often do – so you can have lunch amid the aromas and atmosphere of the place. There are French, Moroccan, Italian and even Japanese stalls, all of which make a refreshing break from chocolate croissants, macarons and *poulet rôti*. The market is named for the orphanage that once stood nearby – the name literally means "Market of the Red Children" – and alludes to the orphans who all wore red uniforms.

39 Rue de Bretagne, 3rd

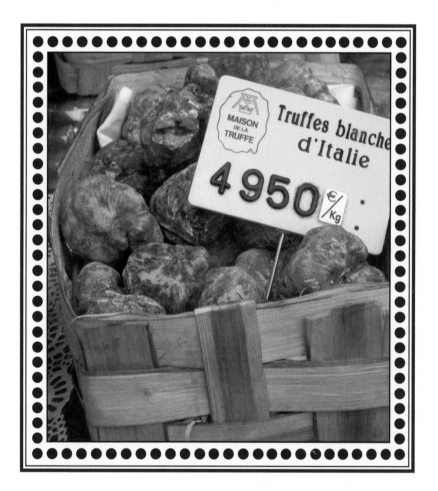

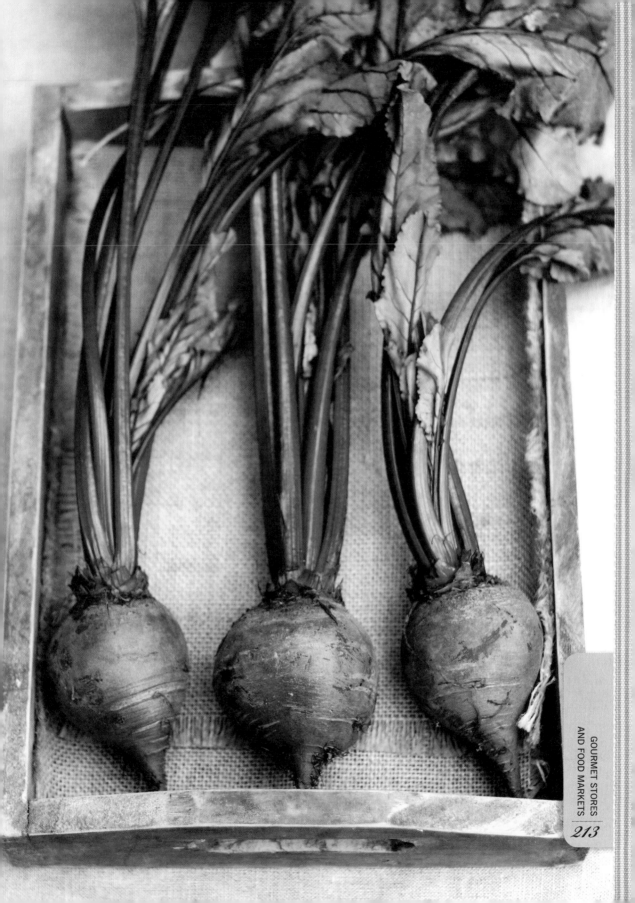

CAPTIONS

Page iv–v

Paris's most famous landmark, the Eiffel Tower, viewed from the 8th arrondissement.

Page xii

The view over romantic Montmartre, in the 18th arrondissement.

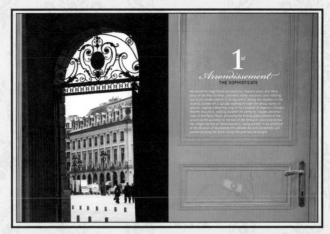

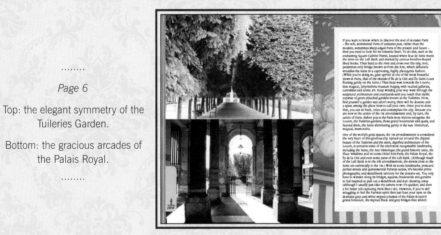

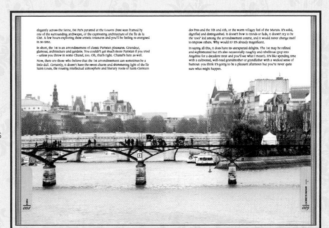

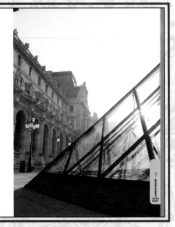

Page 11

The striking lines of the Louvre's pyramid at first light.

Page 14

The shuttered charm of the Romantic Museum (Musée de la Vie Romantique; page 169).

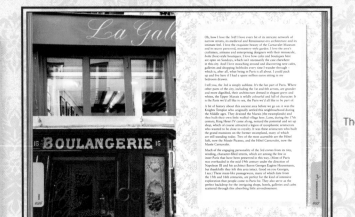

Page 26

The enchanting galleries and stores of the 3rd arrondissement.

Page 33

The classically Parisian interior of Cafe Charlot (page 202).

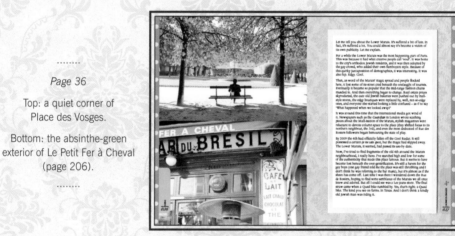

Page 36

Top: a quiet corner of Place des Vosges.

Bottom: the absinthe-green exterior of Le Petit Fer à Cheval (page 206).

Page 38–39

Each summer, a carnival enlivens the square in front of the Hôtel de Ville.

Page 41

The garden of the Place des Vosges is a sanctuary of calm in the middle of the bustling Marais.

Page 43

The entrance to the divine tea salon at the La Grand Mosquée de Paris (page 195).

Page 46

Top: a view of the Notre Dame from the 5th arrondissement.

Bottom: one of the many lovely food stores scattered throughout the 5th arrondissement.

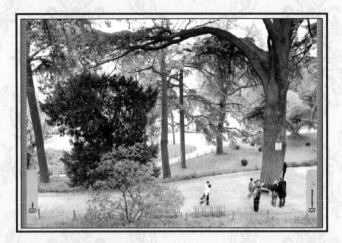

Page 48–49

The quiet beauty of Jardin des Plantes.

Page 53

A pretty pink room in the Hôtel du Panthéon.

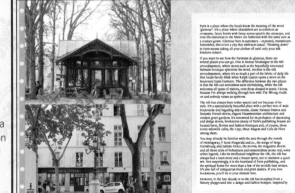

Page 56

Top: the gorgeous Luxembourg Gardens.

Bottom: Place de Furstemberg is a great place to start your exploration of the 6th arrondissement.

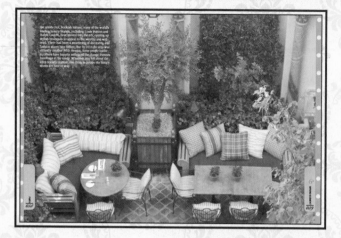

........

Page 58–59

The Ralph Lauren store in the 6th arrondissement has an elegant restaurant with a charming courtyard.

........

........

Page 61

The cafe of the Luxembourg Gardens is like something from a fairy tale.

........

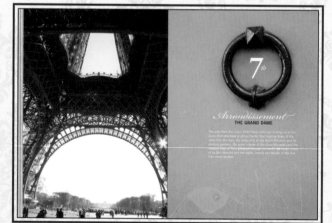

........

Page 64

The view from the base of the Eiffel Tower is almost as spectacular as the one from the top.

........

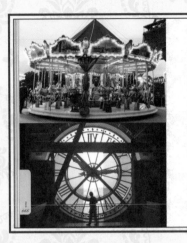

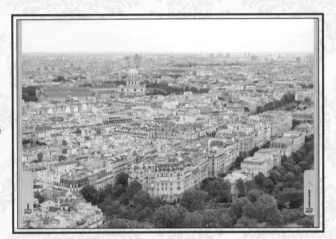

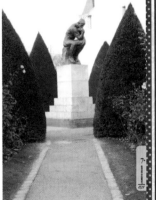

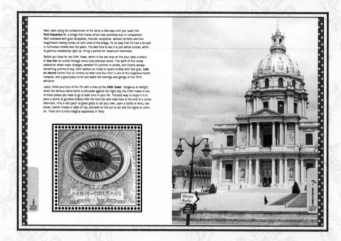

........

Page 73

The Military Museum of the Army of France (Musée de l'Armée) is one of the many buildings in the Les Invalides complex in the 7th arrondissement.

........

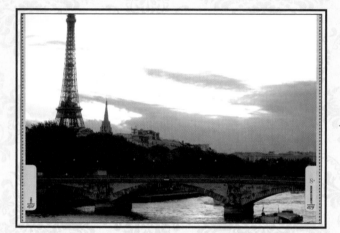

........

Page 78–79

The Eiffel Tower at sunset from the Pont Alexandre III bridge.

........

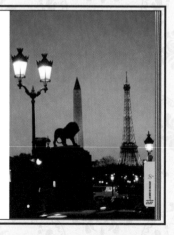

........

Page 81

The elegant streetlights of Paris, which illuminate its beauty long after the sun has gone down.

........

Page 83

The glorious architecture of the
Pont Alexandre III bridge.

Page 84

The 10th and 11th
arrondissements are full of
gorgeous tree-lined streets and
lovely spots to sit and relax.

Page 86

The colors of the 10th and 11th
arrondissements are as pretty and
whimsical as its stores
and artisans.

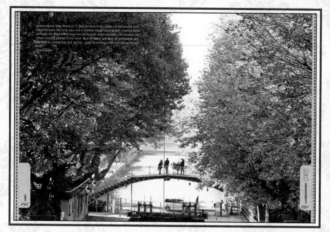

Page 92–93

The Canal Saint-Martin is the perfect place for a stroll on a sunny Parisian day.

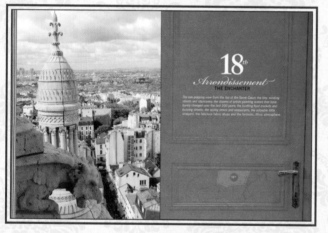

Page 94

One of the best views of Paris is from the Sacré-Cœur basilica atop Montmartre.

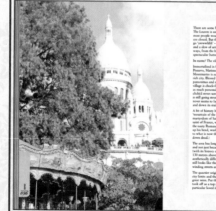

Page 96

The Sacré-Cœur looms large on a wander through the streets of Montmartre.

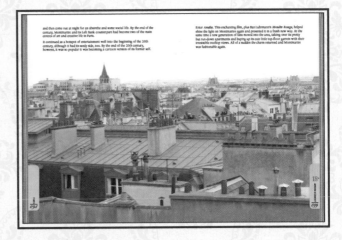

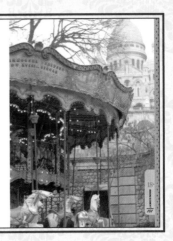

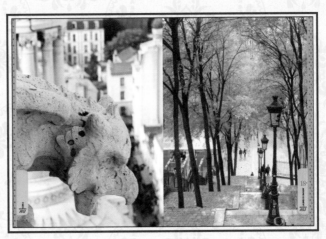

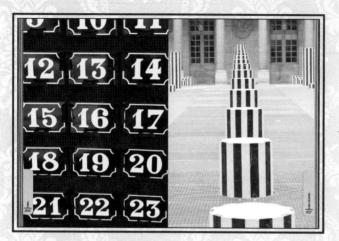

.........

Page 107

The black-and-white sculptures of
the Palais Royal.

.........

.........

Page 110

The spectacular gardens at
the Carnavalet Museum
(Musée Carnavalet; page 161).

.........

.........

Page 112

The atmospheric
Abbey Bookshop (page 118) in
the 6th arrondissement.

.........

Page 124

Deyrolle (page 125) is filled with taxidermied animals of all shapes and sizes and is one of Paris's most extraordinary stores.

Page 139

Looking through the stunning balustrades to the beauty of Le Bon Marché department store (page 152).

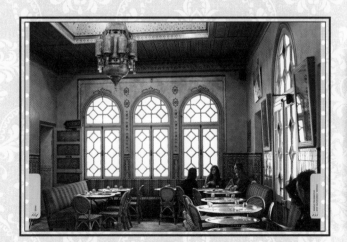

Page 154–55

The gorgeous tea salon at La Grand Mosquée de Paris (page 195).

........

Page 162–63

Left: detail of a staircase in
Le Bon Marché department store
(page 152).

Right: detail of an ornate wall in
the Carnavalet Museum (Musée
Carnavalet; page 161).

........

........

Page 166–67

Left: a classic Parisian staircase.

Right: the gravel paths of the Rodin
Museum (Musée Rodin; page 169).

........

........

Page 170–71

The labyrinth of the
Jardin des Plantes gardens in the
5th arrondissement.

........

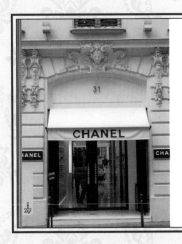

Page 184

The legendary Chanel store on
Rue Cambon (page 185).

Page 190–91

An elegant black, white and
green foyer.

Page 239

Children enjoying an old-fashioned
pony ride in the Tuileries Garden.

MERCI

In October 2010 I traveled to Paris to continue writing and photographing this book. It had been a challenging year, both professionally and personally, and I hoped the trip would provide some much-needed respite. By the time I touched down, I was ready for a hot chocolate at Angelina and a long, slow stroll through the Tuileries Garden. It proved to be just the tonic. Those weeks in Paris may have been frantic, but they were also full of pleasure – the kind that only Paris can give.

This book is intended to be a kind of sonnet to a city I love, a city that has saved me – usually from myself and my frantic life – so many times. It is a loving tribute to a place that revives the spirit, revitalizes the mind and inspires the imagination in a way that few other destinations do.

As with any book, I am not the only one who has put countless hours into this project, and I would like to sincerely thank the following people for their kind contribution. Without their help and hard work, this book would not have been nearly as lovely. My heartfelt thanks go to the beautiful team at Plum – publisher Mary Small, senior editor Ellie Smith and editor Jane Winning, who have been wonderful from start to finish. I would also like to thank copy editor Susie Ashworth and designer Michelle Mackintosh, both of whom did so much to shape these pages. I am grateful to you all. And I would like to send a special thanks to the team at Splitting Image.

Lastly, I would like to thank my partner, who is the loveliest man a woman could ask for.

INDEX

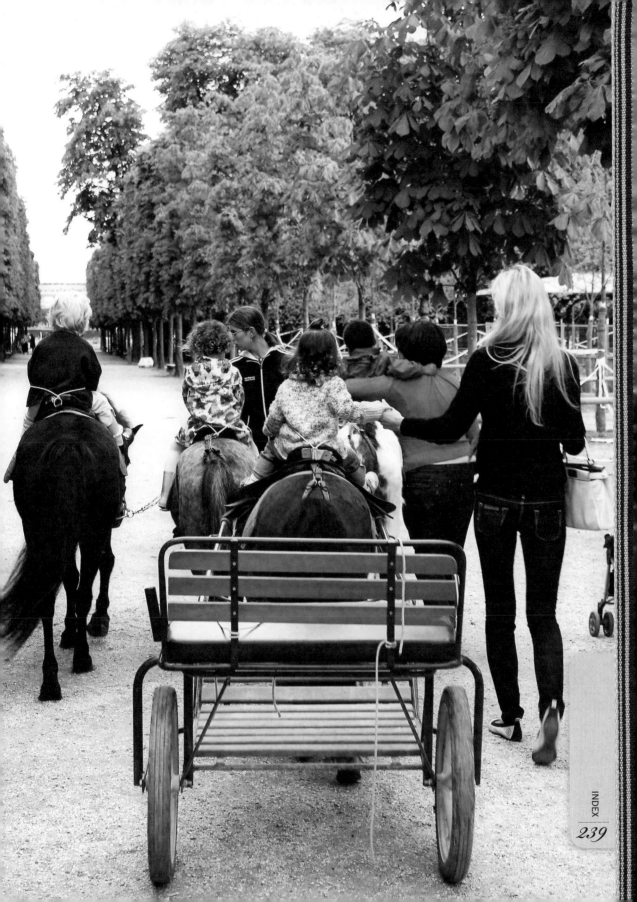

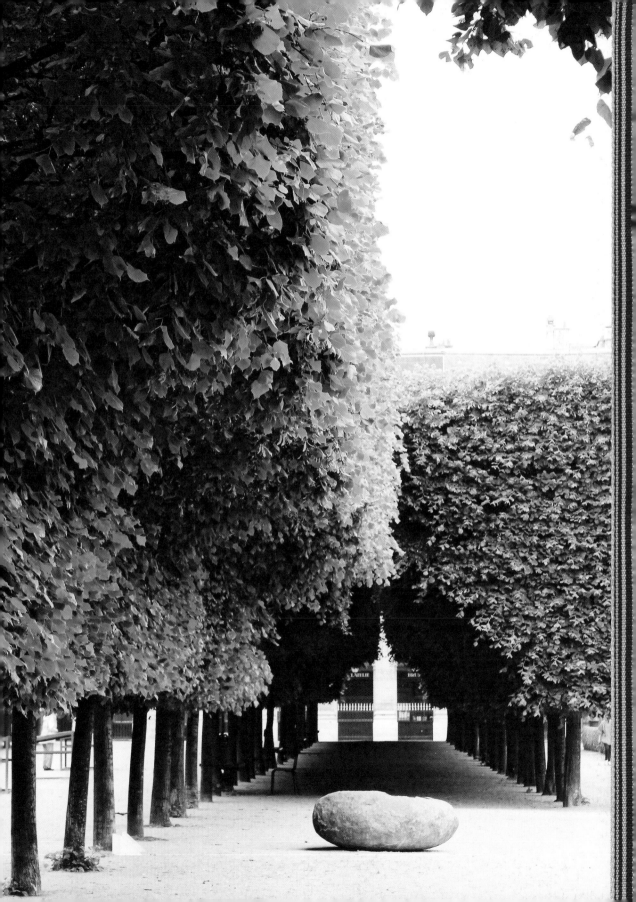

First published in the United States of America in 2012 by Chronicle Books LLC.

First published in Australia in 2011 by Plum, an imprint of Pan Macmillan Australia.

Library of Congress Cataloging-in-Publication Data available.

ISBN 978-1-4521-1385-2

Manufactured in China

Design by Michelle Mackintosh
Cover Design by Michelle Mackintosh and Hillary Caudle

10 9 8 7 6 5 4

Chronicle Books LLC
680 Second Street
San Francisco, California 94107
www.chroniclebooks.com